THE ART & DESIGN SERIES

For beginners, students, and working professionals in both fine and commercial arts, these books offer practical how-to introductions to a variety of areas in contemporary art and design.

Each illustrated volume is written by a working artist, a specialist in his or her field, and each concentrates on an individual area—from advertising layout or printmaking to interior design, painting, and cartooning, among others. Each contains information that artists will find useful in the studio, in the classroom, and in the marketplace.

BOOKS IN THE SERIES:

Carving Wood and Stone: An Illustrated Manual
ARNOLD PRINCE

Chinese Painting in Four Seasons:
A Manual of Aesthetics & Techniques
LESLIE TSENG-TSENG YU/text with Gail Schiller Tuchman

The Complete Book of Cartooning
JOHN ADKINS RICHARDSON

Creating an Interior
HELENE LEVENSON, A.S.I.D.

Drawing: The Creative Process
SEYMOUR SIMMONS III and MARC S.A. WINER

Drawing with Pastels
RON LISTER

Graphic Illustration: Tools & Techniques
for Beginning Illustrators
MARTA THOMA

How to Sell Your Artwork: A Complete Guide
for Commercial and Fine Artists
MILTON K. BERLYE

Ideas for Woodturning
ANDERS THORLIN

The Language of Layout
BUD DONAHUE

Nature Drawing: A Tool for Learning
CLARE WALKER LESLIE

Nature Photography:
A Guide to Better Outdoor Pictures
STAN OSOLINSKI

Painting and Drawing: Discovering Your
Own Visual Language
ANTHONY TONEY

Photographic Lighting: Learning to See
RALPH HATTERSLEY

Photographic Printing
RALPH HATTERSLEY

Photographing Nudes
CHARLES F. HAMILTON

A Practical Guide for Beginning Painters
THOMAS GRIFFITH

Printmaking: A Beginning Handbook
WILLIAM C. MAXWELL/photos by Howard Unger

Silkscreening
MARIA TERMINI

Silver: An Instructional Guide
to the Silversmith's Art
RUEL O. REDINGER

Teaching Children to Draw: A Guide
for Teachers and Parents
MARJORIE WILSON and BRENT WILSON

Transparent Watercolor:
Painting Methods and Materials
INESSA DERKATSCH

Woodturning for Pleasure
GORDON STOKES/revised by Robert Lento

LESLIE TSENG-TSENG YU

text with Gail Schiller Tuchman

PAINTING

IN FOUR SEASONS

A Manual of Aesthetics
& Techniques

A SPECTRUM BOOK

Prentice-Hall, Inc., Englewood Cliffs, New Jersey 07632

Library of Congress Cataloging in Publication Data

Yu, Leslie Tseng-Tseng.
 Chinese painting in four seasons.

 (The Art & design series) (A Spectrum Book)
 Bibliography: p.
 Includes index.
 1. Chinese painting. 2. Painting—Technique.
3. Decoration and ornament—Plant forms—China.
I. Tuchman, Gail Schiller. II. Title. III. Series:
Art & design series.
ND1040.Y866 751.42'51 81-1943
ISBN 0-13-133025-X AACR2
ISBN 0-13-133017-9 (pbk.)

Grateful acknowledgement is made for permission to reprint the following copyrighted material:

"The Lamp and the Moon," "A Flute at Evening," "Midnight," "Climbing Tung Kuan Mountain," untitled poem (p. 134), "The Plum Tree," "Memories of Childhood," "The Call of Spring," and "Butterflies." Reprinted from *Poems of the Hundred Names,* translated by Henry H. Hart, with the permission of the publishers, Stanford University Press. Copyright © 1933, 1938 by the Regents of the University of California. Copyright © 1954 by the Board of Trustees of the Leland Stanford Junior University.

All photos by Henry Garlick Photography.

THE ART & DESIGN SERIES

Cover painting: *Orchids by the Cliff* by Leslie Tseng-Tseng Yu

Quatrain and calligraphy by the author's mother, Lou-Zse Hou Yu

Chinese Painting in Four Seasons: A Manual of Aesthetics & Techniques
by Leslie Tseng-Tseng Yu/text with Gail Schiller Tuchman
© 1981 by Leslie Tseng-Tseng Yu

A SPECTRUM BOOK

Printed in the United States of America

10 9 8 7 6 5 4 3 2 1

Editorial/production supervision: Maria Carella.
Art director: Jeannette Jacobs.
Page makeup: Christine Gehring Wolf.
Manufacturing buyer: Barbara A. Frick.

PRENTICE-HALL INTERNATIONAL, INC., *London*
PRENTICE-HALL OF AUSTRALIA PTY., LIMITED, *Sydney*
PRENTICE-HALL OF CANADA, LTD., *Toronto*
PRENTICE-HALL OF INDIA PRIVATE, LIMITED, *New Delhi*
PRENTICE-HALL OF JAPAN, INC., *Tokyo*
PRENTICE-HALL OF SOUTHEAST ASIA PTE., LTD., *Singapore*
WHITEHALL BOOKS, LIMITED, *Wellington, New Zealand*

To
my teachers
and
my students

CONTENTS

PREFACE

One of my students once said, "I took this course so that I could have an understanding of Chinese painting, but I've found that it has given me a greater understanding of life itself, and I've really grown from it." I hope many of you will have the opportunity to study the discipline of Chinese painting with a competent teacher, well trained in this exacting medium. But not everyone needs actually to take up the brush. Whatever your specific interests may be, you will find that in learning about the *process* of Chinese painting and its underlying rationale, your understanding and appreciation will be heightened. Knowledge of the language of the brush will help you "read" Chinese paintings intelligently. It will also give you insight into Chinese culture as a whole.

The illustrated step-by-step instructions and examples reveal the innate structure and systematic procedures of the art of Chinese painting. The emphasis throughout is on concrete practice, which in turn illuminates abstract theory. The basic techniques of Chinese painting are multifaceted in their applications. Perhaps one of the most obvious applications is the brushwork and design motifs suitable for pottery. Forms from nature can be utilized in a variety of ways in textile design. Appreciation of spontaneous line plays a prominent role in drawing. Brush techniques can be adapted to general illustration. The unique Chinese sense of space and spacing (composition) can be applied to painting and graphic design. There is a spiritual dimension in the practice of Chinese painting which becomes a meditative experience. For those interested in eastern philosophy, Chinese painting is a most concrete and specific means to approach the elusive nature of Daoism (Taoism) and Chan (Zen) Buddhism. The wide range

of applications notwithstanding, the pure art of Chinese painting is its own reason for being.

This book makes its debut exactly 302 years after the publication in 1679 of the *Mustard Seed Garden Manual of Painting*. A classic treatise, its basic principles, standards, and techniques remain unchanged today. As with the *Mustard Seed Garden Manual of Painting*, this handbook is not intended to restrict but rather to provide a foundation of aesthetic knowledge and technical skills essential to truly creative work. The subjects are presented exactly in the order that I introduce them to my classes. Coincidentally, they parallel the progressive order of the four seasons. Chinese painting is one of the supreme achievements of Chinese civilization. I am deeply indebted to this immense artistic and cultural heritage. I feel an affinity to my spiritual ancestors, and gratefully acknowledge their ever-present inspiration. This book is my small contribution to the dynamic and continuous tradition of Chinese painting. It offers the joys of this art in our world, where the east-west polarity is but two currents from the same source, two aspects of the same reality—the *yin* and the *yang*.

The extraordinary Chinese brush and ink capture instantaneously the vital rhythms of nature in a way that no other medium can. For all of you who wish to discover this wonder-filled world, a spectrum of possibilities is waiting.

ACKNOWLEDGMENTS

I wish to express my heartfelt appreciation to the many people who inspired and assisted me along the Dao, or Way, of this book. Special thanks are due to Stella Grafakos for her infinite imagination, to Henry Garlick for his artful photography, to Linn Fischer for her excellent suggestions in design, and to Roberta Stalberg as consultant for the Pinyin spellings. Professional writer-editor and my former student Gail Schiller Tuchman was my collaborator in writing the text, except for the Introduction, The Mystique, and the Summary. It has been a pleasure working with the editorial, art, and production staff of Spectrum Books. My grateful thanks to all, especially Maria Carella, for the constant meticulous care every step of the way in the creation of this book.

L.Y.
New York
Autumn 1981

INTRODUCTION

Chinese painting, the oldest living art in the world, has much to offer artists and art lovers both east and west. Rooted in a rich tradition of over two thousand years yet exceedingly contemporary, Chinese art possesses a beauty that transcends time. A celebration of nature, Chinese painting is orderly yet mysterious, reflecting its source. The highly developed principles and refined techniques, so ingenious yet so logical, are totally absorbing and always fascinating. I never cease to marvel at the superb capabilities of the Chinese brush, the most sensitive of instruments. With each brushstroke I am constantly discovering this mystery anew.

In Chinese painting, nature provides the wellspring of inspiration. Its infinite variety of forms and patterns are unsurpassed. Many of the subjects have acquired symbolic significance through the ages, thus further contributing to their wealth of meaning. The four seasons are major themes pervasive in Chinese painting. Nature's language is universal, and the seasons speak to us in myriad ways from time eternal. The harmonious movements and rhythms of the universe, always dynamic, never static, are captured by the instantaneous medium of the Chinese brush and ink. This vital life-force, intangible though it may be, is crystallized in the Chinese term *qi* (*ch'i*). *Qi* means breath (of life) or spirit. Associated with the concept of *qi*, which can be thought of as a life-giving cosmic energy, is the fundamental idea of *yin* and *yang*. They are interwoven into the very fabric of Chinese life and thought. *Yang* represents the positive, sun, heaven, masculine, spring-summer, and so on. *Yin* represents the negative, moon, earth, feminine, autumn-winter,

and so forth. These are the two opposite yet complementary forces of nature—a duality that actually reflects an intrinsic unity—which together activate all things.

Chinese painting, then, offers a philosophical means for exploring the mysteries of the universe. Being attuned to nature, you become meditative and contemplative. You gain a heightened awareness. The emphasis is on perception through contemplation of the world of nature until you merge with the universal. The boundary between self and nonself dissolves. Through the experience of the brush first hand (literally), you gain illuminating insights not possible otherwise. When understanding is direct and immediate, and when attention and concentration are fully centered, it is possible to approach the *Chan* (Zen) of painting. *Chan* means "meditation" or "becoming one with the universe." The creator and the created become one. You can discover a new world of beauty in the depth of the simple and seemingly insignificant, where each flower and each leaf is transformed into a profound image. You learn to trust your own feelings through which you reach your true consciousness, a deep source of creative power. The most profound things are the most simple. It is a return to the primal source, which exists within everyone and needs only to be discovered. The collective creative impulse finds expression in the spontaneous and intuitive spirit of this art.

Chinese painting is a spiritual discipline, not unlike the martial arts, such as *taijiquan* (*t'ai chi ch'uan*), the ancient Chinese exercise-art. In a sense, the practice of Chinese painting can be considered the most subtle and refined form of these arts, requiring a disciplined coordination of the physical and mental self. You feel the presence of an inner power, because the very act of painting is a spiritual experience. As we shall see, there is a tension of opposites in the rendering of the brushstrokes, a constant balance of force/counterforce, movement/countermovement, and point/counterpoint. The result is a dynamic equilibrium, a fluent interplay of *yin* and *yang*, a magical dance of brush and ink.

Basically, Chinese painting possesses three distinctive qualities: simplicity, spontaneity, and asymmetry. The first and foremost is **simplicity,** which we regard as the height of elegance and the epitome of refinement. This quality led to a preference for monochromes, the quintessence of Chinese

painting. Traditionally, ink painting was in the province known as *wen-ren-hua*,*
or paintings of the literati, a unique category of art with no parallel in
the west. This genre flowered in the Song (Sung) dynasty, an epoch which
coincidentally was the zenith in the development of Chinese culture.
Even though the artists were scholars, their paintings were nonacademic in the
sense that they were antiestablishment and a reaction to the stuffy
constraints of academe. This art form was often avant-garde in character. No
matter that official critics might have dismissed them as eccentric and
insignificant—these individualists nevertheless maintained their independent and
exceptional status by the sheer power of their works. Since these scholars
were well versed in the art of Chinese calligraphy, it was natural that they would
be adept also at the allied art of painting. Bamboo, chrysanthemum, plum
blossom, and orchid were favorite subjects, not only because they lent themselves
so well to treatment in ink, but also because their natural forms were
eminently suited to the vital calligraphic tracings of the brush. Indeed, these four
poetic subjects were vehicles for displaying calligraphic virtuosity, with
each subject offering its unique features to complement the corresponding
qualities of the medium.

The use of ink monochromes, plus the meaningful function of line and
space, led to a sense of restraint and refinement. The love of simplicity is
exemplified by the depiction of a few well-chosen elements with an economy of
line and a conciseness of expression. Accordingly, the painter is sparing
with brush and ink, thus creating an intriguing suggestive quality that provokes
the imagination of the beholder. The aim is to capture the *essence* of an
image or idea. This process of selectivity, of reduction to the bare essentials, is
facilitated by the method of painting indirectly from a mental image
rather than directly from a scene or object. In this way, unnecessary details are
naturally eliminated. The goal is to paint not what the eye sees but rather
what the mind knows; thus Chinese painting is less concerned with the
appearance than the essence of things. Natural images serve only as a point of

**Ren* 人 is usually translated as "man" and *wen-ren-hua* as "gentlemen paintings";
however, it should be pointed out that the Chinese word *ren* has always meant *people* of both
gender.

3

departure, a vehicle for the expression of transcendental images, which ultimately reflect the basic idea of the unity of human beings with the cosmos.

Chinese painting is noted for its **spontaneity**. The nature of the brush and ink demands an instantaneousness of technique. There is a directness from mind to hand to brush and paper. Energy, force, and movement are inherent in each rapid brushstroke, alive and irrevocable. The feeling of freedom and effortlessness comes through. This "effortlessness" in fact requires a great deal of effort, for it is the precise expertise of a perfectly disciplined brush that makes freedom possible. In addition, insight and intuitive knowledge are necessary, ever-present components for the artist in action. Because of the spontaneous quality of the medium, it is often full of delightful suprises, leading the painter to unexpected paths. A truly innovative artist possesses the ability to grasp immediately and take advantage of the new direction suggested by the brush and ink. Once the artist is in tune with nature, the work has its own impetus and, complemented by a highly trained technical dexterity, flows naturally. The brush is wielded with divine power. It is then an inspired work of art—unencumbered, fresh, and original.

Another distinctive feature is **asymmetry** and the related concept of the positive use of space. The intrinsic forms and organic patterns of nature are asymmetrical in their symmetry. In Chinese aesthetics, then, the difference between asymmetry and symmetry is the difference between natural and mechanical, dynamic and static, art and artifice. In every instance, the former is highly preferable to the latter. The aim is to create a dynamic equilibrium rather than a static balance.

In compositions that are asymmetrical, **space** plays a major role. The concept of space as a positive element is an original idea found in Chinese painting. It can be traced to the philosophical thinking predominant in both Daoism (Taoism) and Chan Buddhism, that is, the concept of "emptiness" or the "positive void," which suggests at once both inexhaustible fullness and nothing at all. This profound and lucid space not only serves effectively in harmonizing all the elements in a painting but also gives a hint of the infinite, thus imparting poetic feeling and a spiritual dimension. We see space as metaphor, space transformed into substance. The imaginative possibilities inherent in this liberating space are boundless so that viewer's (as well as the artist's) own experience is brought into play, thereby establishing an open dialogue.

The fluid and skillful use of pure space in Chinese painting became highly evolved and sophisticated. A proper sense of space became a natural

instinct for the Chinese artist. This is especially true of the works of Chan Buddhist monks and painters of similar inclination, where the painting is delineated by a few well-placed strokes which demarcate the space and define the entire picture. In their flair for the succinct, the art of positive space was realized.

There are two basic styles in Chinese painting: *Gongbi* (*Kung Pi*—"labored brush") and *Xieyi* (*Hsieh I*—"write idea" or "idea writing"). The former method is detailed, meticulous, and carried out with slow, fine brushwork. In direct contrast, the latter method is spontaneous and unrestrained, requiring free, swift, and bold brushstrokes. *Gongbi* is academic, whereas *Xieyi* is lyrical. My preference is for *Xieyi*, as I find the dynamics of the freehand method ideally suited to my temperament. It is more difficult and more challenging. To me, the unique demands of *Xieyi* are enormously compelling and highly irresistible. Accordingly, it is the basic qualities and techniques of *Xieyi* painting that are discussed in this book.

Xieyi painting is a condensation of reality. Its style is most closely related to Chinese calligraphy in its imaginative concepts, intensity of expression, purity of treatment, simplicity of media, economy of means, compactness of forms, and suggestive allusions. All these qualities are superbly displayed in the cursive calligraphic style known as *grass writing*, a visually descriptive term recalling slender grass dancing in the wind. Similarly, *Xieyi* painting is characterized by free and flowing strokes of the brush, strength and vitality of the individual lines, plus a bold and daring use of ink washes. We say that one must be courageous and confident to paint in the *Xieyi* manner.

The philosophy and content of *Xieyi* painting were directly influenced by Daoism and Chan Buddhism. Their relationship was natural and intrinsically organic. This is not surprising because, as already mentioned, Chinese painting at its best is meditation and a mystical experience. The artist achieves a communion with nature. There is an inner harmony, a reflection of the Chinese sublime view of nature in concert with the universe. The changing seasons are ramifications of the ever-changing processes of the Dao (the Way of nature), where there is at once order and spontaneity, unity and diversity. In spirit, Chinese painting reflects the harmonious ebb and flow of nature and bespeaks a serene and tranquil eloquence. It is a visible expression of the invisible action of the Dao.

Ultimately, Chinese painting is a direct simplicity in spirit, concept, and execution. It is this classic simple elegance that is the true heart and soul of Chinese painting.

THE
MATERIALS

The simplicity of the materials used in Chinese painting is a manifestation of the aesthetics of the art itself, and vice versa. This simplicity is evidenced by the fact that the equipment necessary for Chinese painting numbers only four. The "four treasures" of Chinese painting are brush, ink, ink stone, and paper. Each has been developed through the years with extreme care and possesses a special significance. The Chinese have always had a profound respect for these materials and have placed a great value upon them.

But we cannot discuss the materials and aesthetics of Chinese painting without first turning our attention to calligraphy, the supreme Chinese art form, for they share the same philosophical foundation and are inextricably related. The parallel between painting and calligraphy is evidenced through the materials and their application.

In both disciplines, the identical materials are used, and the artist holds and moves the brush in the same way.

In both disciplines, the artist must have a mental preparation, a concentration, a coordination of mind and body in order to transmit the ink to the paper with a sureness of hand and a confidence of execution. The brushstrokes exhibit control and fluency, giving way to spontaneity and life.

In both disciplines, the concern is with pictorial beauty: Calligraphy is abstract design grounded in rhythmic execution and dynamic equilibrium of line and space; the brushstrokes in painting are calligraphic strokes. The ideograms themselves are symbolic and pictorial in nature and exhibit a fine sense of proportion. Indeed, it is possible to say (and we do) that the artist

"writes" paintings and the calligrapher "paints" ideograms. Furthermore,
the close affinity between the two is such that each enhances the other, and a
colophon, or inscription of writing (usually a poem or brief essay of
literary, philosophical, or historical nature), is often an integral part of the
painting.

In both disciplines, the most outstanding quality is the liveliness of
brushstrokes, which is the primary criterion in judging the merits of each and
every work. We call this standard of excellence *bi li,* or "brush strength."
The lines created have vitality and a kind of tensile strength, even though they
may be delicate at the same time. Also, through the brushstrokes, the
personality of the artist is revealed.

In both disciplines, the artist must go through arduous training to learn the
rules, master the technique, and obtain precision and control—and
freedom.

In both disciplines, then, the materials must be at the artist's command.

Let us now look at the four treasures. And let us understand that an integral
part of the tradition of Chinese painting is the importance of working
with tools that are aesthetic as well as functional.

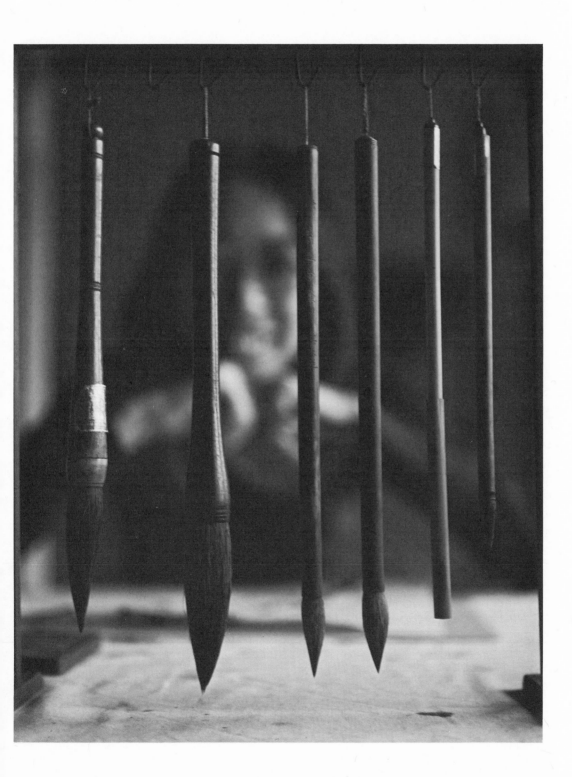

BRUSHES

It has often been expressed that "the brush sings and the ink dances."

UNIQUENESS

The invention of the camel's hair brush is traditionally attributed to Meng Tian (Meng T'ien) in 250 B.C.[1] But brushes probably existed much earlier, as evidenced by the decorations on pottery believed to be from the Shang era (ca. 1523–1028 B.C.). At any rate, this singular event, the invention of the Chinese brush, had a profound significance, for it affected all subsequent development of the arts in China that used the brush for expression. *Bi,* the word for brush, actually means "writing instrument."

The Chinese brush is unique, with the distinguishing feature that the tip always ends in a fine point, no matter how large or how small the brush. It is a superbly sensitive and responsive instrument, the pivotal point from which Chinese calligraphy and painting developed.

The concept for the design and construction is simple yet remarkably ingenious. It differs significantly from non-Chinese brushes in which either the hairs are all the same length or the shorter hairs are clipped on the outside, making the brush roughly tapered at best. Conversely, the Chinese brush is very finely and carefully crafted, with the hairs gradually tapering in layers from the *inside.* The result is a conical shape, with the longest hairs on the outside encompassing a kernel of shorter hairs while at the same time providing a smooth and even surface all around, then ending in a finely pointed tip. This method of brush construction allows for tremendous flexibility and versatility. The brush can twist and turn and adapt itself in every direction, responding to the will of the artist.

The same brush can produce strokes of varying widths, from a very fine line to broad painterly washes. The hairs can be split apart into sections to produce many lines with one single stroke. The same brush can be used with a single loading for a pure tone or with two or three different shades to produce gradations of tone. The same brush can be used on its tip or its base to yield different effects. The same brush produces strokes of different textures—dry or wet, rough or smooth. The remarkable pliability of the brush is such that in the hand of a skillful artist, often only a single brush is needed to execute the entire painting.

To directly experience the Chinese brush is to know a truly fine brush.

HOW TO SELECT, PREPARE, AND CARE FOR BRUSHES

Selection. As the musician's most important means for expression is her/his instrument, so the artist's singular most important tool is the brush, for this is the vehicle for expression, the transmitting device of the painter.

The necessity of selecting a brush of superior quality cannot be overemphasized. A good brush will have life and spring; a poor one will be limp, with coarse hairs which fall out easily. A good brush is a basic and cherished implement that will last a long time.

Chinese brushes come in about ten different sizes, and there are many different types. Although it may be tempting for you, as a beginner, to accumulate a large assortment of brushes, it is most adequate, and in fact, preferable, to limit the selection to only the basics. In this way, you may become thoroughly acquainted with the brush, sensing and feeling how you and it relate and work together. You will get to know your brush well and establish a good rapport with it so that you can depend upon it with a certain predictability and reliability.

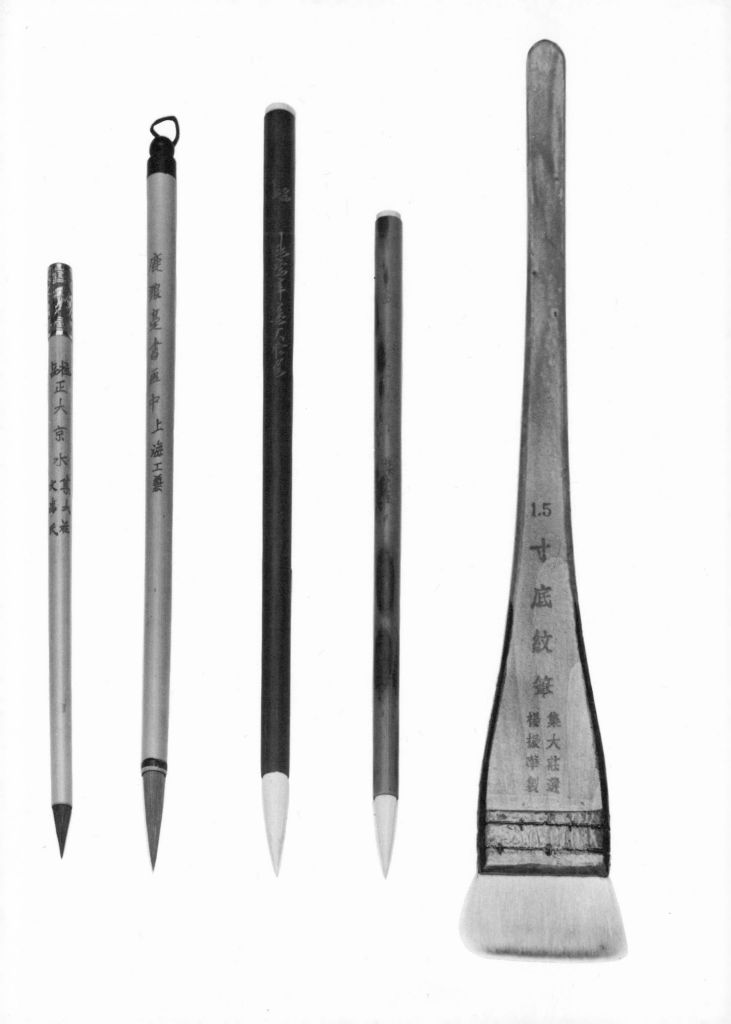

The basic Chinese brushes (left to right): A, B, C, D, E.

Types of Brushes. Many different kinds of hair have been used over the years for the tuft of the Chinese brush, such as weasel, rabbit, deer, sable, fox, wolf, sheep, and goat hair. The brush consists either of hair from one animal or a combination of hairs from several animals, blended and bound together. This blend of animal hairs is inserted with glue into a holder. Bamboo is commonly used as the holder because of its lightness, which is important for brush balance. The name of the brush (esoteric and cryptic at times) and place of manufacture are often carved into the brush handle, either simply or intricately.

 Although brushes of different types and sizes and stiffness may be used, we will concern ourselves with five basic brushes, hereafter referred to in this book as *A, B, C, D,* and *E.*

Brush *A:* Bamboo handle with wolf hair.
 Approximate size of brush part: ½″ long.
 This is the smallest brush. It is basically used for linear work, including details and sensitive lines, such as for branches, veins of leaves, knots, stems, and dotting. It is excellent for fine work, such as plum flowers.
Brush *B:* Bamboo handle with a combination of deer and wolf hair.
 Approximate size of brush part: 1″ long.
 This is the most versatile and resilient of the brushes. It is used for linear work, such as for chrysanthemum flowers, branches of the plum tree, and bladelike leaves of the orchid and bamboo. It also may be loaded with gradations of shades for painting the bamboo trunk.
Brush *C:* Bamboo handle with goat hair.
 Approximate size of brush part: 1⅛″ long.
 This brush is usually used in the slant position for tonality, such as for chrysanthemum leaves.
Brush *D:* Bamboo handle with goat hair.
 Approximate size of brush part: ⅞″ long.
 This brush is used in the same manner and serves a similar purpose as brush *C,* but it is smaller in size.
Brush *E:* Flat brush with goat hair.
 Approximate size of brush part: 1½″ wide.
 This brush is used for background washes, such as in a composition of bamboo in the moonlight. Unlike the other brushes, a genuine Chinese brush is not imperative here. You can use any comparable non-Chinese brush with fine, soft bristles.

13

The hairs in brushes *A* and *B* have more strength and spring to them and are primarily used for more delicate and linear types of work. The goat-hair brushes, *C* and *D*, have softer hairs and are usually used for bolder shapes and strokes—ones with gradations of tone and shading. This is not to say, however, that the goat-hair brushes cannot be used for line, keeping in mind the multipurpose nature of almost any good quality Chinese brush and their interchangeability in use.

Preparation. The hairs of a new brush are stiff from the sizing. To soften your brush for use, soak it in warm water until the hairs spread out. After this initial soaking, do not soak the brush again because this will shorten its life span. Brush *A* requires no soaking—simply press the tip down gently on a flat surface before initial use.

Care. Proper selection and preparation of the brush are not enough, not without proper care. Just as a friendship is optimal when it is cared for and nurtured, so is a brush, for the brush you select is worthy of respect and proper care. In return it will do you justice.

Keep in mind the following:

- Clean the brush with water immediately after each painting session. Do not use soap.

- Shake the brush and then wipe off or blot out excess water with a paper towel.

- Always reshape the brush by bringing it back to its original point so that it retains its shape.

- Whenever possible, carefully slip the covers back on the brushes. This should always be done with brushes *A* and *B* (the other brushes expand after use and no longer fit into the covers). The bamboo covers are naturally porous, and therefore they do not interfere with the drying process.

- After the brushes are completely dried, store them in a brush holder or in a covered box or hang them from a brush stand (if the end of the handle has a hanging loop).

HOW TO HOLD
THE BRUSH

There is a special way of holding the Chinese brush. It is a highly developed method which results in optimum flexibility and control. Through proper positioning, loading, and use of the brush, a wide variety of strokes, forms, and textures are possible. Place the brush handle between the middle and ring fingers, bracing it with the thumb and resting your index finger against the handle. The brush should be held firmly but not tightly. By holding the brush in this manner, you have maximum control. You can move the brush freely while maintaining complete control over the movements. (Never grip the brush like a pencil or pen.)

Basically, the brush can be used in two positions (see pp. 16 and 17).

VERTICAL POSITION

Position your hand approximately in the middle of brush *A* or *B*. When you want to paint something linear, hold the brush firmly and perfectly straight, perpendicular to the paper. (This is the position used for calligraphy.) In this position, only the tip of the brush is used; the remaining portion serves as a reservoir for the ink. When the brush is held in the vertical position, the strokes painted are linear, producing a feeling of roundness and firmness.

SLANT POSITION

Hold the brush the same way as for the vertical position, but with a somewhat looser grip and about two-thirds of the way down. Then turn your hand slightly so your palm faces upward and the brush is slanted. The slant will vary from about forty-five degrees to almost parallel to the paper, depending on the circumstances. The strokes that are achieved by using the brush in the slant position are broad and bold, promoting form, gradations of shading, and different tonal qualities. In this position, the entire brush may be brought into play.

The Chinese way of holding the brush for linear strokes (this page). Position the brush perfectly straight, perpendicular to the paper.

Use the slant brush position (opposite) for broad, bold strokes, gradations of shading, and different tonal qualities.

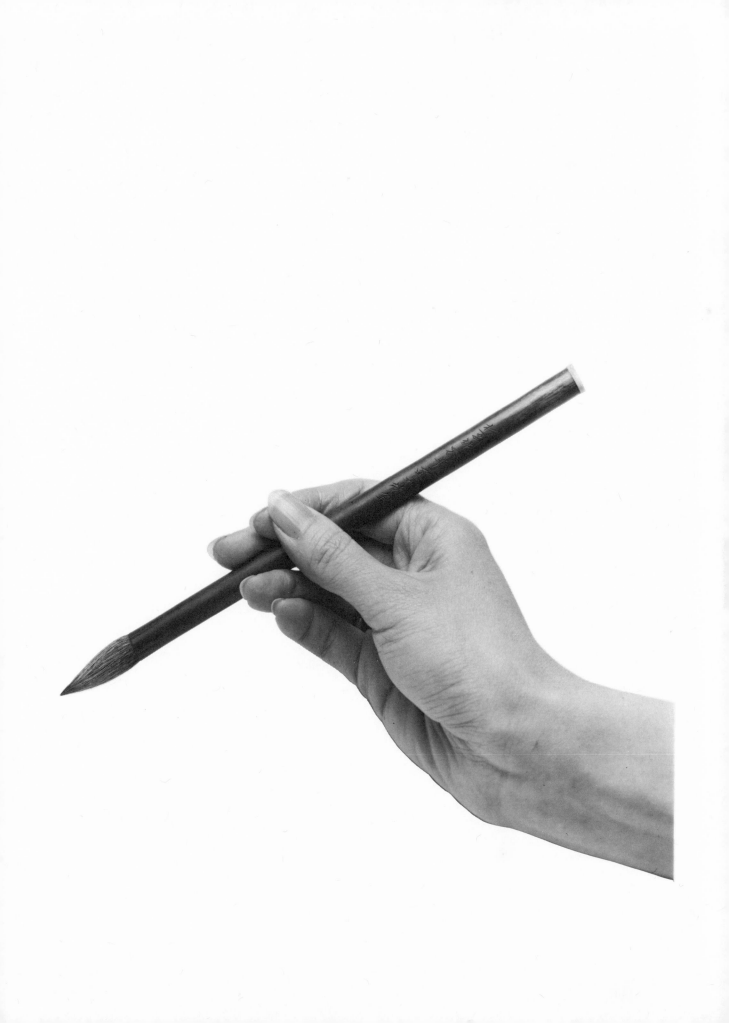

INK

*Ink uses brush as its sinew and bone.
Brush uses ink as its spirit flower.*
 Shen Hao

Let us now examine the brush's essential counterpart, the Chinese ink. It
is this ink, after all, that has secured for monochrome Chinese painting the
eminent position of being the most sensitive, subtle, and refined form of
pictorial art, and which has rendered "ink play" a favorite medium of expression
for Chinese scholar-artists then and now.

 The oft-quoted expression goes, "If you have ink, you have the five
colors." The "five colors" range from jet black to pale gray. The pure ink tones
possess rich potentialities of expressive and imaginative power, surpassing
those of actual colors, so that the ink serves admirably well for the Chinese
palette.

 The invention of ink has been attributed to different historical
periods. Its origins must have been at least as early as the brush, perhaps as far
back as the Shang era. The predecessor of the ink as we know it today
probably came into use during the Han dynasty (206 B.C.–220 A.D.). True ink
from lampblack was developed in 400 A.D.[2] By the Tang dynasty
(618–907 A.D.), the art of ink manufacture was far advanced.

 The Chinese ink is permanent, indelible, and does not fade with time. It is
transparent and possesses a wonderful richness and depth of tone, vibrant
with luminosity.

18

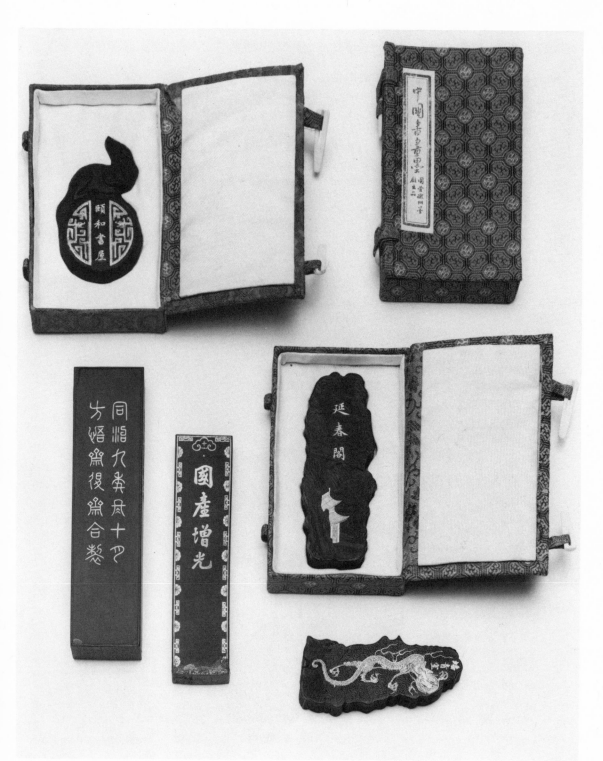

INK STICK AND INK STONE

Chinese ink comes in solid form. It is made of either pine soot (from burning pine wood) or lampblack (from burning vegetable oil). The soot or oil is blended and mixed with a kind of glue. The mixture is compressed, set in a mold, and dried into either stick or cake form. The ink stick is then embossed with Chinese inscriptions and/or decorations, polished, and sometimes gilded.

Although now there are available oriental types of inks in bottles or tubes, most of these are not recommended because they lack the desirable fluidity and consistency. India ink, for example, is flat and lacks depth and luster; therefore it is not suitable for Chinese painting. India ink, by the way, was also invented in China.

The ink stone is the object on which the ink is ground. It is made of slate. In former times, jade, quartz, and iron were also used—as well as certain kinds of bricks and roof tiles.[3]

Some ink stones have a well-like area on one side to store water. Others may be entirely recessed, with a small drainage spout for pouring off excess water, plus a cover to keep the ink from evaporating when not in use. In either case, ink is made by grinding the ink stick with water on the ink stone.

Ink stones of antiquity were designed and carved into a variety of shapes inspired by nature, such as lotus leaves, fruits, flowers, fish, and animals, each with their respective symbolic significance.[4] Now very rare, these ink stones are considered works of art in and of themselves and are highly prized. So are the ink sticks. Old ink can be compared to vintage wine and is treated as such by connoisseurs.

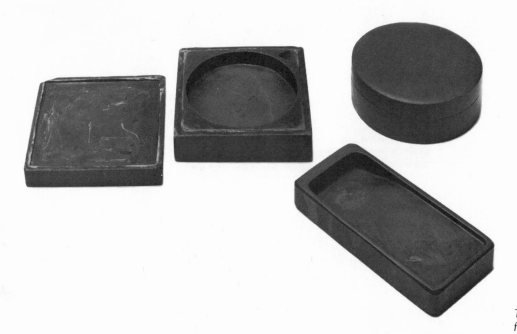

Three types of ink stones made from slate.

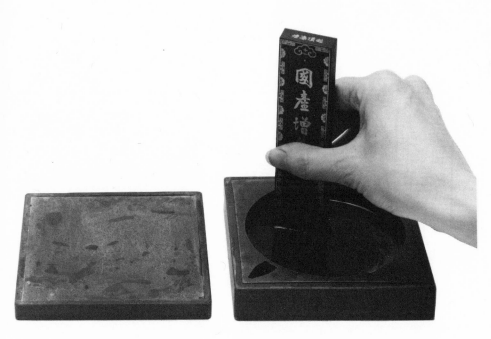

Ink is prepared by grinding the ink stick and water on the ink stone with a circular, clockwise motion.

PREPARING THE INK

Always prepare fresh black ink before beginning to paint. Follow these steps:

- With brush *B* or *C*, dab a small amount of water on the flat surface of the ink stone.
- Hold the ink stick vertically from the top, bracing it between your thumb and other fingers. The end should be flat against the ink stone.
- Rub the ink stick firmly on the ink stone, using a rather slow circular clockwise motion and exerting a certain amount of pressure. Your action should be smooth, even, and continuous. You should feel this rhythmic movement and regard it as part of the tradition and ritual of conditioning your mind and body for painting. It is a contemplative process, a preliminary preparation for getting into the actual "action" of painting.
- Stop grinding when the ink becomes somewhat thickened and concentrated—when it reaches a creamy consistency. This process requires time. If you stop too soon, the ink will be too watery and light. You can test the ink on scrap paper to see if it is indeed a rich, deep black. A high-quality ink yields a lustrous effect on paper. Prop the ink stick on the edge of the ink stone when it is not in use.

You should use ink directly from the ink stone for pure black. And you can achieve rich tonality by combining varying proportions of ink and water in a porcelain dish and mixing them well. In this way, you can produce a range of shades of gray from light to dark.

When you run out of ink, prepare more. Wash your ink stone thoroughly with water (no soap) at the end of each painting session.

LOADING THE BRUSH

For a single loading, simply dip the tip of your brush into the ink, slanting your brush while doing so.

For a multiple loading—the Chinese technique employed to achieve shading and a range of subtle tonal qualities in one single stroke—saturate the brush with different tones of ink. Use this more "natural" method instead of outlining with a dark shade and then filling in with a lighter one, or applying one shade at a time. For a triple loading, soak the entire brush first in a light tone (combination of ink and water to make gray); then, with the brush slanted, dip half of the brush into a darker tone (ink and a little less water); finally, dip the tip into the darkest tone (black ink). For a double loading, eliminate the middle step.

As you stroke with the brush slanted, the dark and light ink run off the brush simultaneously, producing gradations of color all at once. Different loadings result in different effects. You can thereby create a full range of tones, depending on how you load the brush and the amount of water you mix with the ink. By varying the density and fluidity of the ink, you can achieve subtle nuances suggestive of a sense of color.

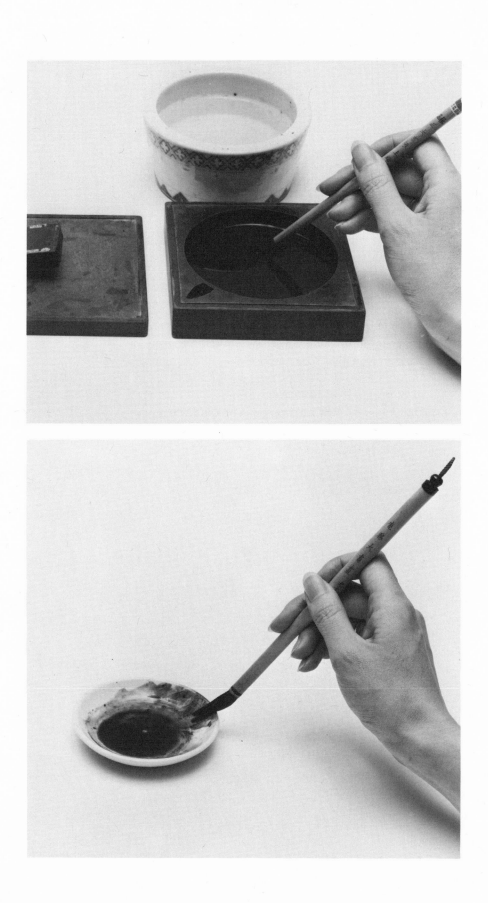

ACCESSORIES

PORCELAIN BOWLS AND PLATES

You will need a simple but aesthetic porcelain bowl for holding the water as well as for washing your brushes. Use several small shallow porcelain dishes (about 3½" in diameter) for mixing shades of gray. Porcelain containers are preferable to plastic ones because of their smooth and solid quality and the way they feel against the brush. The plate edge serves well for proper loading and shaping of the brush.

BRUSH RESTS

Another practical accoutrement in Chinese painting is the brush rest, which serves to prop up wet brushes when they are not in immediate use. It can be quite simple and functional or more elaborate and imaginative. You can use one of your bamboo brush covers for this purpose. Or if you are a potter, you can try designing and making your own, as some of my students have done. You can also improvise and utilize other suitable objects, such as chopsticks or knife rests.

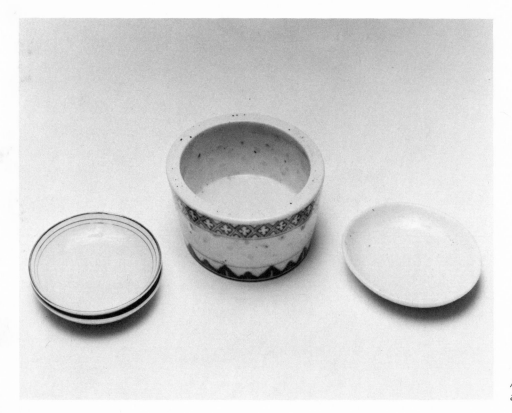

Accessories for Chinese painting are simple and elegant.

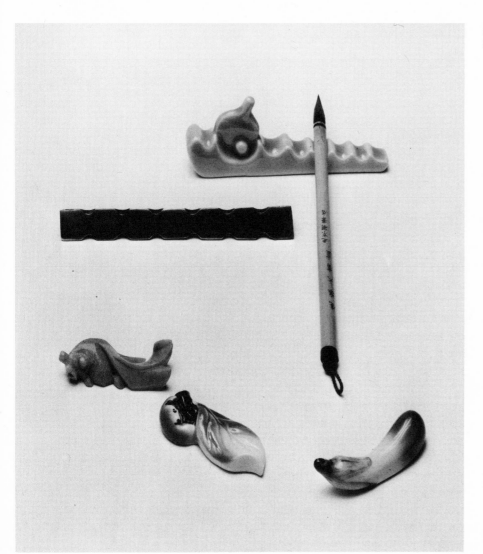

COLOR

Traditionally, actual colors are not included in the four treasures. Color is considered an embellishment in painting and is secondary to the ink. Even in paintings with color, the basic Chinese ink is almost always used and is usually predominant, providing the structure. A typical Chinese palette includes indigo, red, vermilion, burnt sienna, gamboge yellow, and white. Of mineral or vegetable origin, Chinese watercolors are similar to western ones in kind, although they are more limited in number. Nevertheless, the Chinese techniques for using color are highly interesting and warrant further study.

PAPER

Just as ink and brush need one another,
so they need paper.

Paper was invented in China around 105 A.D. The invention is attributed
to Cai Lun (Ts'ai Lun), a member of the imperial household during the reign of
He Di (Ho Ti) of the Eastern Han dynasty. For some five hundred years,
Chinese artisans kept the papermaking method a secret, and it was not until over
a thousand years later that this revolutionary discovery reached Europe.
The Chinese invention traveled to Europe via the following route: to Korea and
Japan; then westward through Samarkand, Bagdad, Egypt, and Morocco;
finally arriving in Spain in 1151. The art of papermaking reached the New World
in 1575 when it was brought by the Spanish to Culhuacan, Mexico. In
America, the first paper mill was established around 1690 near Philadelphia.[5]
 Paper is made from matted filaments of fiber which have been macerated.
Since this method was discovered, the basic process of papermaking has
changed little. The first paper was probably made from bits of discarded silk,
particles of hemp, worn-out rope, and perhaps the inner bark of the
mulberry tree. The basic papermaking process employed by Cai Lun and his
assistants is surmised to be as follows. They gathered the raw materials
and put them into a stone mortar. These scraps and fragments were covered with
clear water and pounded with a stone pestle. This beating reduced the
matter into separate fibers, which were then transferred to a large vat containing
water. The silk, hemp, and bark particles rose to the water's surface after
being stirred. Cai Lun invented a sievelike mold to gather these fibers and to
allow the water to drain away. The disintegrated fiber was poured upon
the mold's surface and allowed to dry. The resulting compact layer of fiber was a
sheet of paper. This paper proved to be extremely well suited to the
Chinese brush and ink.[6]
 Chinese painting is usually executed on rice paper, mulberry paper, or silk.
Silk was used before the invention of paper. However, once paper came
into being it became more popular, especially for the freer type of brushwork.

26

Silk, being less absorbent, was used primarily for more detailed work.

There are various types and qualities of suitable paper on the market. They come in different weights—from thick to thin—and different textures—from rough to smooth. In selecting papers, the quality is important. For best results, the paper should be absorbent and not too thin.

Always work on a flat table, not an easel. Use a backing sheet (such as newsprint) to absorb any excessive ink.

Rice Paper. Authentic rice paper is made from wood pulp and the fibrous parts of certain bushes and plants. The most common natural fibers used are mulberry, bamboo, hemp, and sandalwood; less common ones are rice stalks, corn stalks, cotton, flax, reeds, and moss.

Rice paper has become a generic name for all kinds of paper, which may or may not be true rice paper. Chinese rice paper is delicate, yet strong at the same time. It is noted for its absorbency and gives the optimum effect in Chinese painting because it responds to the ink very well.

Mulberry Paper. Mulberry paper possesses similar qualities to rice paper, facilitates a smooth flow of ink, and therefore is an excellent alternative to rice paper. It is also more readily available than authentic rice paper.

Sumi-e. Various papers of Japanese manufacture, often called sumi-e paper, are readily available, and some are good substitutes for Chinese rice paper.

Newsprint. For practice, you should use newsprint, which comes in two varieties, rough or smooth. Newsprint is a very good practice paper (you will use lots of it) because its quality approximates the other finer papers in such features as taking the ink. Smooth newsprint is preferable to rough; 9″ by 12″ and 12″ by 18″ are good sizes to work on.

The four treasures—brush, ink, ink stone, and paper—are the materials, interacting harmoniously together, that are needed for the artist's individual expression and entry into the world of Chinese painting.

THE
MYSTIQUE

SIGNATURE

What is in a name? Everything.

MEANING AND SIGNIFICANCE

The artist's signature, calligraphy personified, can be part of the total design of the painting. Let us consider the nature of Chinese names, which differs in many respects from those in the west.

Chinese given names are not ready-made, like Mary or John, but are derived from a combination of any two characters or ideograms in the Chinese language (sometimes only one character is chosen). Consequently, the possibilities are virtually infinite, and rarely do we find two individuals with the same full name. The surname comes first, followed by the given name. However, in contemporary usage, when anglicized, the order may be reversed, thus causing possible confusion in determining which is the surname. A helpful clue is the hyphen in the given name, but again this form is not used consistently. With the recent adoption of China's official Pinyin system, the hyphen is dropped and *usually* the two elements of the given name are run together.

Since the Chinese language is not written with an alphabet, it must be rendered into other languages by a phonetic system which represents the sounds implied by the graphic ideograms. A number of schemes have been devised.

The most commonly used in English has been the Wade-Giles system, named after two British scholars from Cambridge University who devised the method in 1860. Pinyin has superseded the Wade-Giles system because it represents more accurately the actual sounds of the Chinese language. The new Pinyin (for the Chinese word meaning "transcription") system was established in China in 1958 to serve as an aid in studying the ideograms and to foster the standard spoken language of Mandarin. Pinyin is also intended as a standard system to render Chinese names (as well as other words) into western languages and eventually to eliminate the different existing styles. The change means that many familiar spellings are modified. As yet, there still remain inconsistencies in the romanization of Chinese names. I must confess that I am not prepared to change the spelling of my own name from Yu Tseng-Tseng to Yu Zengzeng. This is a moot point in the Chinese context, however, as one should remember that names written in Chinese are always the same and no confusion exists. The Chinese ideograms, with the exception of some simplification, have remained basically unchanged throughout the centuries.

To say the least, one must have some knowledge and preferably imagination in order to choose an appropriate name. The key word is *appropriate*, indicating that one needs an understanding of the many interplaying forces in the larger cultural context. For example:

Writer, calligrapher and sometimes painter, Ch'en Chi-ju chose to retire from worldly affairs early in life and had ample time to befriend the eminent potter Chiang Po-fu. Their relationship was more than that of client and supplier, for Ch'en changed the last character of Chiang's name to give it a touch of class, facilitating the potter's entry into the literati circle as an equal.[7]

This, I think, gives you some idea of the importance of the meaning and implication of Chinese names as well as the complexity behind them.

The words themselves often have many levels of symbolic significance; all can be used to advantage. The meanings may be phonetic, graphic, literary, and/or associative.

My name, 余 锊 锊 (Yu Tseng-Tseng), consists of the ideogram 锊 repeated. This word has a gold radical (the left part by itself is the word for gold), a clue to its meaning: the sound of gold coins. So first of all, Tseng-Tseng means exactly as it sounds. Second, because 锊 is associated with gold, it alludes to wealth and riches, although not necessarily in the material sense. Third, 锊 is to gold as sterling is to silver, therefore, "the finest and purest of all metals." Personalize these qualities and associative connotations and we have the full meaning.

WAYS TO TRANSLATE

To translate names into Chinese is not an easy matter. One way is to use the meaning of your name and select two Chinese words corresponding in meaning. Another way is to translate phonetically, syllable by syllable. However, this method more often than not ends up with four or more characters, which sound extremely "foreign" since Chinese names, as mentioned already, almost always contain two or three characters only. One way to deal with this situation is to choose part of the name (for example, surname only or part of the given name, depending upon which Chinese equivalents are more appropriate) for phonetic transliteration in order to reduce the name to three elements or characters. Of course, you can always use poetic license; this, nevertheless, should be done with discretion.

ARTIST'S PREROGATIVE

Then there are the sobriquets, pseudonyms, playful or fanciful names, informal names, or nicknames by which an artist is known. I also have a nom de plume, 半 癫 (Banchi), meaning "Half Mad." My surname, 余 (Yu), is the literary equivalent for "I," so that taken all together, Yu Banchi becomes the statement, "I am Half Mad"—no need to explain further.

SEALS

One always notices the distinctive red imprint of the seal or seals
appearing on most Chinese paintings. The seals usually bear personal names and
may be used alone or with the signature of the artist. It is also a
common practice for owners to add their seals to the paintings, so that paintings
of antiquity may have many seals of subsequent owners, thus adding
some historical light to these works as well.

The seals themselves are made from a variety of materials, ivory probably
being the most popular. Some other materials used are wood, horn,
metal, and various types of jade and stone. The seals are of different sizes and
shapes, often displaying ornamental or decorative details. As with the
other adjuncts associated with Chinese painting, here again seal carving has
developed into an independent art form, its beginnings dating back to the
Zhou (Chou) dynasty (ca. 1027–256 B.C.)[8] This art requires accomplished technical
skill as well as talent in graphic design, especially in reference to balance
and intricacy of spacing.

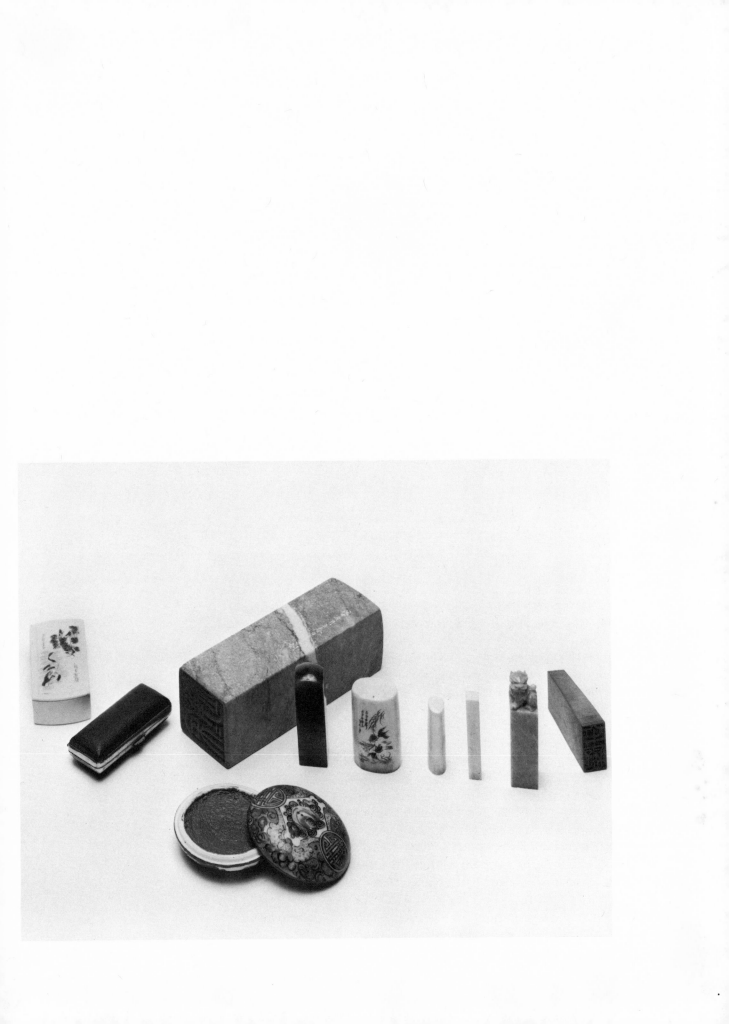

Most seal carvers employ the calligraphic style known as Small Seal, although other styles may also be used. This style of writing, derived from ancient script incised on bronze and stone, lends itself well to the engraved seals. Although there are many variants within the category of seal script, generally speaking the distinguishing characteristic is that every line has the same thickness and corners are gently rounded with no sharp angles. Compared to other, later evolved scripts, seal script is more stylized in appearance.

For sheer beauty of design, dignity of form, and decorative elegance, seal script is the most popular and the most suitable style for this carved medium.

The red substance used for imprinting is composed of cinnabar and mineral oil mixed into a pad of raw silk. This imprinting ink first came into use in 450 A.D. Prior to this time seals were used for impressing in clay without the use of ink.[9] Seals can be *yang*, or positive (carved in relief to produce red characters on a white background), and *yin*, or negative (carved in intaglio to produce white characters on a red background). They can also be a combination of *yang* and *yin*.

In a painting, the placement of the signature and/or seal is important because they become an integral part of the total picture.

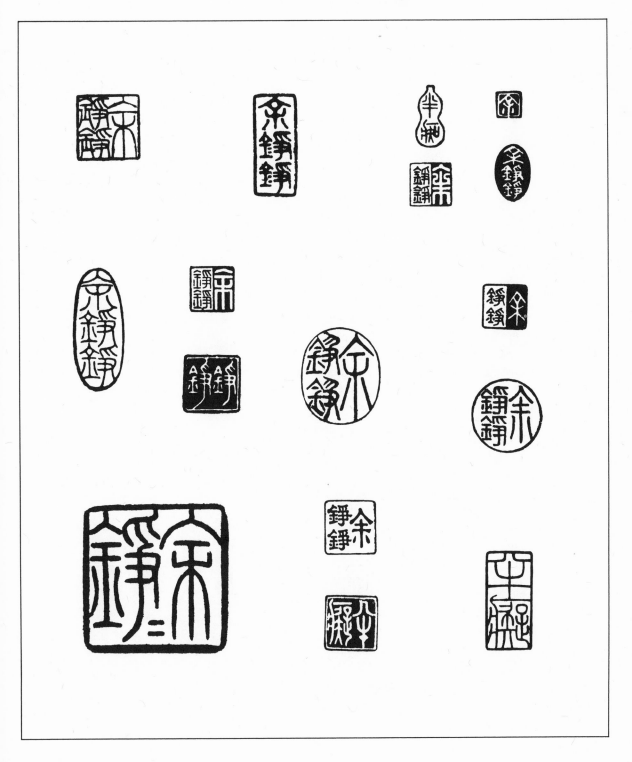

SCROLLS

Traditionally, paintings were mounted on elegant silk scrolls and trimmed
in brocade, an art in itself, which had its beginnings in the Tang dynasty.[10] They
are mounted either vertically or horizontally. The mounting serves both as
a protection and a proper setting for the painting.

For the vertical scroll, the proportion of silk is longer on top, symbolic of
heaven, and shorter at the bottom, representing earth. The middle section,
product of heaven and earth, is of course the painting. The wooden roller
attached to the bottom of the painting serves as a weight when the painting is
hung and as a dowel when the painting is rolled. The format of Chinese
painting determines the composition to a large extent—certainly they are related.

The long vertical scroll, slender and graceful, is the most typical. This form
serves especially well in terms of design in the sophisticated use of space,
well known in Chinese painting. The composition may extend beyond the border
to an imaginary plane, then return back in, rather than stay fixed rigidly
within the frame. Not only does this treatment suggest expanded space beyond
the picture itself, it also stimulates the imagination of both artist and
beholder.

The horizontal scroll is not hung but is a handscroll. It can be as long as
thirty feet, and the subject most often is landscapes. A temporal dimension is
introduced here, since the narrative handscroll is to be viewed
sequentially, section by section. The panorama unfolds with the unrolling of the
scroll from right to left, not unlike the reading of a book. The painting
must be appreciated in time, like music or literature. Parallel to these arts, the
theme has a beginning, development, and ending. The rhythmic phrasing
of the melodic lines is played out with crescendos and diminuendos, now
advancing, now receding. The tempo is set by the viewer, who also composes
her/his own frames while contemplating nature in its profound grandeur
and ever-changing moods. Ultimately, the handscroll is a harmonious symphony
orchestrated with infinite skill and feeling by the artist.

Scrolls today still retain their advantageous features of elegance of
design, ease of display, convenience of storage, and portability. If hung, they can
be changed at will according to the season or mood.

ALBUM LEAVES

Album leaves are another popular format for Chinese painting. These came into being during the Song dynasty (960–1279).[11] They usually consist of a set, or concertina, of eight to twelve small paintings mounted and preserved in an album and thematically grouped together—such as flowers or plants symbolizing the four seasons.

Album leaves also include the innovative fan paintings (suggested by their shapes, whether or not they originally were actual fans), a favorite among Chinese artists because of the fans' curvilinear boundaries and irregular shapes, which present a compositional challenge and provide a fitting vehicle for the imaginative artist. The fans are either the fixed or folding type. Often they were painted on special occasions for presentation to friends. The modest size of this genre also imparts a special charm and intimate quality to these works of art.

FRAMING

Chinese paintings are also mounted in silk mat form (rather than scroll) for framing. Contrary to popular belief, bamboo or pseudo-bamboo frames are not always the most appropriate. Generally, bamboo is considered more casual than elegant, so that often simple frames of antiqued gold or lacquer finish are preferred. Classic Chinese style frames have rounded corners to soften the otherwise angular appearance.

Of course paintings can also be matted and framed in the conventional manner, since Chinese paintings possess a timeless style and are remarkably suited to both modern and traditional settings alike.

BAMBOO SUMMER

The bamboo, ever green through all the seasons, has the distinction of being called *green jade,* thus equating it with China's most prized gem. Also known as the *friend of China* because of its many uses, the bamboo is unique in many respects. Botanically, it is classified in the grass family even though some species grow as high as fifty feet. Its hollow body is at once sturdy, light, and flexible, suggesting constancy and versatility. The division of its stem symbolizes orderliness.

The bamboo possesses the ideal qualities of a cultivated person. "It represents the essence of refinement and culture. It is gentle and graceful in fair weather, strong and resilient under adverse conditions. Its suppleness, adaptability, uprightness, firmness, vigor, freshness, and even the sweet melancholy of the rustle of its leaves have been translated into qualities of mind, spirit, and character."[12] The bamboo is the most enduring of Chinese motifs.

An age-old favorite subject of Chinese painters, the bamboo is in a unique category by itself—somewhere between painting and calligraphy—and is the subject par excellence for the introduction of Chinese painting. Its precise structure reflects the perfection of nature. Because of this precision, the rules for painting the bamboo are so clear and well defined that it is also an excellent subject for you to use in approaching and understanding the dynamics of Chinese painting and its basic principles of composition.

Each series of exercises is designed to help you gain more control of the intricacies of the Chinese brush techniques and an increased awareness of Chinese painting itself. You must obtain a certain degree of proficiency before proceeding to the next step, as each step is built on the preceding one, particularly in the beginning exercises. The learning process is a process of refinement; the exercises are aimed toward perfection of technique. Practicing the various brushstrokes is essential if you are to attain the ease, skill, and technical knowledge which are necessary for painting and which ultimately lead the way to artistic freedom.

LINES

The line is the essence and the backbone of Chinese painting.

Chinese painting is basically linear. Therefore, each brushstroke is of extreme importance. When executed correctly, every stroke is natural, substantive, and expressive—giving spontaneity, strength, movement, vitality, elegance, charm, or a lyrical quality to the painting.

TO MAKE A STRAIGHT LINE

- Dip brush *A* into the ink, loading only the *tip*. Since the brush should
 start with its original point, shape the tip by rolling it against the edge of the
 ink stone if necessary.

- Hold the brush in the vertical position.

- Press the brush down on the paper, moving it slightly to the right,
 then back to the center before pushing up. This initial movement is very
 important because it gives momentum and strength to the stroke.
 Apply an even pressure as you move along. Your hand must maintain a
 certain speed and must not hesitate at any point. Otherwise, the
 brushstrokes will be faltering and weak. Each stroke must be decisive and
 sure, firm and even. You must have control of the brush.

- Every line should have a definite beginning and ending. Do not flip
 the brush off the paper at the end of the stroke. Rather, make a definite stop
 before lifting the brush from the paper. If you concentrate on getting
 a good start and a good finish, the middle will take care of itself.

Spirit and freedom should flow from your body through the brush, the
brush becoming an extension of your hand. As this spirit is transmitted, energy
flows through the shoulder and the arm. Movement is from the arm. The
fingers should be kept stationary; the wrist should not be flicked. Neither the
elbow nor the wrist should rest on the paper. When your movements are
correct and well coordinated, and this coordination is mental as well as physical,
you can feel the flow take form in the line. Hand and mind are in
accord. You are involved in the totality of the movement.

You should sense a certain rhythm in painting these lines, one after the other. It is neither necessary nor advisable to dip the brush in the ink every time you make a line. Maintain the rhythm and momentum until your brush is nearly out of ink. (Try doing about five or more strokes for each dip.)

- Do not overload your brush, for then it is impossible for the lines to have strength. On the other hand, if you keep the brush on the dry side, it is possible to achieve an interesting textured effect. For a dry brush, load it sparingly with ink, or if there is too much ink on the brush already, blot out the excess on a paper towel or scrap paper.
- Variation in width is controlled by the pressure of the brush. For a thicker line, increase the pressure of the stroke, and for a thinner line, lighten the pressure.
- Never try to paint over or "patch up" a stroke. The immediacy of the medium is such that this is impossible. Going over a stroke mars the spontaneous effect—thus the challenge of Chinese painting.

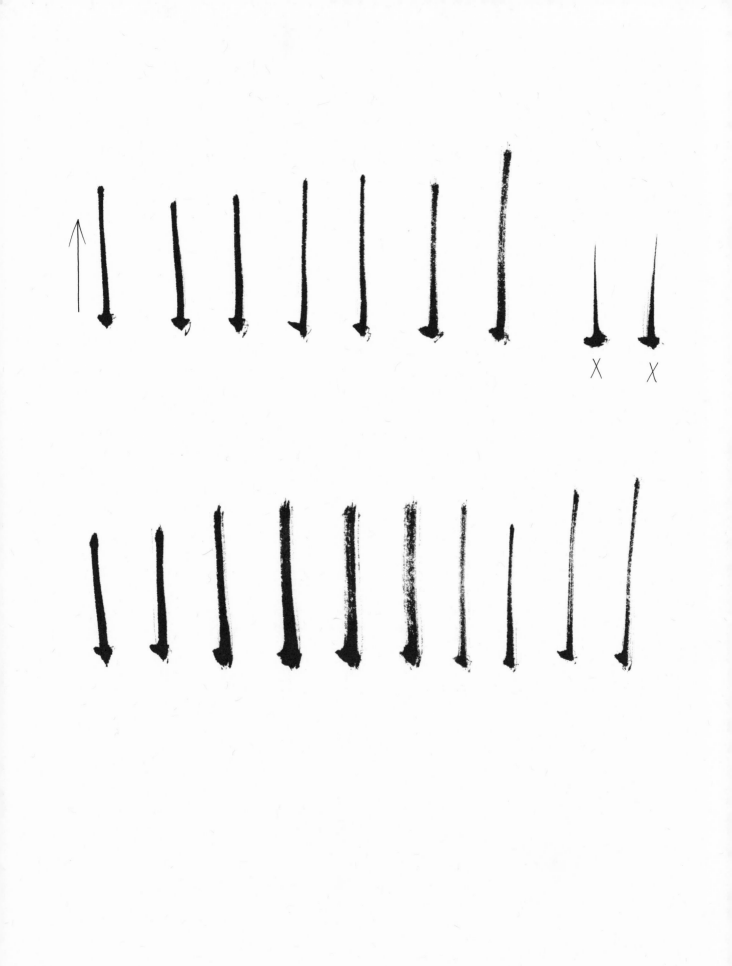

A SERIES OF LINES

One stroke (yihua) *is the source of all.*

Through the brush, you give every stroke a touch of life. Each stroke is a statement and has its own character. Each additional stroke builds and further develops the character. In combination, the strokes take on form and shape—breathing, pulsating, and interacting as a unified whole. They possess *qi*.

- Combine individual strokes by painting one stroke above the other.
 Try working up to a series of five, leaving a small space between each stroke.
 Notice that the line gets progressively thinner. Diligent practice will
 help you develop brush control to achieve the proper result.
- Execute every stroke the same way as the individual line, so that
 each line maintains its own strength. Paint each series of strokes with a
 definite rhythm and vitality, without breaking the flow in the middle.
 Make sure that your elbow and wrist are raised and off the paper to give the
 proper sweep.

NODES

- Paint each node in one stroke, with the tip of the brush.
- Keep the stroke slightly asymmetrical.
- Always start at the bottom and work up.

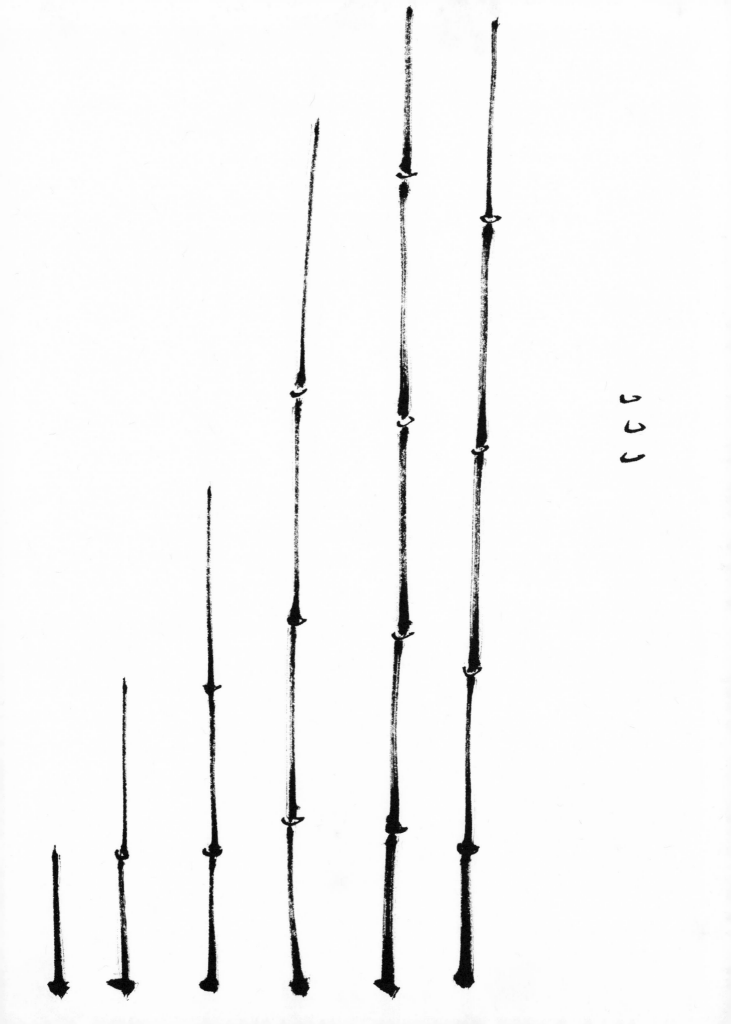

LINES IN DIFFERENT DIRECTIONS

Brushwork renders lines through which movement is achieved.

These lines move in different directions.

- Paint the center five strokes. After you have gained control in doing
 the middle line, execute the lines that bend to the right and to the left.
 Notice that each stroke remains straight. Achieve the direction of the
 line by bending at the joint of the line. You are either pushing your brush to
 the right or to the left.
- Add the nodes last, again systematically from the bottom up.

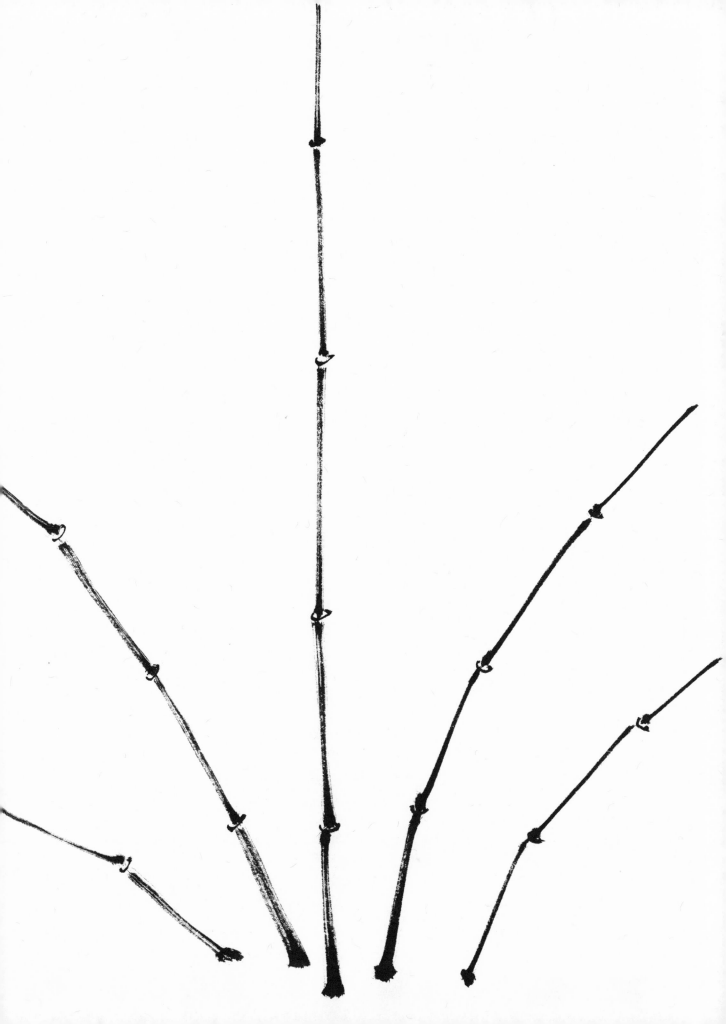

BRANCHES

Branches become fluent, linear expressions;
fluent, linear expressions become branches.

When painting branches you should be conscious of reflecting the life-force inherent in the growing limb.

- Start with a primary branch and then add the secondary branches, alternating from one side of the main branch to the other. Notice that the angle is approximately forty-five degrees.
- Decrease progressively, from bottom to top, the number of sections of the secondary branches which emanate from the main branch.
- There is a slight curve in the main branch. You can most easily achieve this curve by regarding the branch not as a number of separate strokes but as one single line with parts. The branch should look natural, not stiff.
- Add the nodes last, starting at the bottom.
- You should also practice branches going in the opposite direction (mirror image of the example).

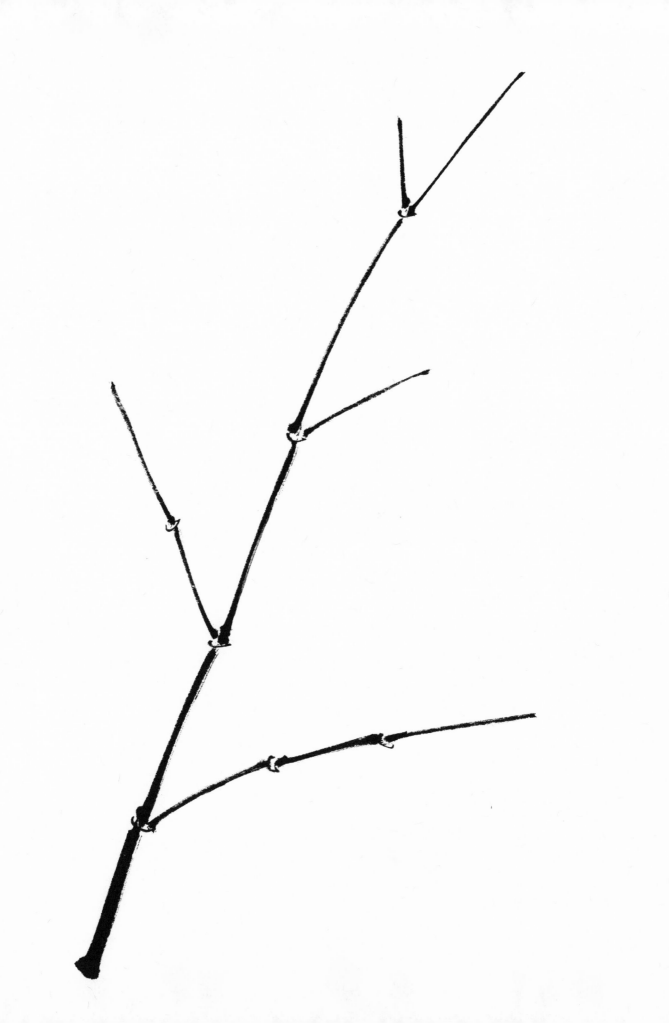

TRUNKS

It is said that "brush outlines shape and in shape spirit dwells."

You should strive to bring the bamboo trunk to life. The representation
must reflect the spirit breathing within the form. You can use your brush to
express this life.

- Use brush *B*. In a small porcelain dish, dilute a little of the black ink
 with water to make it gray.
- Saturate the entire brush with gray. While you are mixing your gray
 ink, you are simultaneously loading the brush.
- Press the brush firmly against the edge of the porcelain dish to
 eliminate excessive ink.
- Dip the *tip* only into the black ink. Only a small amount of the black
 is needed.

Now the brush is loaded with a gradation of shades. It is very important
to load the brush correctly, as too much or too little ink will not give the proper
effect. If the shading is not right—too light, too dark, too much or not
enough contrast—rinse your brush out and start over.

- Hold the brush in the slant position. Otherwise, this stroke is
 executed in the same manner as for the lines. Start at the bottom of your
 paper and work up.
- Move the brush slightly to the right, back to the center, and push up
 firmly. Stop the brush before lifting for the next stroke. This first stroke, the
 base of the trunk, is shorter than the other sections.
- Leave a small space between each stroke.
- Add the nodes with brush *A*, using black ink. This should be done
 immediately while the trunk is still wet so that the strokes blend in naturally.
 Remember to hold brush *A* in the vertical position.
- You can obtain differences in width by varying the width of the brush
 that is pressed on the paper. Try practicing thin trunks as well as thick ones.

The white space showing through the strokes is known as *feibai*, or
"flying white," so named because it conveys a sense of speed and movement. A
highlight effect that is more accidental than controlled, it suggests the
play of shimmering light and imparts a three-dimensional quality to the form.

 In Chinese painting, the aim is always to express the most with the least—a
minimum effort, a maximum result. Minimum effort does not mean, of
course, that you don't do any work. It means nothing is *wasted,* whether it is
your energy, ink, or paper. Everything is utilized in the most economical
and efficient way to achieve the best results. Painting the trunk is a perfect
example. With one single stroke, you can obtain the form, line, tone, and
texture, thus giving the trunks a feeling of roundness, strength, and durability—in
other words, the feeling of the bamboo.

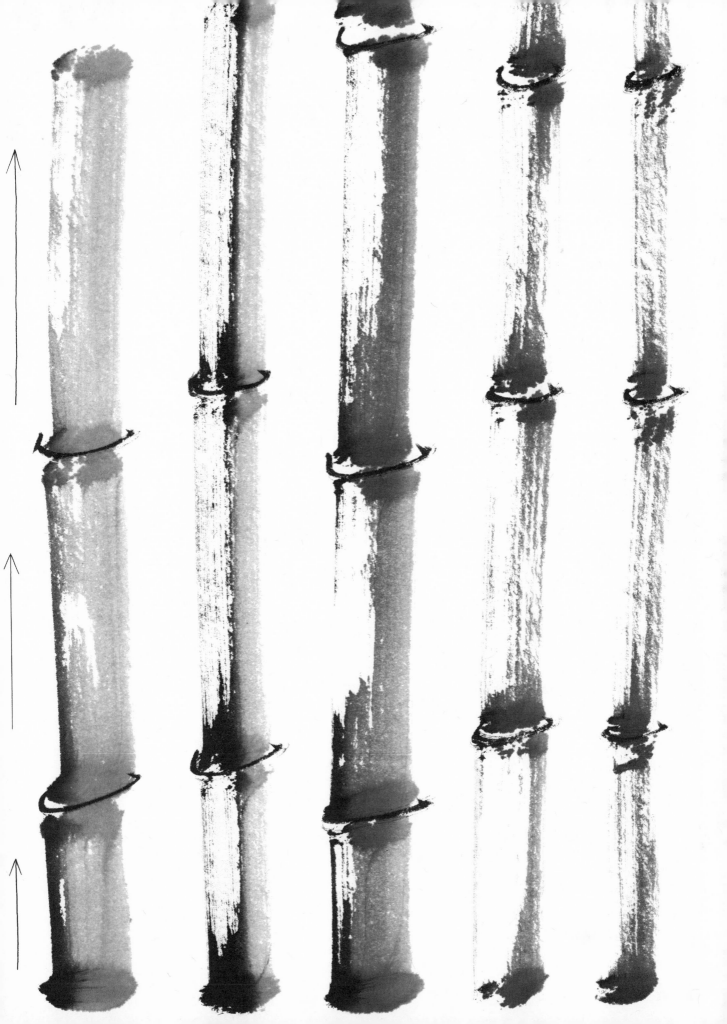

COMPOSITION
WITH ONE TRUNK

As each part lives, so does the whole.

PLACEMENT

- In practicing the trunks, you can paint them vertically or parallel to
 the paper's edge; in doing a composition, the trunk or trunks should have a
 slight diagonal slant in either direction. This is considered more
 natural and more artistic.
- Always consider the total space, as space is of primary importance in
 Chinese painting. Pictorial space is utilized in a positive way, and what *is not*
 painted is as significant as what *is* painted—sometimes even more so.
 Compositions are usually asymmetrical rather than symmetrical. In other
 words, there should be more space on one side than the other.

COMBINING BASIC ELEMENTS

- Paint the trunk first, making sure it is *not* in the center of the page
 nor in any way dividing the space equally.
- Add the nodes next. Remember to do this immediately while the
 trunk is still wet so that the strokes blend in naturally. The nodes further
 indicate that the trunk is round.
- The branches fork out from the trunk, to the left and right. Add the
 branches systematically from the bottom up, alternating on each side of the
 main trunk. Two branches emanate from each node. For added
 interest or variety, paint the branches so they cross in front or behind the
 trunk.

The whole composition should have structural integrity, with each
element harmoniously relating to the other. First and last, all elements must be
correctly spaced.

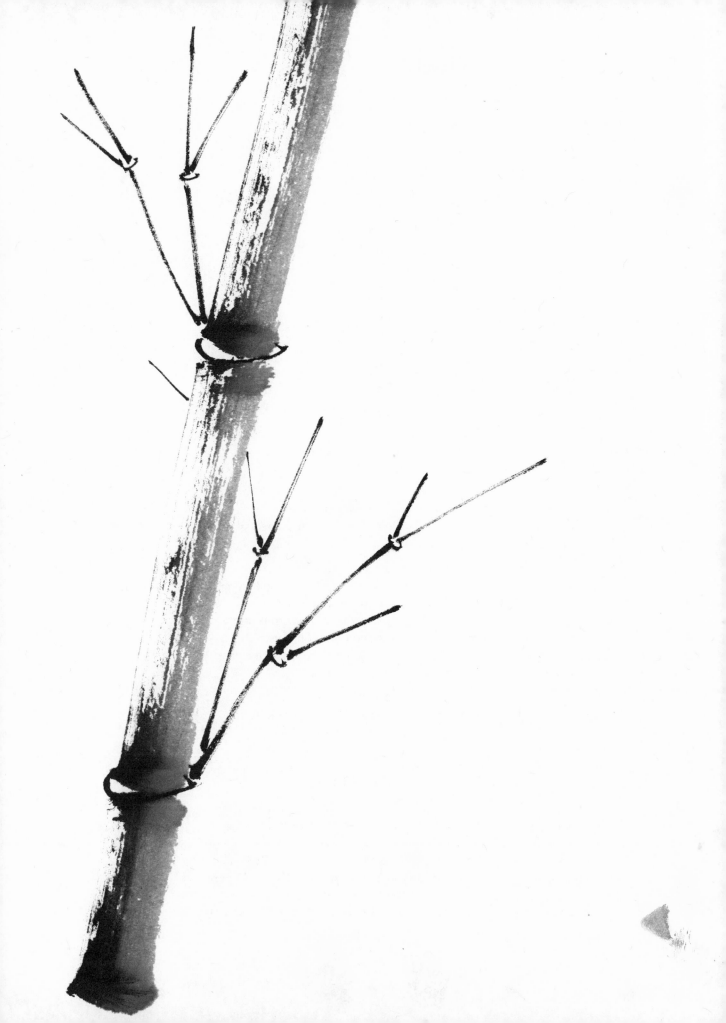

COMPOSITION WITH
MORE THAN ONE TRUNK

Unity exists in multiplicity.

In compositions with two trunks, one trunk should be brought into a harmonious relationship with the other, the division of space being unequal. Consider the following when planning and executing your composition.

- Contrast and variation are important. You should execute the two trunks with only one loading of the brush. By doing this, the second trunk will naturally be a lighter shade. Thus, you will create a variation and/or tonal contrast to the first trunk. If you make the second trunk thinner than the first, you again create a contrast or variation, this time in size or dimension. Begin the second trunk at a different level from the first. In this way, you achieve a variation in height and/or distance.

- The two trunks may cross each other. When depicting this crossing, do not paint over the first trunk. Instead, stop before the first trunk and continue on the other side. The trunks should not form an X, that is, cross at the middle.

- The two trunks should not appear symmetrical in any way. For instance, you should not make them parallel to one another.

Following these basic rules, a number of variations are possible. You can slant the trunks slightly to the right or left, and you can have the "center" of interest on one side of the paper or the other. You may position the paper horizontally or vertically. Try compositions both ways.

When painting more than two trunks, the same principles apply. In Chinese painting, using an odd number of elements is considered more artistic and more interesting. Odd numbers are unequal and thus asymmetrical. (Two is an exception in this case.)

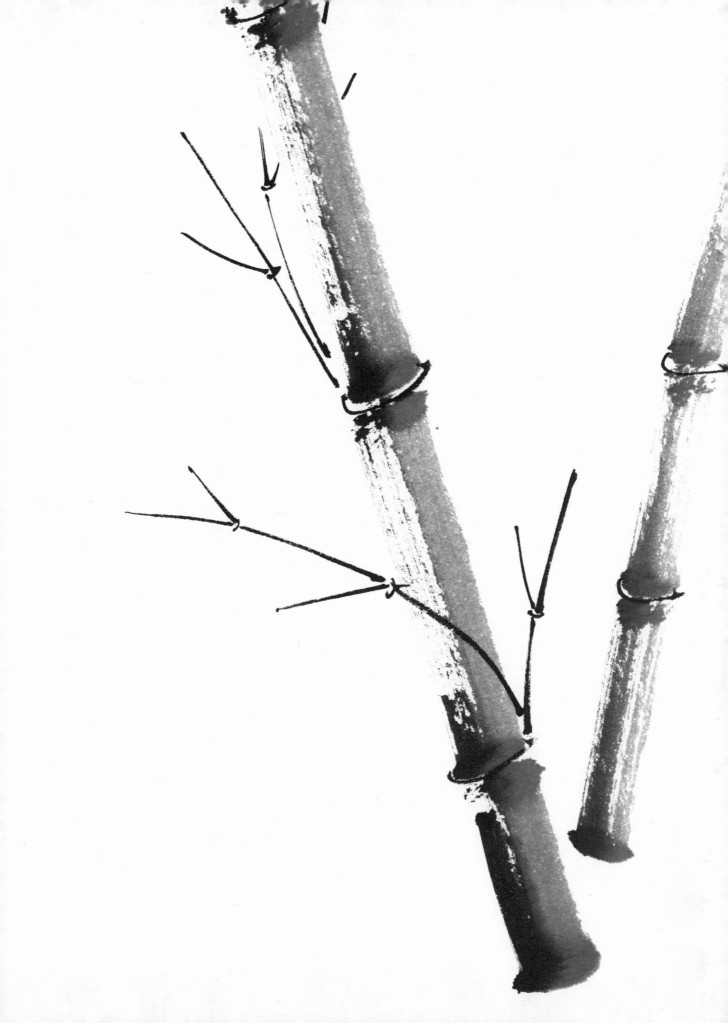

LEAVES

Perfection may be achieved in a single moment.

- Use brush *B*. Saturate the brush well with black ink. Unless the brush is fully loaded, it is difficult to obtain the correct shape.
- Hold the brush in the vertical position, grasping it firmly yet not as tightly as for the lines. The stroke should be somewhat looser and freer. Make certain that the brush always begins with its original shape (pointed tip).
- Each leaf is completed in one downward stroke. The motion is *press and lift* in one sweeping movement. Press down at the beginning and lift at the end for the pointed shape. Needless to say, you must press and lift at the right moment. Split-second timing is important. If you lift the brush too soon or not soon enough, you will not obtain the proper shape.
- Movement comes from the arm. Keep the wrist and fingers steady. Aim for rhythmic flowing motions. To facilitate the freedom of movement, try standing up when executing these strokes.
- Practice slanting the leaves to the right and to the left, so that you can control the brush in different directions.
- Practice these individual leaves until you can easily and consistently produce the accurate shape.

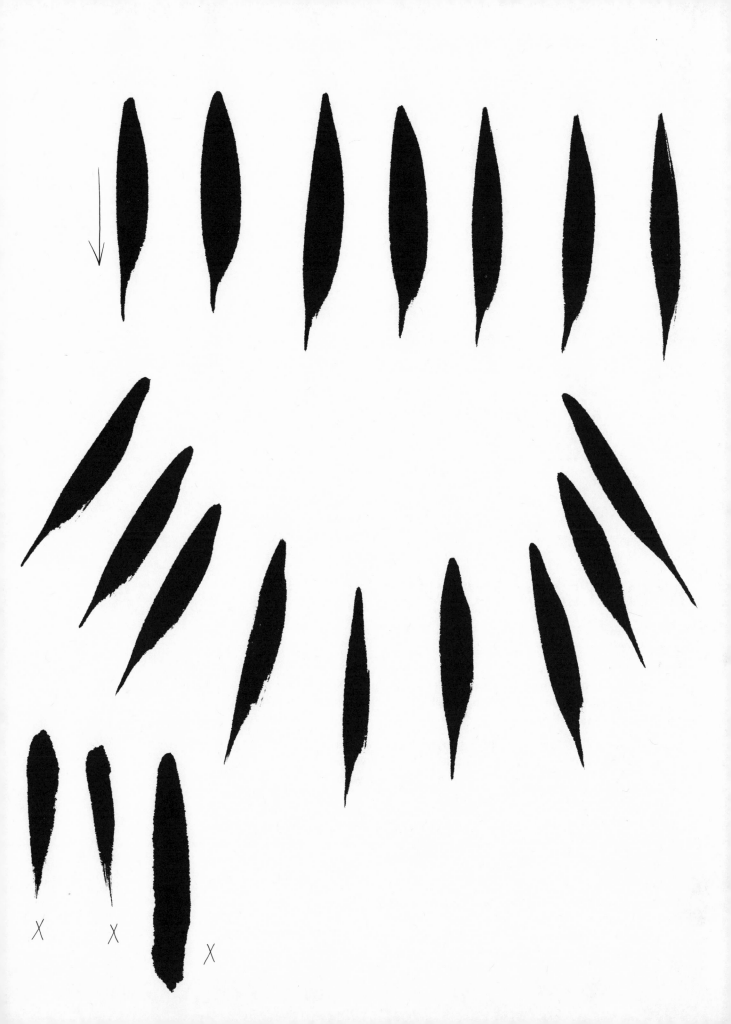

BASIC LEAF GROUPS

Nature's patterns are unsurpassed.

Individual leaf clusters may be viewed as letters of the alphabet. With the proper vocabulary of brushstrokes, meaningful words are formed and vivid statements are created.

- The basic groups consist of either two, three, or four leaves. Always paint the center leaf first and then add the side leaves.
- You should slant the main leaf in each cluster one way or another and not depict it straight up and down.
- Strive for subtle variations. Do not bring the leaves to a single point at the top. Stagger the side leaves slightly from the top of the main leaf. Make the side leaves slightly thinner than the main leaf. The angle is also important. For all these reasons, you should reproduce the examples as faithfully as possible.
- For the bottom examples, paint the branches first, with brush A. Then add the leaves.
- Do as many groups as possible before reloading the brush.

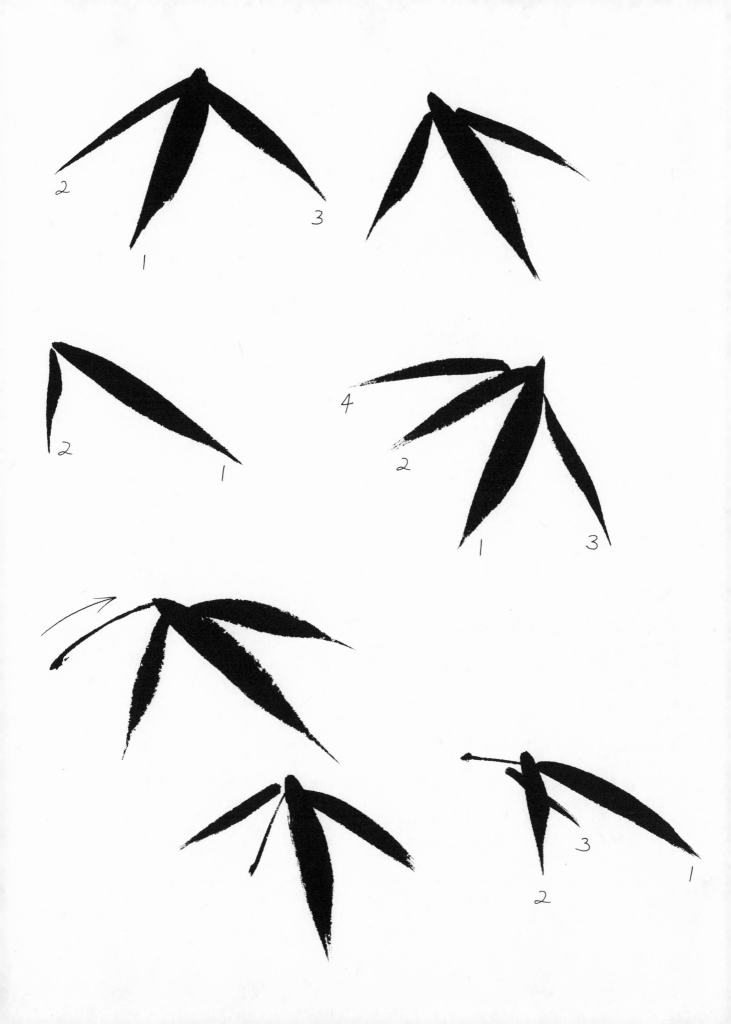

MORE COMPLEX
LEAF GROUPS

The innate structure and order of nature is reflected in the leaf groups.

Essentially, these more complex leaf groups are combinations of the basic groups.

- For the double groupings, paint one cluster slightly higher than the other. Make the sizes of the two groups differ slightly. Pay attention to the crisscrossing of the leaves and their interrelationship.
- The new groups of three shown in the examples are variations of the basic combinations of three. The leaves should look lively and natural.

Aim to memorize all the leaf arrangements so that you can recall these "alphabets" easily and use them freely in various combinations when painting. Until you have the patterns firmly etched in your mind, however, you should refer constantly to these examples and the ones on the preceding page.

60

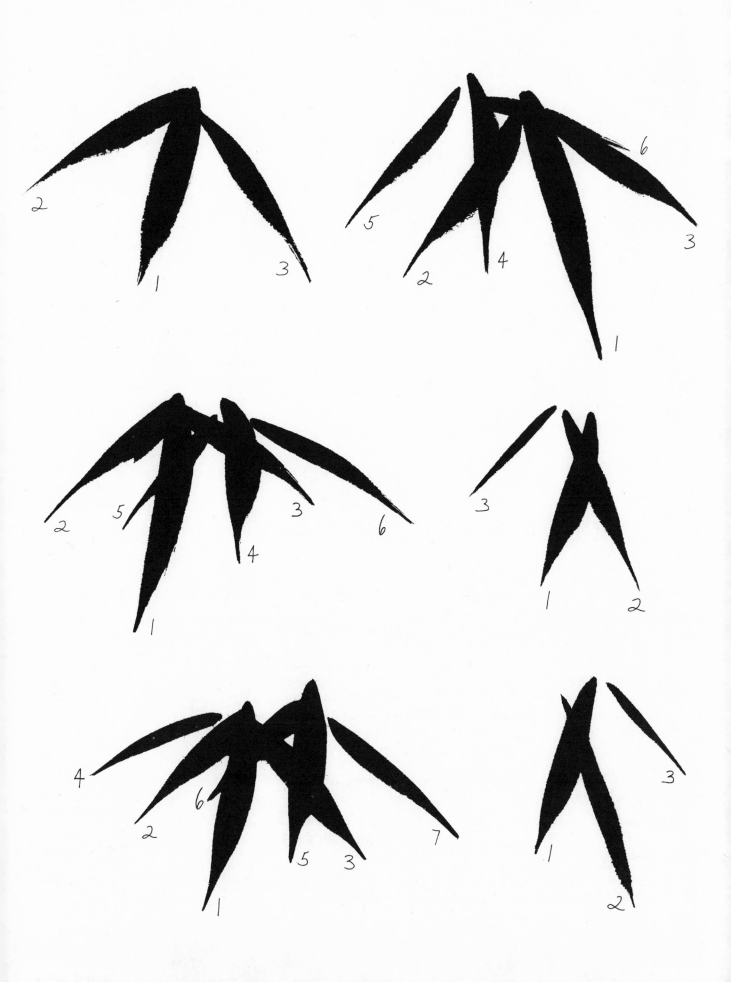

COMPOSITION

Less is more.
Mies van der Rohe

Before you begin, you should visualize what you want to paint. Start with the placement of the trunk or trunks, add the branches, and then paint the leaves. By this time, holding and manipulating the brush should be second nature to you. You need to focus your attention on the composition as a whole, that is, on the placement and spacing of elements as well as their relative tonal contrasts.

- Place the leaves in interesting groups. In the beginning, limit yourself to one main group or area and one or two secondary areas.

- For tonal contrast, add some leaves in gray ink. Keep in mind that the ink appears darker when wet but dries lighter, so adjust the shade accordingly.

- The space in between these areas plays a very significant role, because without the space, the groups will be indistinct and undefined.

In Chinese painting, the artist rarely paints directly from the subject itself, but rather, from a mental image. The immediate and overall impression left in the artist's mind is what is transmitted to the paper.

Therefore, do not think solely in realistic terms, but also regard the bamboo leaves as abstract patterns in accord with nature and an artistic arrangement of the same. Since the total design is the main consideration, only the essence of the subject need be conveyed. It is not necessary to show a leaf on every branch or have a branch for every leaf or leaf group.

Because a reduction to essentials is an integral part of the underlying philosophy of Chinese painting, restraint is necessary. The approach may, in a sense, be considered impressionistic. The painting is not a botanical study but rather a *poetic idea* inspired by the bamboo.

• Follow the example (page 65) as closely as possible in order to experience, grasp, and understand the basic principles involved, so that later on you can utilize and apply them in compositions of your own. Careful study of the other paintings in this book will also broaden your understanding.

You should regard copying not as an end in itself but as part of your learning process: to understand how Chinese painting is done, to be directly involved in every step and detail, and to comprehend the many elements and considerations in the creation of a successful painting. In this way, you will also appreciate Chinese painting infinitely more.

You should understand, too, that Chinese painting is always grounded in tradition and a unique set of fundamentals which have evolved in time, and that the validity of this immense technical and aesthetic heritage has stood the test of time. This does not preclude innovation, originality, or individual creativity. Quite the contrary, as the tradition itself is a dynamic one, constantly adapting to change. Hence, its remarkably long survival. As discussed succinctly in the introduction to the *Mustard Seed Garden Manual of Painting* (the book itself is an affirmation and transmission of tradition), if you want to dispense with method, first learn method. The end of method is to *seem* to have no method, when method has become an integral part of the self. You must master the rules first before you can break them. Copying is an excellent way to learn method.

In planning compositions, remember that emphasis is placed on the central subject. After deciding upon your focal point, concentrate only on that which is relevant, that which relates to your center of interest. Keep in mind the importance of space. Do not try to "fill in" all areas of white space, as this space is utilized to enhance and accentuate the subject by offering balance and contrast. When you try your own compositions, resist the temptation to add leaf upon leaf indiscriminately. Never add a stroke unless it is absolutely essential. A cluttered painting is the mark of an amateur; *learn when to stop.*

Compositions should have a dynamic equilibrium rather than a static balance. Avoid complete regularity of form and arrangement. Always strive for some subtle unevenness rather than evenness, irregularity rather than regularity, difference rather than sameness, asymmetry rather than symmetry. Yet with all these variations and contrasts, there must be a total structural coherence and unity among all the elements in a painting, resulting in an interesting design with a perfect rhythm. Ultimately, it is a matter of careful judgement and discrimination arising from a finely tuned sensibility.

All the while, be aware of the rhythmic tempo of your brush and play it like the fine instrument that it is, spontaneously infusing the entire painting with *qi*, thus bringing it to life.

64

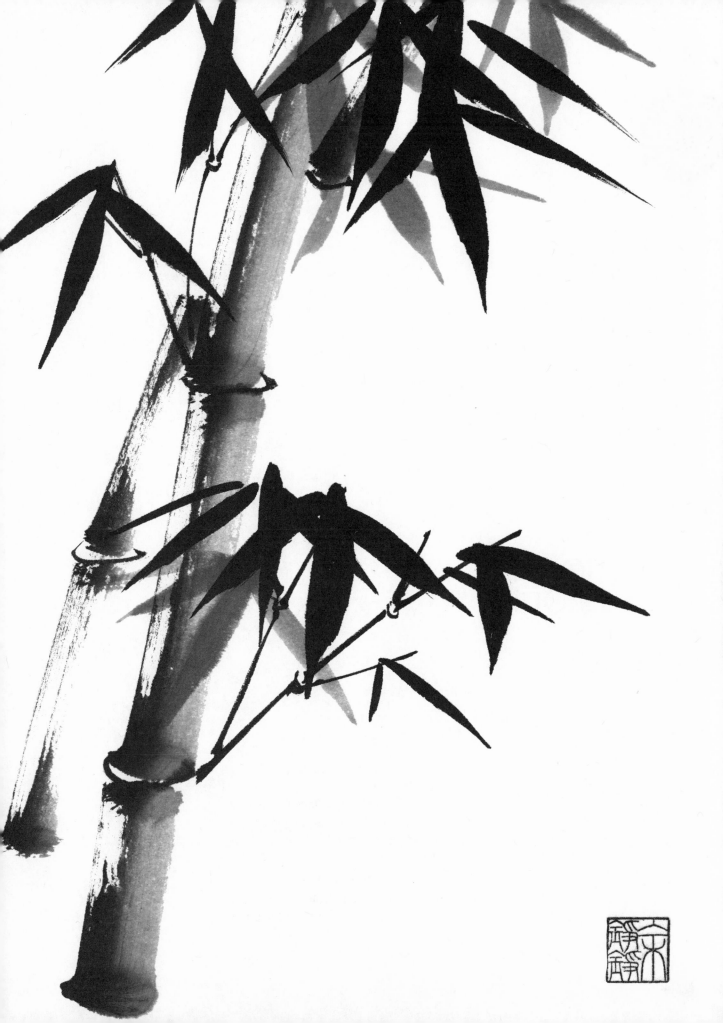

ADDITIONAL
LEAF GROUPS

Luminous ink kindles the luster of bamboo leaves.

This type of leaf formation is used for hanging branches.

* Execute the branches downward rather than upward. Instead of pushing up with your brush, pull down, using the same momentum and force.
* Each leaf is distinct. The leaf arrangement is such that there is a variation in size and in proximity of leaves to one another.
* The leaves can be thought of as consisting of two groups: the first, a grouping of three leaves; the second, a grouping of three or four leaves relating to the first. The leaves in the second group should appear thinner, with the last leaf pointing in the opposite direction as a counterweight.

If on occasion the white of the paper shows through the leaf, as in the top example, do *not* touch it up. Perfection requires—insists on—no tampering. Such is the accidental delight of brush and ink.

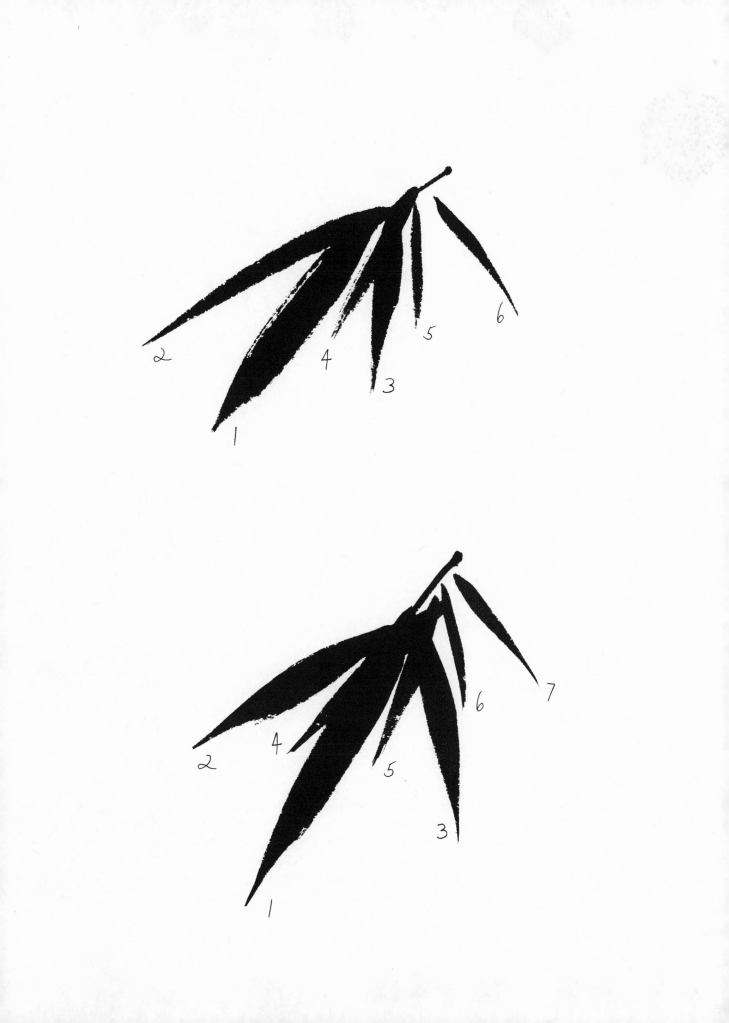

HANGING BRANCH
WITH LEAVES

Dynamic brushwork evokes the inner rhythm of each branch.

- Paint the downward branch first; then add the leaf groups.
 Remember, the branch should be slightly curved, and the leaves should be depicted as possessing an inner strength and vitality.
- Be conscious of the spacing and placement among the three major groups of leaves in order to convey effectively a branch that looks natural. Use a combination of the leaf groups that you've learned thus far.
- The three elements or leaf groups occupy uneven and unequal amounts of space—a basic principle to keep in mind, not only for paintings of bamboo, but also for compositions of all subjects.

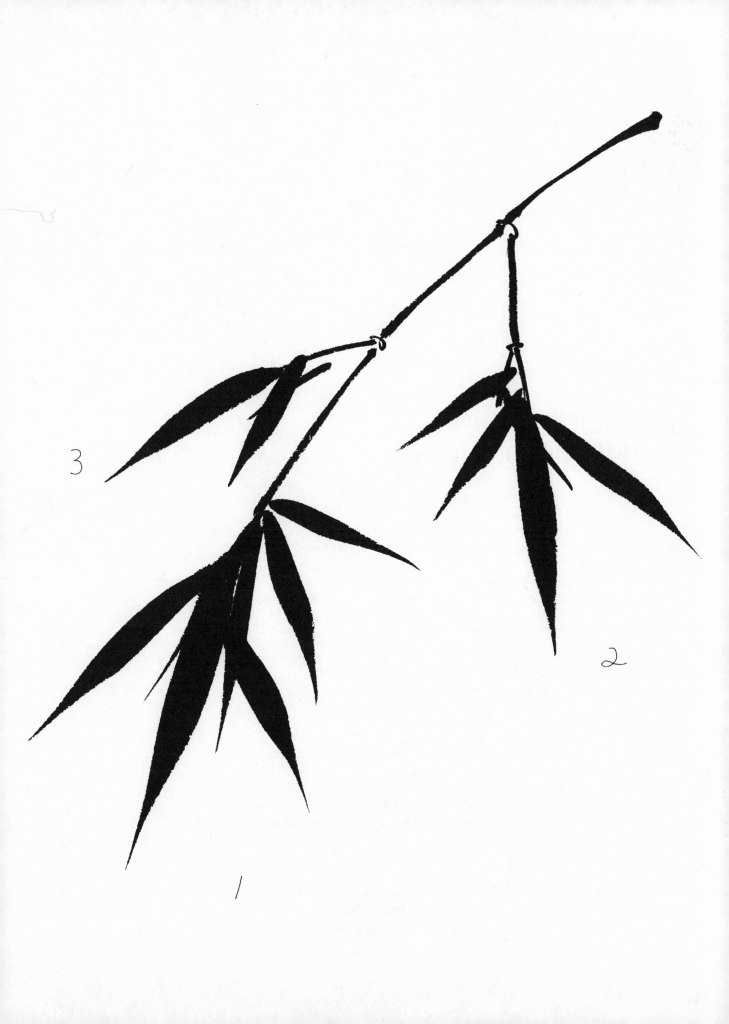

BAMBOO
IN THE MOONLIGHT

One can feel the hushed intimacy of a moonlit night.

The mood created by the bamboo in the moonlight appeals universally to one's imagination. An atmosphere of poetic tranquility is conveyed by the image of the moon.

 The composition of a branch or two exemplifies a typical practice in Chinese painting in which a small part is chosen to convey the whole, the specific alludes to the universal; or conversely, the universal is sought in the particular.

BRANCHES AND LEAVES

* Follow the basic rules for composition. Although the scene is tranquil, the brushwork is active.
* Paint the downward branches first, beginning with the main branch. To assure that your composition will be asymmetrical, begin the branch two-thirds of the way up the paper.
* Add the secondary branches, the nodes, and the leaves. Paint the black leaves before the gray, adding the latter for contrast.
* Make certain the painting is completely dry before starting the background.

MOON BACKGROUND

* Place your painting on a piece of newsprint or other backing sheet.
* Using clear water, wet the entire paper with the flat brush (E). Brush horizontally in one direction from the top of the paper with overlapping

strokes and work your way down. The quality of the ink is such that
when you wet the paper, the painting does not run or blot; it is left
undisturbed.

- Place a circular bowl or plate of appropriate size in the area where
 you want the moon to be. Make sure that the leaves within the circumference
 of the moon itself are well placed and form a pleasing arrangement.
 This is achieved by moving the plate until you find the best position. Be
 certain, of course, that the moon is not centered. Since the moon is
 the focal point of the painting, have it loom large, so that it is dramatic and
 striking.
- Mix a small amount of white tempera with gray ink in a porcelain
 dish. The tempera adds body to the gray, thereby preventing streakiness. Be
 sure not to use too much tempera or the application will look chalky.
- Load the flat brush with gray and work very quickly, using
 overlapping horizontal strokes in one direction. As you work, vary the shades
 of gray. Different values will prevent the background from looking flat
 and lifeless.

The symphony of varying shades creates a sense of light in the
atmosphere. The play of ink in the leaves and the washes in the background
imbue the painting with a soft dancelike feeling.

- Remove the plate, and if necessary, touch up the edges of the moon.
- At this point, if you decide upon a cloudy night, paint a few quick,
 uneven streaks of gray lightly across the moon with the flat brush to give the
 effect of clouds obscuring parts of the round moon.
- Carefully lift your wet painting from the backing sheet and place it on
 another sheet of paper to dry.

Your painting should be alive with a sense of quiet energy—the branches
and leaves in the moonlight reaching out with a buoyancy of life against the
resplendent clarity of the moon.

THE LAMP AND THE MOON

My silver lamp
Sways gently in the wind,
And the graceful shadows
Dance
Upon the wall.

I draw back my screen,
And see the pale moon,
Shining on a sleeping world.

Through the open window
Drifts the scent of blossoms,
And, from afar,
I hear
The plaintive piping
Of a flute.

> Shan Heyu (Shan Ho Yu)
> Qing Dynasty

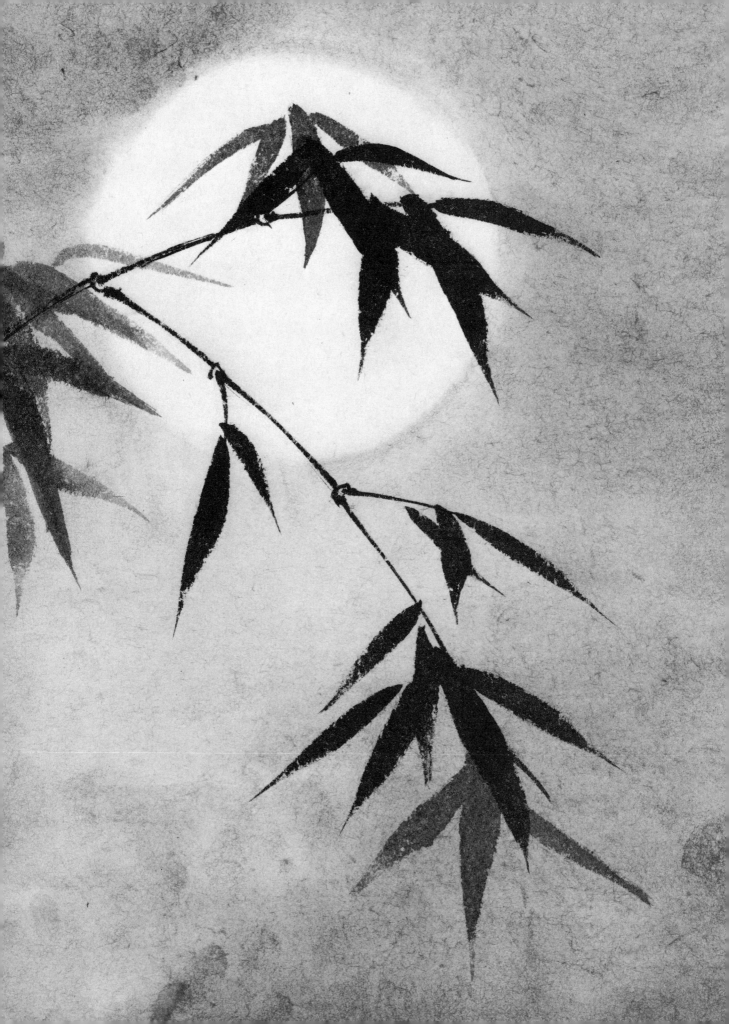

LEAF REFINEMENTS

To imbue with fine sensibilities is to perfect.

These single and double leaf groups are basically the same as the ones
you've learned so far, except that they incorporate certain refinements. By adding
these subtleties or fine distinctions, you will further polish your paintings.

- Coordinate the manipulations of your brush to correspond with the
 graphic results. The refinement is at the beginning of each stroke. In order to
 paint the leaves with a flat rather than a pointed top, press the tip of
 your brush sideways before proceeding with a downward stroke.
- Some of the side leaves turn up before continuing down. Do the
 same with your brush.
- Even though the extra movement in another direction is slight, the
 strokes still should all be rendered by arm movement and not by the wrist or
 fingers.
- You can use these forms here and there for variation and to add
 another dimension to the whole.

The feeling of natural vitality is due to the fact that each cluster possesses
subtle variations in shape, size, and spacing.

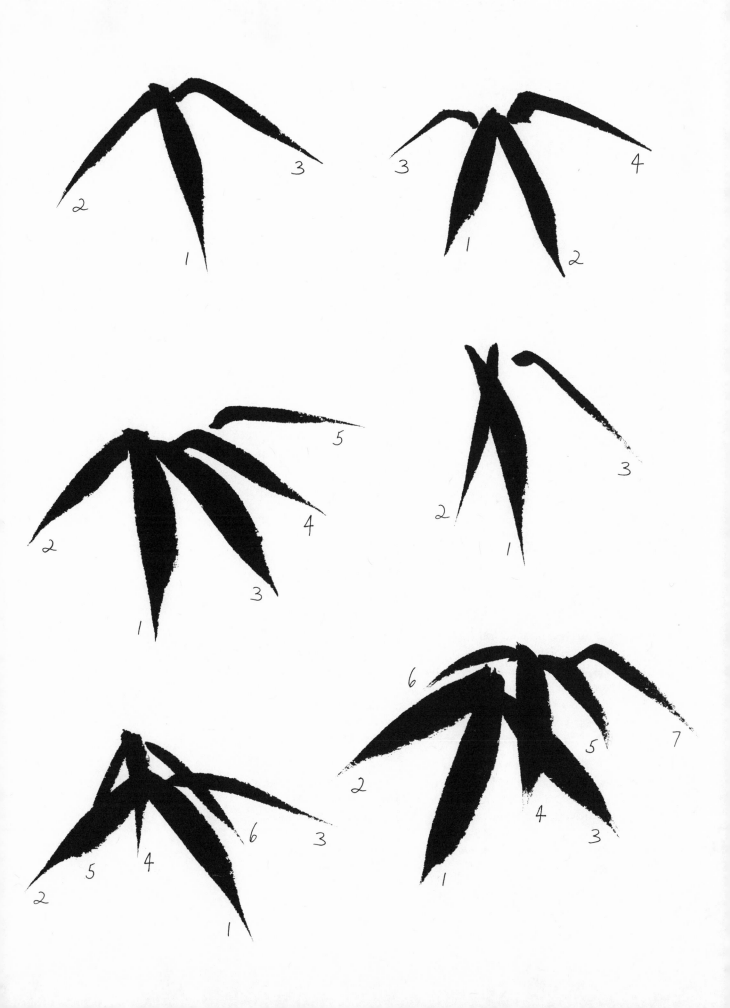

BASIC
UP-LEAF GROUPS

Emulate the bamboo's imagery and idiom.

These groups of leaves, growing on spring or young bamboo, point
upward rather than downward.

 The leaves are painted essentially in the same way as the downward leaves,
except the direction is reversed. In one quick stroke, press brush *B* down
at the base and lift up gradually as you move up, ending in a pointed tip.
Remember to keep your well-saturated brush perpendicular to the paper
and to move the brush with your arm while keeping your wrist and fingers
stationary.

- First render the branches, making sure that the lines are strong. Then
 add the leaves, starting from the branches and working outward.
- Execute the leaves with an upward stroke, using the same motion and
 momentum as for the downward leaves.
- The basic leaf groups consist of two, three, or four leaves. Study the
 different arrangements.

You can think of these leaf groups and the ones that follow as additional
phrases for your brush vocabulary.

76

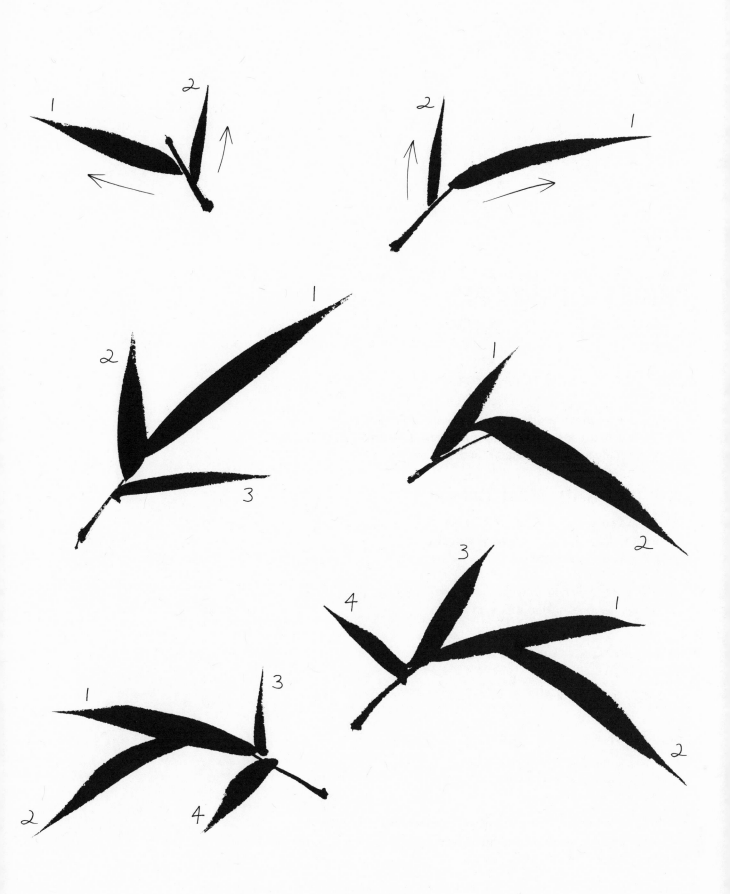

MORE COMPLEX
UP-LEAF GROUPS

Look to the bamboo for artfully arranged patterns.

At first glance, these leaves may look complicated, but when you break
them down into parts—groups and subgroups—the arrangement becomes clear.
Study the intricate natural patterns and analyze the structures carefully.

TOP LEFT AND RIGHT GROUPINGS

- When you paint, think in terms of the main group and subgroups,
 and the leaves will be easier to visualize.
 1–2–3 is the main group.
 4–5–6 is the subgroup.
 Notice the variation in width, with the thicker leaves in the main group and
 the thinner ones in the subgroup.

BOTTOM LEFT GROUPING

- 1–2–3–4 is the main group.
 5–6 is the subgroup.

BOTTOM RIGHT GROUPING

- 1–2–3 is the main group.
 4–5 is the secondary group.
 6–7–8 is the tertiary group.

The relative position of the leaves is important. After you gain an
understanding of their basic structures, you can try to paint approximate mirror
images of these patterns.

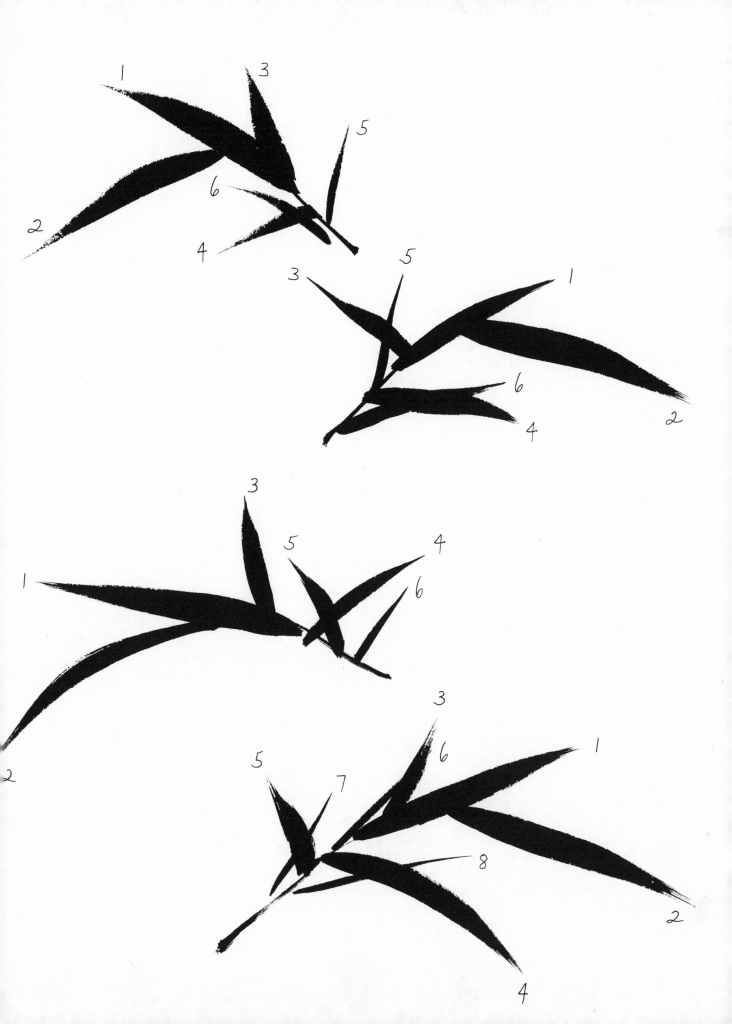

COMBINING
UP-LEAF GROUPS

To bring into close relationship is to follow nature's arrangement.

Different combinations can be used together, incorporating various leaf patterns. These leaves, on the whole, are slightly slimmer than the downward types.

- Paint the branches first; then add the leaf groups. Notice that on the main branch, the leaves grow from the top only. Further down the main branch, the leaves grow from side branches. In other words, leaves do not emanate directly from the lower parts of a main branch.
- Give careful thought to the spacing and placement, striving to achieve harmony among the groups. The clusters of leaves should relate to and complement each other. They are uneven in size and staggered in height. Their overlapping and crisscrossing also contribute to, and further enhance, the feeling of life-movement.

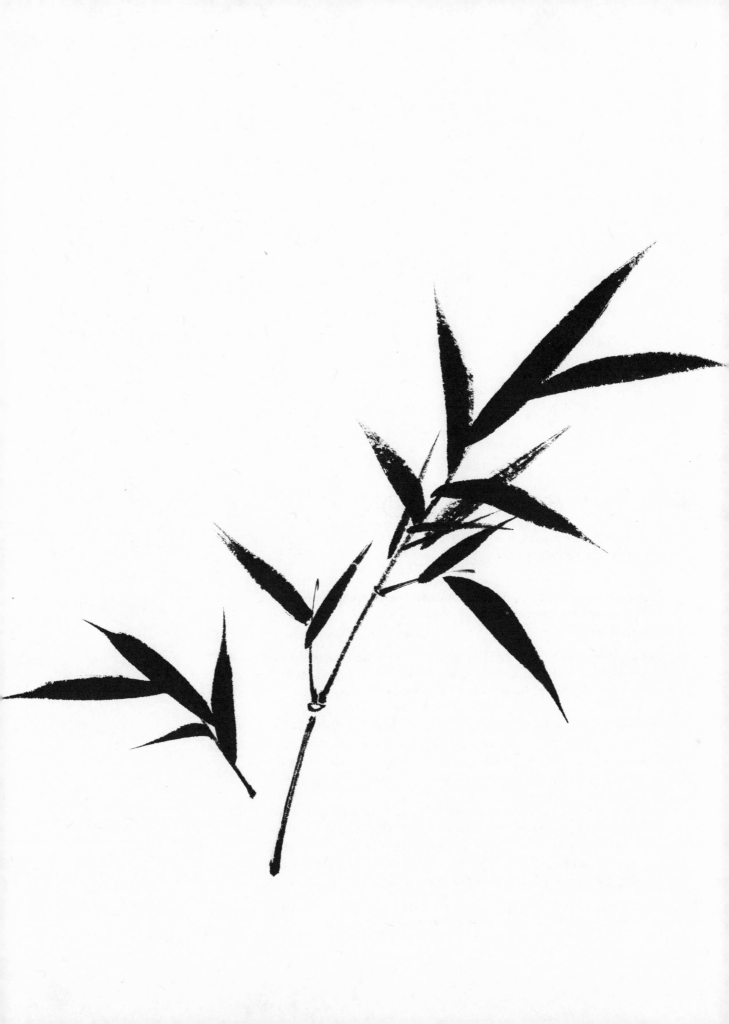

UP-LEAF COMPOSITION

Qi *resides in harmonious space.*

This composition, with leaves pointing upward, shows another possible variation by employing thin trunks only. Again, the overall "balance" is an asymmetrical one.

- Using either brush *A* or *B* held in the vertical position, paint the trunks (do this in the same manner as you would do branches) with gray ink. Use a fairly dry brush. Be conscious of the uneven space between the trunks.
- Add the leaves, working out the main group first, then the secondary ones. The groups themselves occupy varying amounts of space. Distribution of these areas is important: You may have a density of leaves in one area in contrast to sparser areas elsewhere. The composition should have evocative empty spaces.
- Gray leaves are added to the secondary trunk. Dark and light shades indicate spatial relationship between elements. Usually the dark tones are in front and the lighter tones are behind or in the distance. Perspective, as known in western terms, is not an important consideration in Chinese painting and is not dealt with in the same way.

The interplay of elements in the composition should create a rhythmic pattern, with balance and harmonious contrasts prevailing.

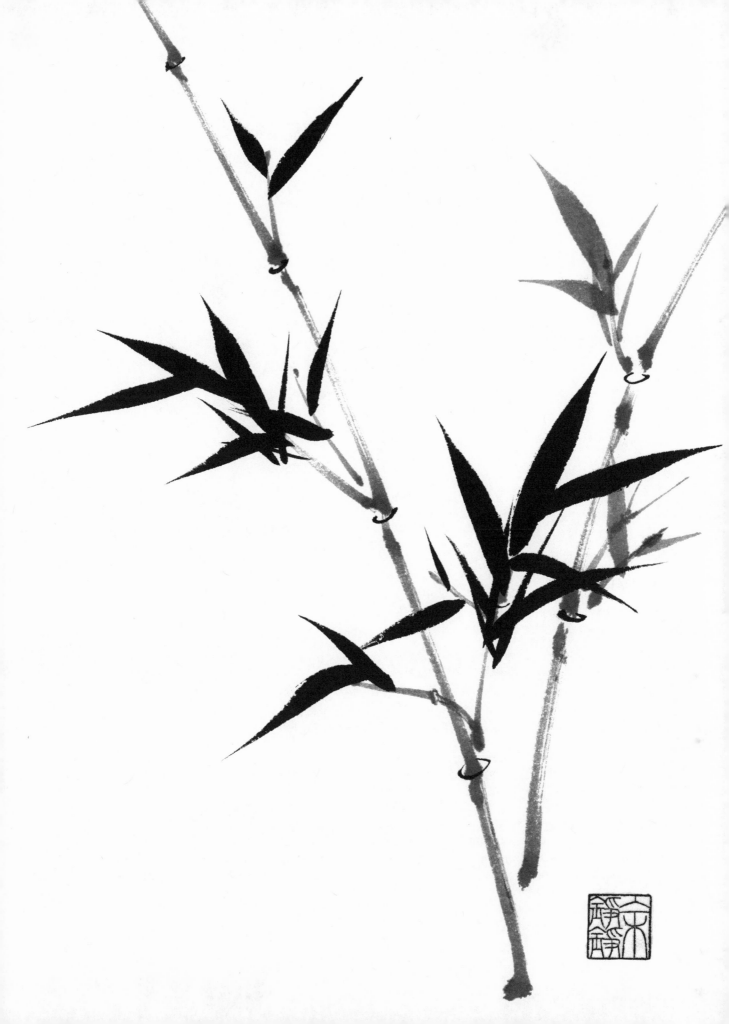

LEAVES
IN THE WIND

To bend with the wind is to move in accord with nature.

These leaf groups follow the basic patterns of the downward leaves,
except that they move in one direction: the direction of the wind.

- Paint the branches first. These may be depicted with a slight curve.
 The movement of the branches reflects the direction of the wind and the
 gentleness or strength with which it blows. Remember always to
 maintain a steady pressure and strength when painting the branches.
- The patterns of leaves flow from the curving lines of the branches.
 When painting the leaves, manipulate the brush with a brisk twist. This is
 achieved with a sweeping movement of your arm. To enhance the
 feeling of motion, add an extra stroke at the end of some of the leaves to
 indicate that their tips are twisted.
- In order to better understand the double groupings, visualize them as
 combinations of the basic groups of three.

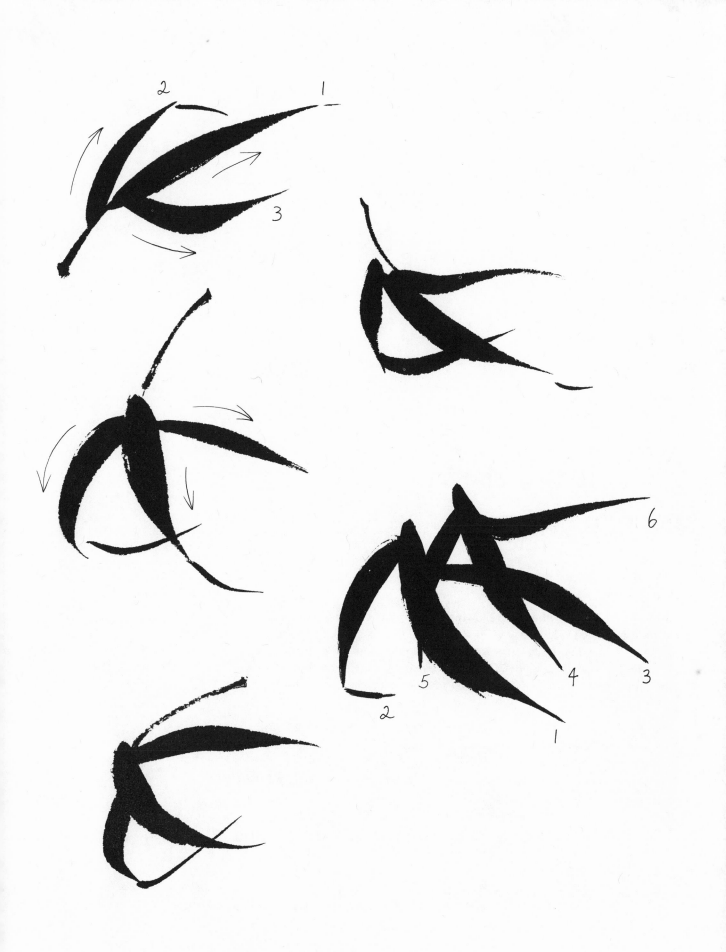

BAMBOO
IN THE WIND

One can hear the melodic rustle of the leaves in the wind.

Capture the feeling of the wind blowing through the bamboo, breathing
life into its branches and leaves. At the outset, be clear in your mind which way
the wind is blowing. Make sure the leaves all move and sway in the
same direction. In this composition, the wind is blowing from the left to the
right. The whole thrust of your painting will be in that one direction.

- Paint the branches in the same manner as you would for the
 downward branches, except with a slight curve in one direction. The
 secondary branches still emanate from opposite sides. However, even the left
 ones swing to the right. The branches should reach out into space
 with a sweeping arc. They should be rendered with a direct simplicity and
 energetic liveliness.
- You may add an extra stroke here and there in terms of the overall
 composition, as simple suggestive strokes will convey the substance and
 evoke the mood. The leaf groups, however, should still remain
 distinct and not confused.

The composition is an example of how the bamboo is shown in its
various moods. The transient moods of nature may be communicated: the poetic
quality of a cool evening breeze, the force of a driving wind.

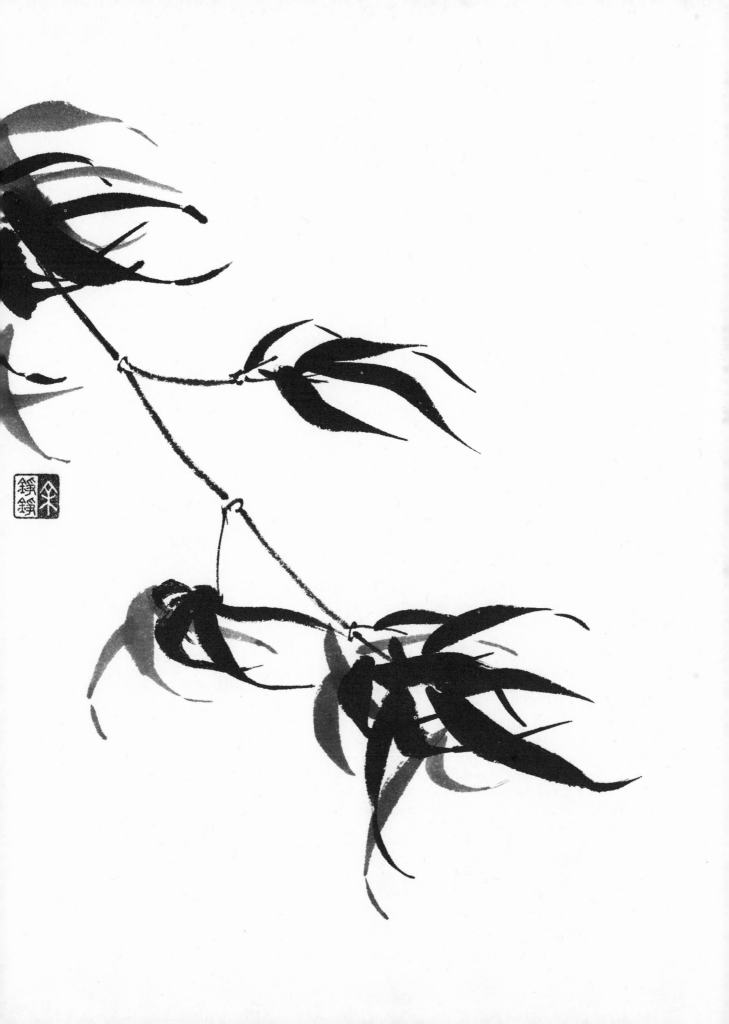

BAMBOO
IN THE SNOW

The solitude and peacefulness of winter is conveyed
by the freshly fallen snow.

Although a symbol of summer, the bamboo's perennial growth spans the
four seasons. It continuously adapts to nature's rhythms. With each seasonal
change, the bamboo reveals a new personality and evokes yet another
mood. We have seen how it is young and fresh in spring, full and lush in
summer, and wafted and windswept in autumn. The bamboo in winter,
alive as ever, is laden with snow.

- Paint a bamboo composition as usual. Notice also that in this
 composition the trunks bend slightly at the joints, but each section remains
 straight.
- After your painting is completely dry, add white tempera to create the
 illusion of snow. Use the tempera in two ways—diluted and full strength. For
 contrasting highlights, alternate with thick and thin and dry and wet
 tempera. Use brush *B* in the vertical position with light, sweeping strokes.
- Pile snow on top of trunks, branches, and leaves where it may fall.
 Indicate the snow in a natural, uneven manner, taking care not to cover too
 much of the painting.
- Be conscious of the layering of the leaves when you add the snow so
 that leaves in the front and in the back are not confused.
- Pay attention to how the snow accumulates on the trunk above each
 node.
- Here is one instance in which you have the opportunity to cover up
 certain mistakes and imperfections.

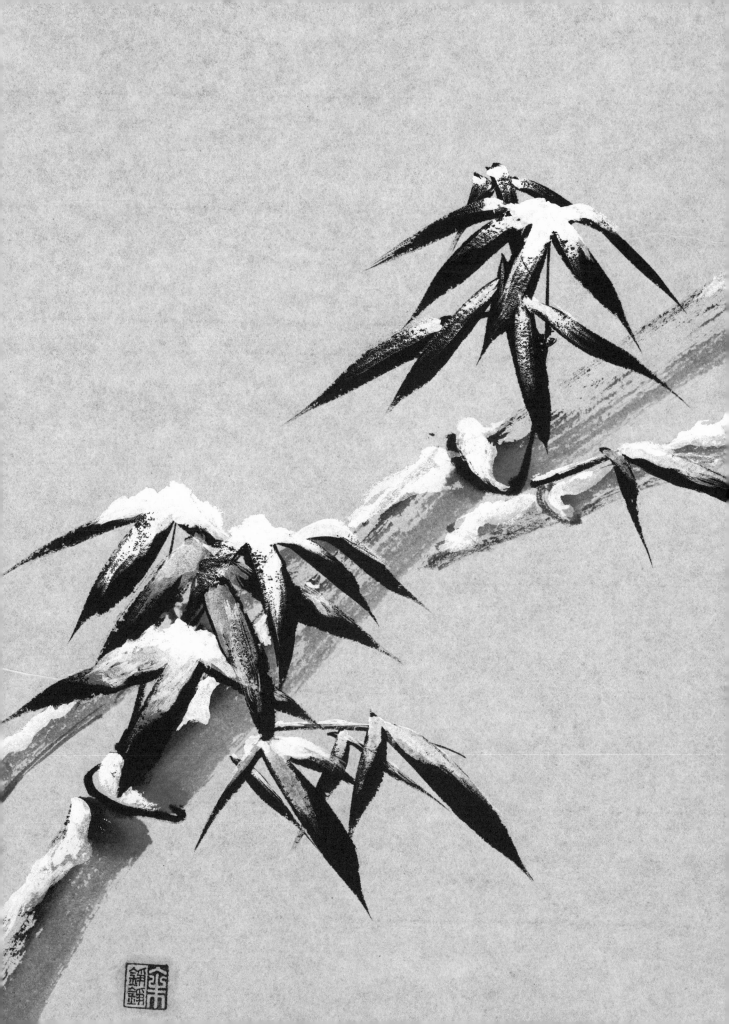

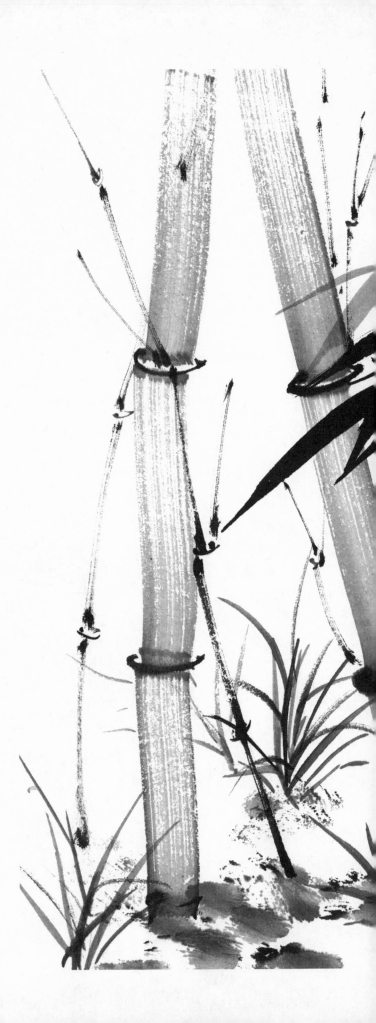

Luxuriant foliage of summer bamboo
Enduring limbs of silver-dusted jade
Surely these intricate patterns of time
Were meant for my brush and ink.
Leslie Tseng-Tseng Yu

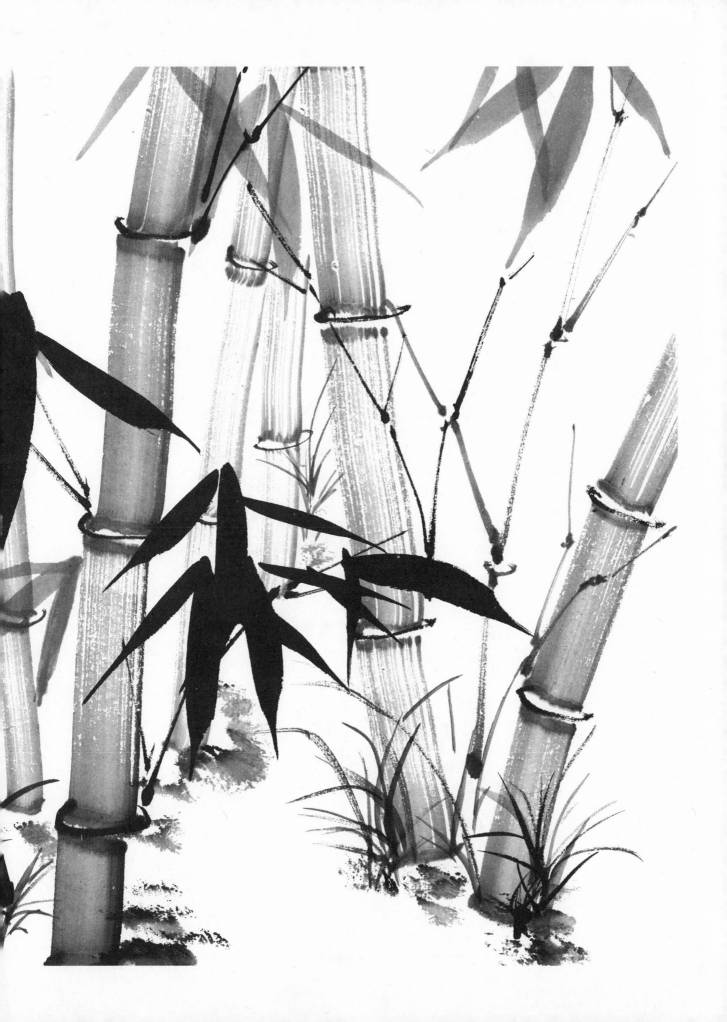

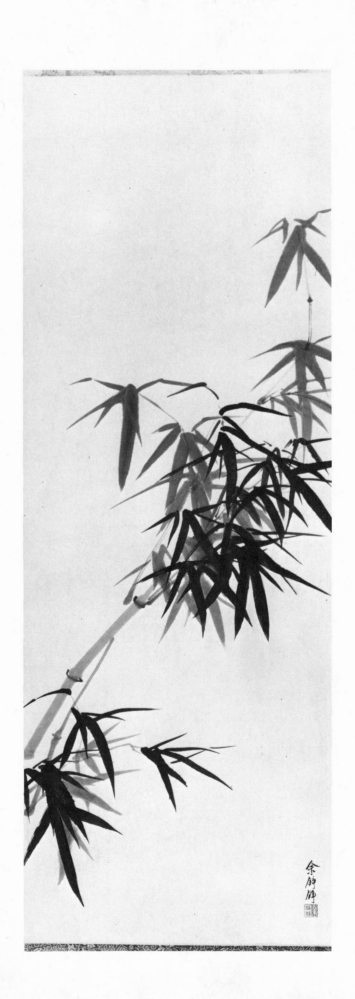

A FLUTE AT EVENING

The dewdrops cling
To the green bamboos
Like pearls.
The wind stirs lazily
In the lotuses,
And their pale red petals
Flutter to the earth.

As the night creeps on apace,
The twinkling glowworms
Light my path,
And faintly, from a tower
In the east,
Calls a bamboo flute.

Huang Wanqiong
(Huang Wan Ch'iung)
Qing Dynasty

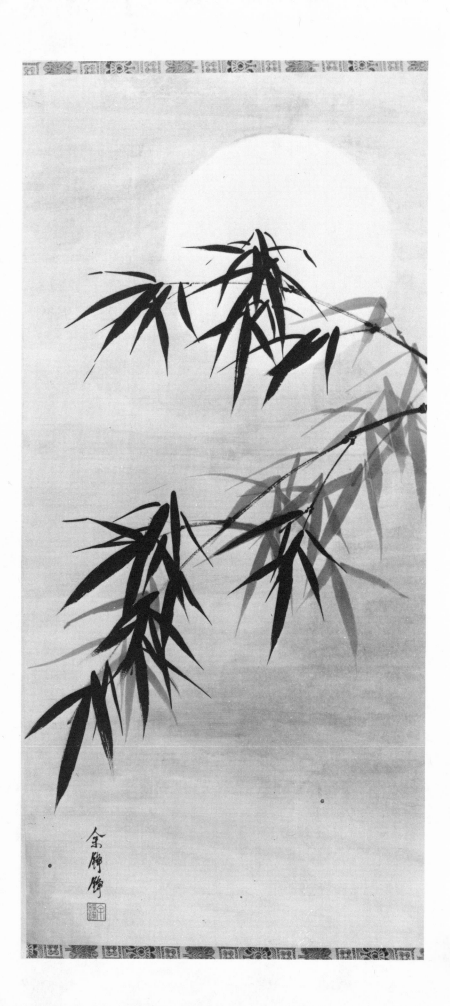

MIDNIGHT

How still and silent
The pavilion in the courtyard
Is at midnight!

The flowers
Stir in their sleep,
And from under the hedge
A solitary cricket calls.

Half in a dream
I hear the whisper of the wind,
And from my bed
I watch the bamboo's slender shadow
Wave across my window
Like a flag.

Zhao Ci (Chao Tz'u)
Qing Dynasty

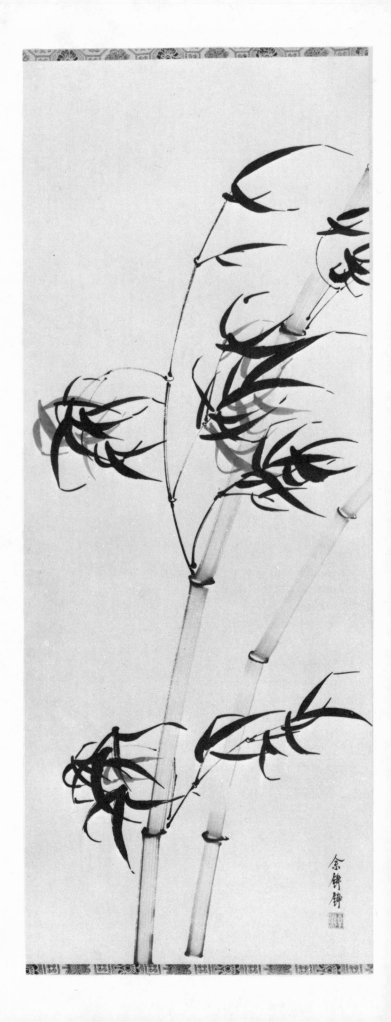

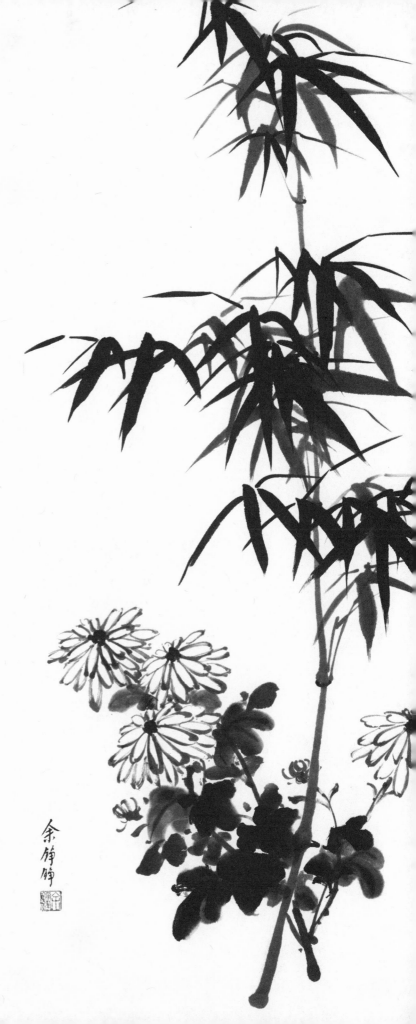

CLIMBING TUNG KUAN MOUNTAIN

The mountain path
Is steep and strait.
It is autumn,
And the yellow leaves
Flutter slowly to their rest.
The sunlight
Through the forest pines
Splashes gold upon the earth.
The birds seem numberless;
Their calls
Fill the forest aisles with joy,
And the gentle winds
Are sweet
With the scent
Of wild chrysanthemums.

Dai Bing (Tai Ping)
Song Dynasty

CHRYSANTHEMUM
AUTUMN

The chrysanthemum, often called the *flower of the east,* has been cultivated in China for over three thousand years. This flower is a symbol of integrity, friendship, and joviality. It also has an association with a pleasant life after retirement, as the growing of chrysanthemums became a favorite pastime.

Autumn is the season when chrysanthemums reign, and the ninth month of the lunar year is known as chrysanthemum month, a time for admiring the flowers and contemplating their fragrance. While other flowers are withering in autumn's frost, chrysanthemums bloom and thrive, standing strong and glorious against the chill of the wind.

The name *chrysanthemum* comes from the Greek words meaning "golden flower." Very poetic and imaginative names are given to this oriental flower of many decorative shapes and exotic hues. "The yellow button, similar to the wild form, is called 'Heaven full of Stars'; the white quill, 'Goose-feathers Tube'; the yellow quill, 'Carrot-threads'; the large ragged mauve, 'Drunk with Wine made from Peaches of the Immortals'; the big single white with a yellow center, 'Jade Saucer Gold Cup'; the varieties with very fine petals, 'Pine Needles,' or 'Dragon's Beard' . . ."[13]

Of the many varieties of chrysanthemums, some are elaborate and showy whereas others are charming and discreet. The favorite kind painted in ink monochrome is the daisylike variety, chosen for its simplicity and elegance to complement the like qualities of the brush and ink. These unpretentious flowers are akin to the wild chrysanthemums which grow almost unseen in the mountains and fields. They are preferred by artists of pure and simple taste.

Although we've studied the bamboo from the graphic and calligraphic approach, we can also begin from the opposite end: by acquiring a thorough understanding of the chrysanthemum itself before attempting to paint it. Get to know its shape, form, and structure through observation. Experience and conceive the whole plant. This comprehension, combined with technical skill, will enable you to capture the chrysanthemum's spirit. Understanding the flower will free you to transmit and express its purity and essence.

FLOWERS AND STEMS

Does the chrysanthemum transform the ink,
or does the ink transform the chrysanthemum?

FLOWERS

- To portray the flower, begin by dotting the center, using brush A in the vertical position, loaded with black ink. Make the dots solid, full, and rather rough. Strive for unevenness, positioning the dots asymmetrically so they do not form a circle. Allow enough space between the dots so they don't run together into a solid black mass, but not so much space that they appear isolated and disconnected. The right spacing gives you a strong center that holds together.

- After dotting the center, add the petals. Load brush *B* with two shades of gray: light and dark. Hold the brush in the vertical position. Moving from the elbow and keeping fingers and wrist stationary, paint two downward strokes for each petal, starting from the center of the flower and moving toward the tip to form an elongated heart shape. Each stroke turns upward at the end. Paint with firm and lively brushstrokes to create lines that are natural.
- Render each petal individually with a continuous rhythmic flow of your brush, varying the length of the petals as you arrange them in a cluster around the dotted center to form the flower.
- At the top of the flower, show only part of the petals, painting them from the top toward the center of the flower.
- Vary the shading by painting the layer of petals closest to the center of the flower darker than those of the outside layer. For the second layer, you may wish to reload the brush with lighter ink. As you paint the second round of petals, tuck them in underneath and between the petals of the first round.
- Try arranging the petals to show flowers in different stages of growth and development, from the bud to the flower in full bloom. For the young bud, paint a few petals closely clustered together. For a partially opened flower, paint some petals close together, keeping the two sides of the flower asymmetrically balanced.
- Practice painting the flowers facing in different directions and in various positions.
- The calyx consists of quick staccato strokes coming together at the center. Take a small amount of ink with the tip of brush *A*. With your brush in the vertical position, press straight down and immediately lift up again. Wrist action is acceptable for this type of stroke. Vary the length and thickness of the sepals.

Do not underestimate the importance of these minute details. The slightest difference can be the difference between art and artifice. Everything must look natural. The calyx acts as a support for the flower contained within. The ink for the calyx is darker, thus creating a contrast between the flower and stem.

STEMS

- The flower stem connects to the calyx. For painting the stem, use brush A with gray ink in the vertical position. Pull downward quickly with an even pressure, maintaining a firm start at the beginning and end. Stop at the end before lifting your brush from the paper. In this way, the stem will appear round instead of flat.
- The stem should be slightly curved, emanating from the center of the flower. Make sure the stem is sturdy and strong, yet supple. This effect is not possible if your brush contains too much ink, so keep it on the dry side.

COMBINING FLOWERS AND STEMS

- When painting two chrysanthemums together, dot the centers of both flowers first, and then add the petals. Indicate the relationship of the flowers to one another by positioning one slightly behind the other.
- Next, add the stems. The stem of one flower should intersect at a point on the stem of the other flower but not break or divide it in half.

Each flower is unique. The petals may have a variety of forms: thick or delicate, long or short, wide or narrow. No matter what the form, all flowers follow the same basic structure.

The relationship of the flower, calyx, and stem should be structurally accurate. However, it is most important to convey, through free and rhythmic lines, the chrysanthemum's feeling and spirit rather than reproducing an exact copy. The brushstrokes should vibrate with energy, capturing the essence of the flower.

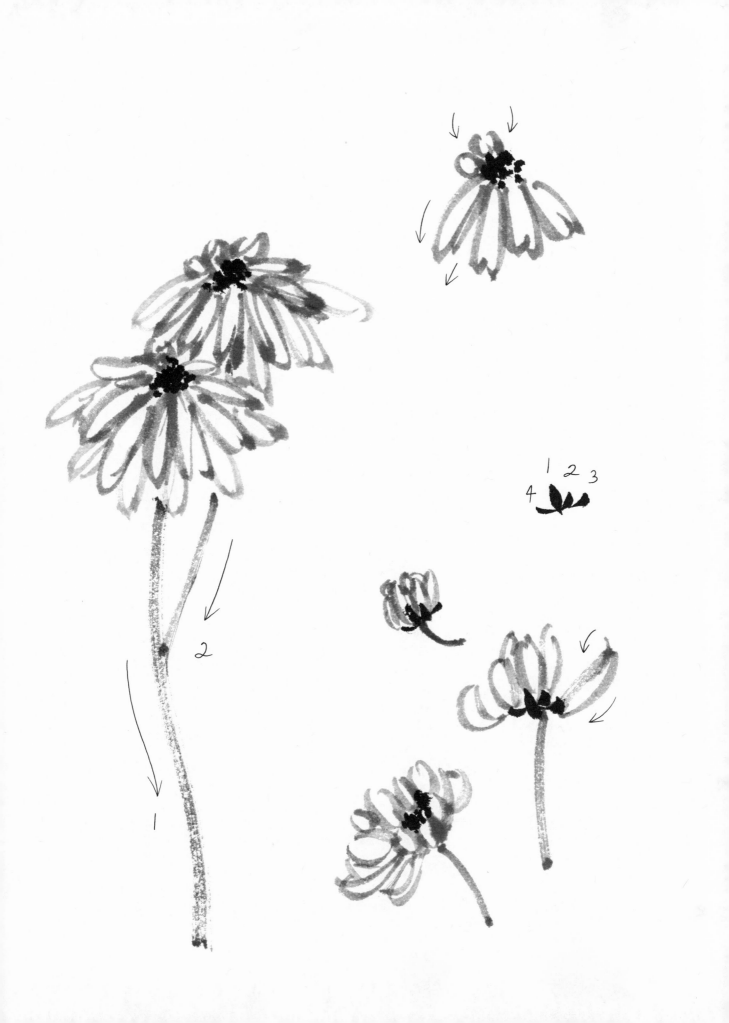

BASIC LEAVES

Borne by the stem of the plant, the leaves emit the rhythm of life.

FRONT VIEW

Use brush C to paint the leaves. The softness of the hairs make this
brush ideal for achieving the form and shape of the leaf, as opposed to the lines
achieved with brushes A and B.

- When painting leaves, there should always be two tones of shading.
 Load the brush with gray, eliminate the excess on the edge of the plate, then
 dip half of the brush in black ink. For lighter leaves, use two tones of
 gray. When using two tones, prepare a small amount of dark gray in one
 porcelain dish and light gray in a second dish. Hold the brush in the
 slant position.
- The basic leaf consists of three strokes. The slant brush position will
 enable you to achieve shading. For the broad, slightly curved center stroke,
 hold the brush sideways and press downward. The two side strokes
 should be thinner and shorter, running into the first stroke to form the leaf

shape. Use the tip of the brush for the left side stroke and the base
for the stroke on the right. These vivid strokes should be controlled, yet free.
- Vary the direction of the strokes to show leaves in different positions.

VEINS

- While the leaf is still wet, add the veins so that they become an
 integral part of the leaf. Use brush A with black ink. For lighter leaves, add
 lighter veins, using dark gray instead of black.
- The veins form the principal framework of the leaf and further define
 it. Each leaf has a main vein with smaller, subsidiary veins. The vein stroke is
 a calligraphic one. Hold the brush in the vertical position; pull the
 brush swiftly and firmly in slightly curved strokes. Maintain a continuous
 movement within each leaf. Begin with the center vein, add the side
 veins, and then the other auxiliary veins. The two side veins should be
 staggered, with the strokes on alternate sides of the main vein. Note
 that the auxiliary veins move outward and downward toward the tip of the
 leaf.

The accent strokes showing the veins add spirit and life to the leaf. Fine,
subtle, and free-flowing strokes are in harmony with nature, thus bringing forth
the essence, or inner rhythm, of the leaf.

SIDE VIEW

- Load brush C with two tones for shading, and hold it in the slant position. To make the strokes for the side leaves, utilize the shape of the brush to achieve the shape of the leaf. Start with the tip and move the brush slightly downward and press.
- For the side leaves, combine two or three strokes of different lengths, painting them in sequence so that they will blend together. Then add the veins.

LEAF GROUPS OR COMBINATIONS

- If you paint several leaves at one time without reloading the brush, you will naturally get a variation in ink tones. When combining leaves, keep in mind that the darker leaves are considered to be in front and the lighter ones behind.
- Remember to use lighter ink for the veins of the lighter leaves and black ink for the veins of the darker leaves.

ADDING LEAVES TO THE STEM

- Since the leaf is an outgrowth of the stem, paint the stem first and then add the leaves. You may use either brush A, B, or C in the slant position for the smaller leaves. These sprouts have only one leaf with one center vein. Start from the stem and press the brush outward.
- Stagger the leaves on alternate sides of the stem.

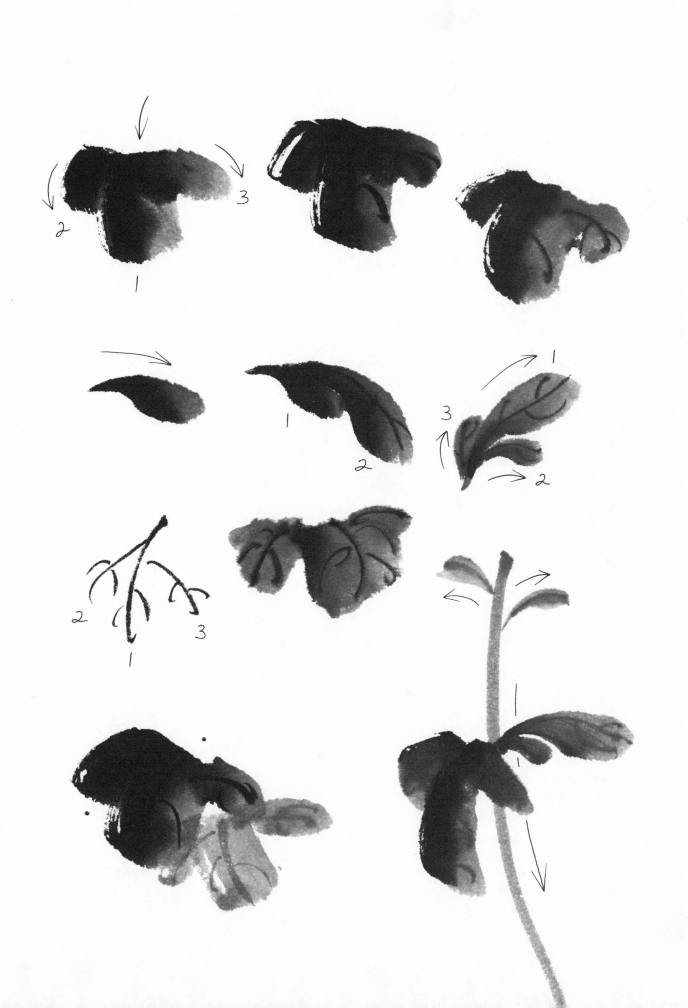

COMPOSITION

Rhythmic brushstrokes create compositional rhythm.

- Begin with the placement of the dotted centers of the flowers. The distribution of the flowers should not be even. An odd number of flowers is preferable to an even number because of their asymmetrical connotation. For instance, three, five, or seven flowers and/or buds create a more interesting design than four or six.

Consider the entire compositional space. Give careful thought to the placement of the flower centers, which dictate the structure and design of the composition. These centers should not form an equilateral triangle nor be on the same level with one another.

- Next, add the petals to the dotted centers to form each flower. The strokes should be smooth and unconstrained. Show variation in the shading, positions, directions, and stages of growth of the flowers.

Although the elements in a painting should have a common denominator, too much repetition is monotonous and therefore should be avoided. Aim for a unified diversity, with the flowers echoing each other in concert.

- Add the stems, using strong, firm strokes. These will help to pull the composition together.
- Last, add the leaves. Consider their positions and the directions that they face: up, down, front, back, side; and how they grow from the stem.
- Use dark ink to indicate large leaves, old leaves, and those in front. Use light ink to indicate young leaves and those behind. Remember, all leaves, whether light or dark, should have a range of shadings (two tones of ink on your brush). Add the veins last, while the leaves are still wet.
- Contemplate the placement of the leaves. In this composition, the main dark leaves were painted first, near the base of the stem. Then the lighter leaves were added, with the small leaves placed closest to the flowers. As you arrange the leaves pay attention to the overall variation in ink tones. It is the jet black ink that contributes to the vibrancy of the painting and gives it verve. Without a significant amount of this liquid brilliance, the painting will appear weak and tentative rather than strong and definite. The more variation in tonality, the more vivacious the painting.
- Think about the arrangement and spacing of the leaves in terms of the overall composition. Group and overlap the leaves so they look natural and give the illusion of depth. Create a contrast of dense areas with groupings of leaves and sparser areas with, perhaps, only one or two leaves.

Create a rhythm in your composition through *yin/yang* opposites: dark and light areas, wet and dry strokes, dense and sparse space. The rhythm of your strokes, through the spontaneous movement of your brush, should complement the rhythm of the opposites. The completed painting will then project a feeling of spontaneity and vitality, reflecting the rhythms of nature.

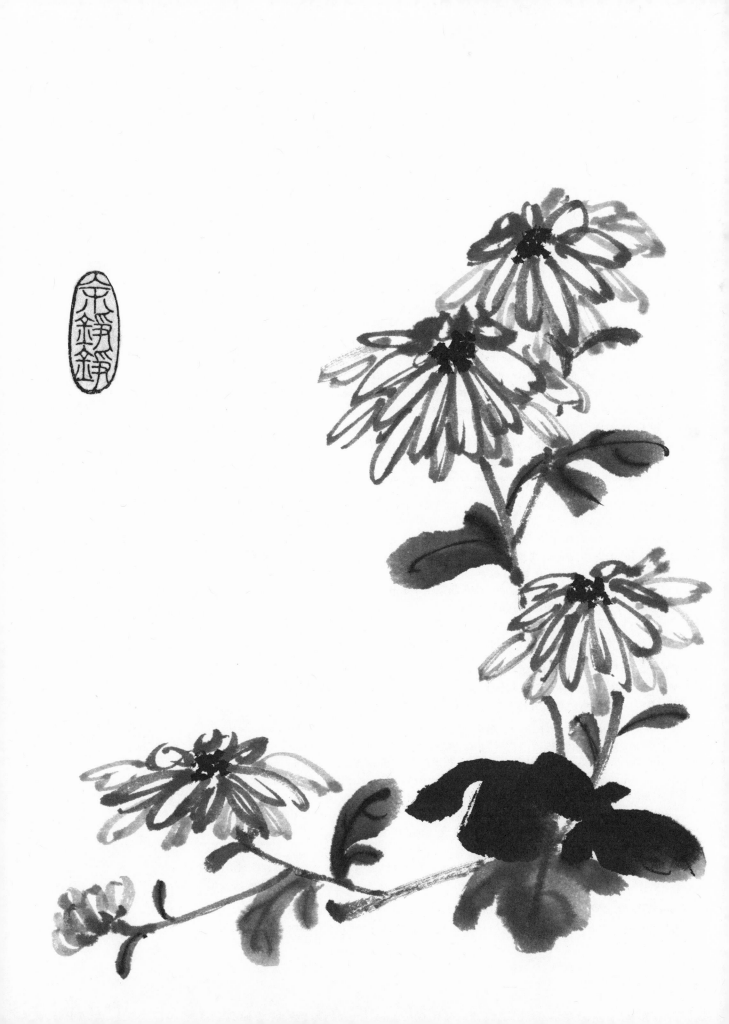

MORE COMPLEX LEAVES

From one basic leaf, many others are derived.

FRONT VIEWS

The first example (top left) shows the leaf previously introduced, upon which these leaves are based.

- For pointed-tip leaves (top middle), begin the main stroke in the same manner as for the basic leaf, but lift the base of your brush at the end of the stroke to achieve the point. Use essentially one stroke with two steps, manipulating your brush from the slant to the vertical position.
- The next leaf (top right) has five sections rather than three. First paint the main leaf, then the lower side leaves, and last the two smaller top sections. Add the veins, making sure they all meet toward the top of the leaf. No auxiliary veins are necessary in the top two sections.
- Small leaves toward the top (third row down, right) of the plant can also be rendered in the opposite direction from what was previously shown. In painting leaves toward the stem, press at the beginning; then end the strokes with a point to connect with the stem.

SIDE VIEWS

- For a variation of the side views of the leaf (second row down, middle), begin with the center stroke and add the side parts in different positions. When stems are necessary, add them last.
- For the next variation (second row down, right), paint the top side stroke first; then add the bottom one.

VIEWS OF FACE AND BACK

When both the face and back of the leaves are shown, one side should be lighter and one darker. It is a good idea, in this case, to work with two brushes, C and D, loading one with light tones of ink and one with dark.

- For the next leaf (third row down, left), begin with the darker shades, making three strokes. For the third stroke, lift the base of your brush and use the tip to achieve the curved point. Fill in the underpart with lighter ink. The veins are also in darker and lighter tones. Add the stems last.
- Paint the back of this leaf (bottom right) with the lighter shades, making three strokes. For the inside, or face of the leaf, use darker ink. Utilize the tip of your brush to achieve the point at the bottom of the leaf. Show veins in the lighter parts only. Last, add the stem.
- This leaf (bottom left) consists of three side strokes, with two tones of light ink. Again, the third stroke is painted with the brush tip only. Add the stem last.

Generally speaking, you should not mix the round and pointed leaves together in compositions, but rather, should use one type or the other.

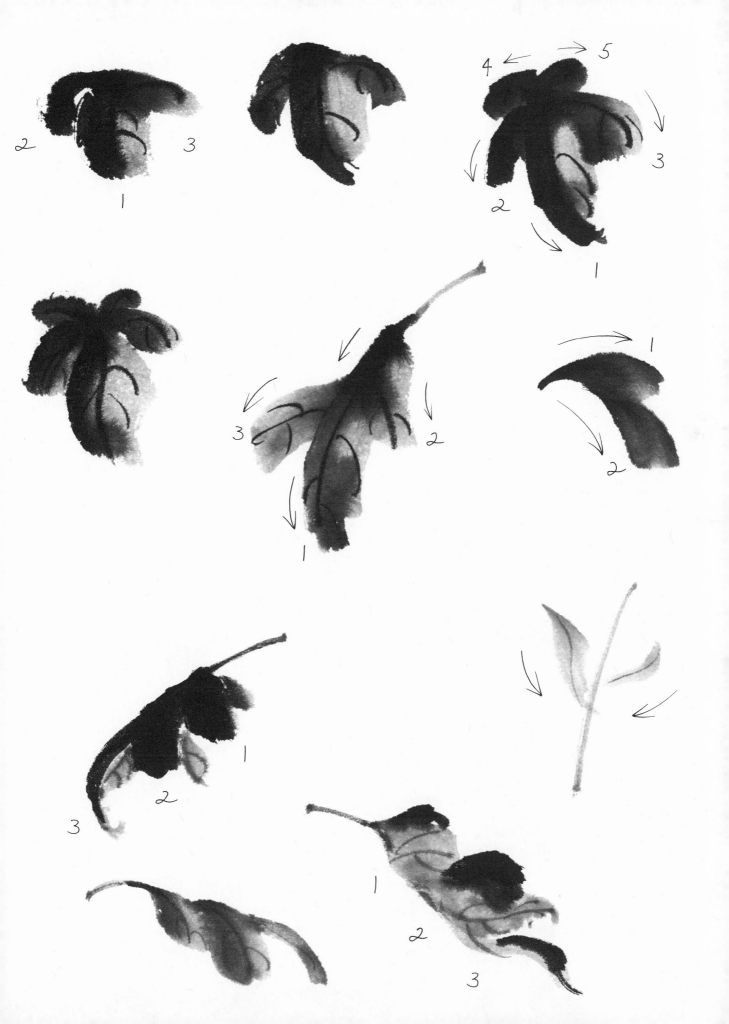

COMPOSITION

Simplicity is profound.

This simple composition utilizes some of the more complex leaf
variations.

- The rhythmic flow of the composition is established by the graceful
 curve of the stems, placed in just the right position.
- In this composition, the darker leaves are placed near the base, with
 the leaves becoming progressively lighter as they approach the flower. This
 progression is not always the case; it depends on the individual
 composition. The interplay of ink tones spark nuances of subtle beauty. Study
 each stroke carefully to get a feeling for these essential qualities.

Simple compositions are more difficult because the fewer the elements,
the more perfect they must be. Each element is essential and all are carefully
composed, imparting an understated elegance.

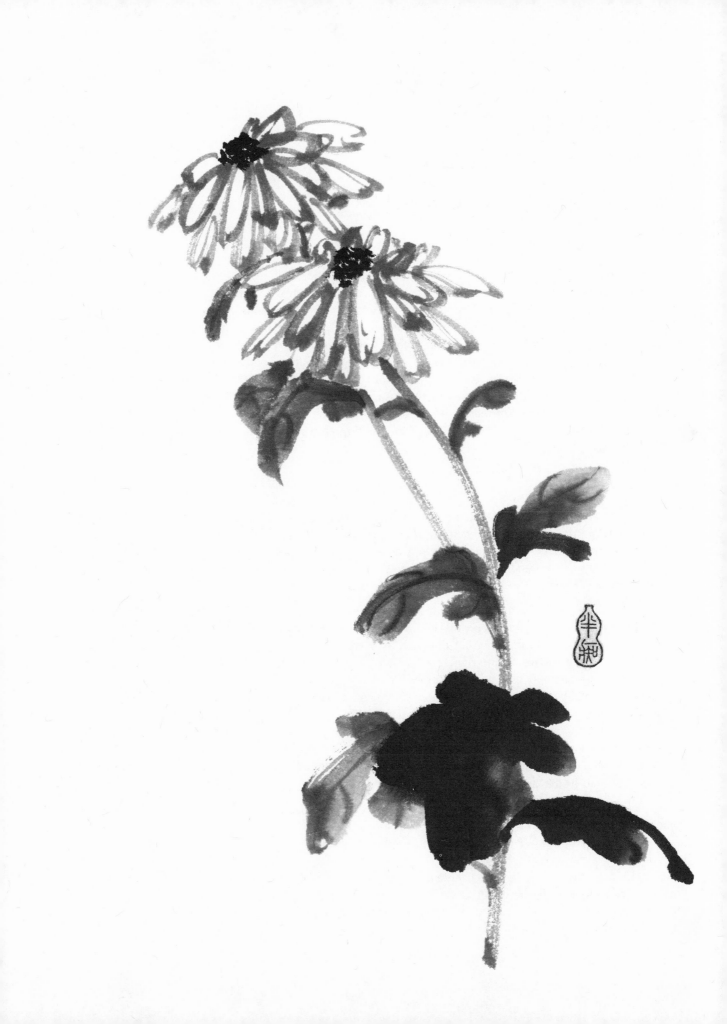

INCURVED CHRYSANTHEMUMS

Gemlike petals fall into a flowering constellation.

This variety of chrysanthemum is more elaborate, possessing and professing its own special beauty.

The chrysanthemum may also be painted in the *Meigu (Mo Ku)*, or boneless, method. Whereas the outline style is linear, with brushstrokes that are the bone structure or skeleton of a painting, the boneless method is characterized by the absence of contour lines. The brush is usually used in the slant position, enabling solid forms to be created with a single stroke. In the boneless method, the brush may also be held in the vertical position, but instead of making lines, the brush is pressed down in various ways to create forms.

As you can see, the all-purpose Chinese brush can give you many different shapes with a single stroke. The nature and shape of the brush is used to advantage to obtain the various petal forms when creating chrysanthemums in the boneless method.

FLOWER

The incurved chrysanthemum has numerous petals, arranged in layers. To paint the flower, you should paint each layer, starting with those petals near the center and working outward. The compact and densely packed petals should be tightly layered and tucked in together. Whereas short, dark petals cluster around the center, the outer petals are longer and of a lighter tone.

- Hold brush *B*, loaded with two tones of gray, in the vertical position. Make three downward strokes on the left, as if writing the cursive letter *W*. Add a fourth stroke in the opposite direction as a counterpoint and then three more strokes on the right, as if writing the letter *M*. Practice these strokes before attempting to paint the entire flower. When you're ready, add other strokes to fill in the flower's center, as shown.
- Add the next two layers, making these petals a shade lighter than those of the darker center. Fill in the spaces with lighter petals.
- Practice the five individual strokes shown for the outermost layer. The order in which you paint these strokes does not necessarily have to follow the sequence in the example.

These longer strokes define the final shape of the flower. Note the difference in their form: The petals are thinner at the base and curl up at the end. Each petal is a kind of rhythmic play of line and form, with every action having a counteraction: a firm stroke ending with a curl in the opposite direction. Each stroke is designed to achieve the expressive quality and buoyant movement of the flower. You should have enough strokes to represent the multipetals but not too many to confuse the image and undermine, if not destroy, the flower's essence.

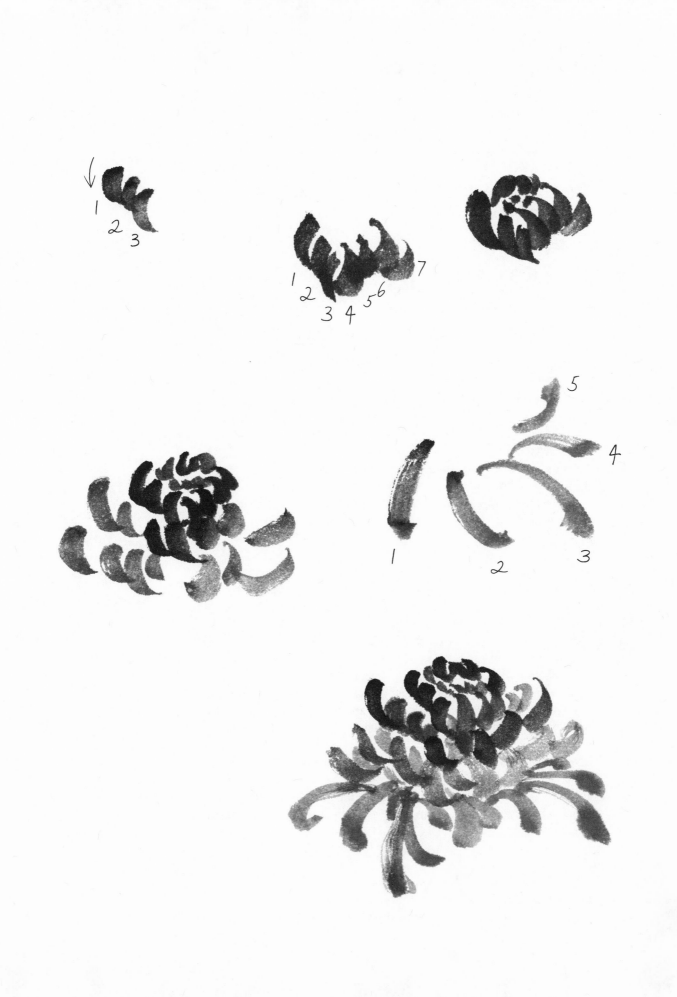

BUDS, FLOWERS, STEMS, AND LEAVES

Strength lies in compactness of shape and structure.

BUDS AND FLOWERS

- The buds and side views consist of the basic petal strokes. Paint about five short strokes for the bud. Arrange the petals in an uneven and asymmetrical manner for the side views. Before the petals are dry, add the sepals with brush A held in the vertical position.
- The spontaneous and freely executed flower in the bottom left illustration has center lines in the two petals on the left side. These lines were unintentional, but witness how well this "accident" suggests the essence of the flower.

STEMS

- These stems are thicker than those of the daisylike chrysanthemum previously introduced, and brush B is the most suitable. The brush should be fairly dry, and the best way is to saturate the entire brush with gray ink and then eliminate the excess on the edge of the plate.
- Hold the brush in the vertical position and use your entire arm, moving with one sure stroke of even pressure. You can stop momentarily at some point to steady your hand and to gather the strength to finish. When you continue again, you can proceed in another direction (see curve of stem, bottom right), keeping in mind that the entire stroke should be done with speed.
- Further strengthen and define the stem with thin, fluent lines on both sides, using brush A loaded with a darker gray.
- Indicate the natural knobs and ridges to enhance the three-dimensional quality of the stem. The momentary stops in your strokes work out naturally to show knots.

LEAVES

- Add the leaves last. Usually with these more elaborate chrysanthemums, the more complex, pointed-tip leaves are used.

114

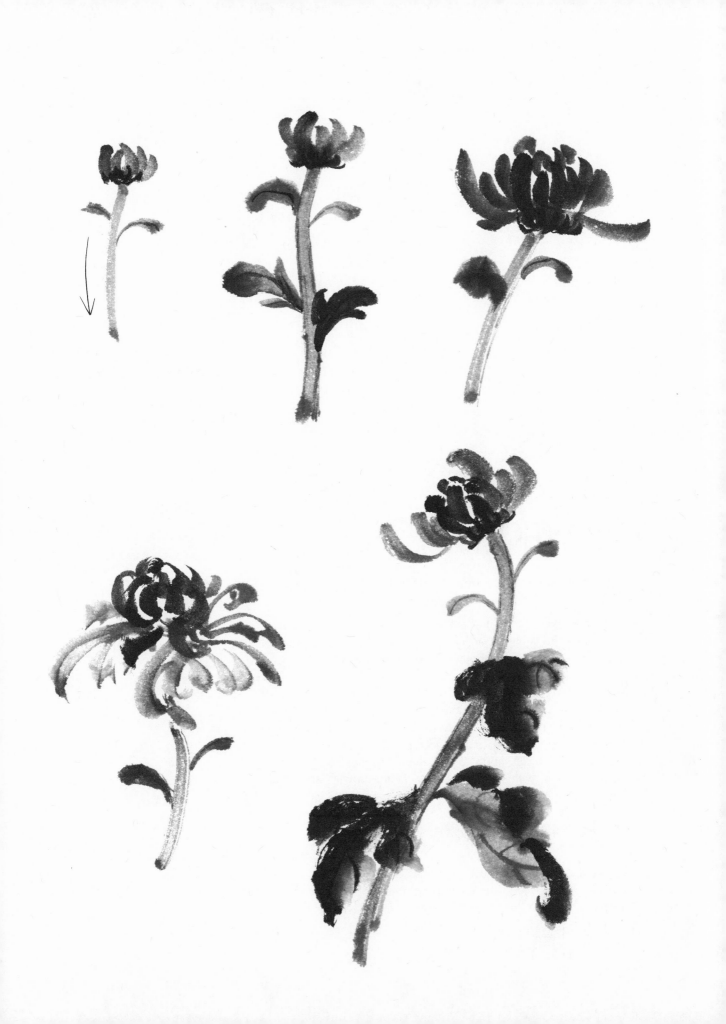

COMPOSITION

The chrysanthemum is a surging sweep of sunny radiance.

- Begin with the placement of the main flower, noting that it should be the focal point—the strongest or leading element—which predominates over the composition. Then add the other flowers, observing their relationship to one another.
- When the flower center is in view, fill it with a light gray wash and dot it with black while it is still moist.
- Paint the stems next, with firm steady strokes, noting in the example the diagonal sweep of the main stem to the bottom left corner. Where stems connect, you can indicate knots to join them together.
- Add the leaves next, with smaller leaves near the flowers and larger ones further down the stem. Discern the sense of tonal depth conveyed by the dramatic dark leaf at the bottom. When leaves overlap or hide the stem, simply paint directly over the stem or show them behind.
- Add the outline to the stems last.

The forceful feeling swelling through this composition is enhanced by the juxtaposition of ink intensities—the contrasting areas of light and dark, from the deep resonance of tone in the foreground leaf to the playful grays of the frolicking flowers.

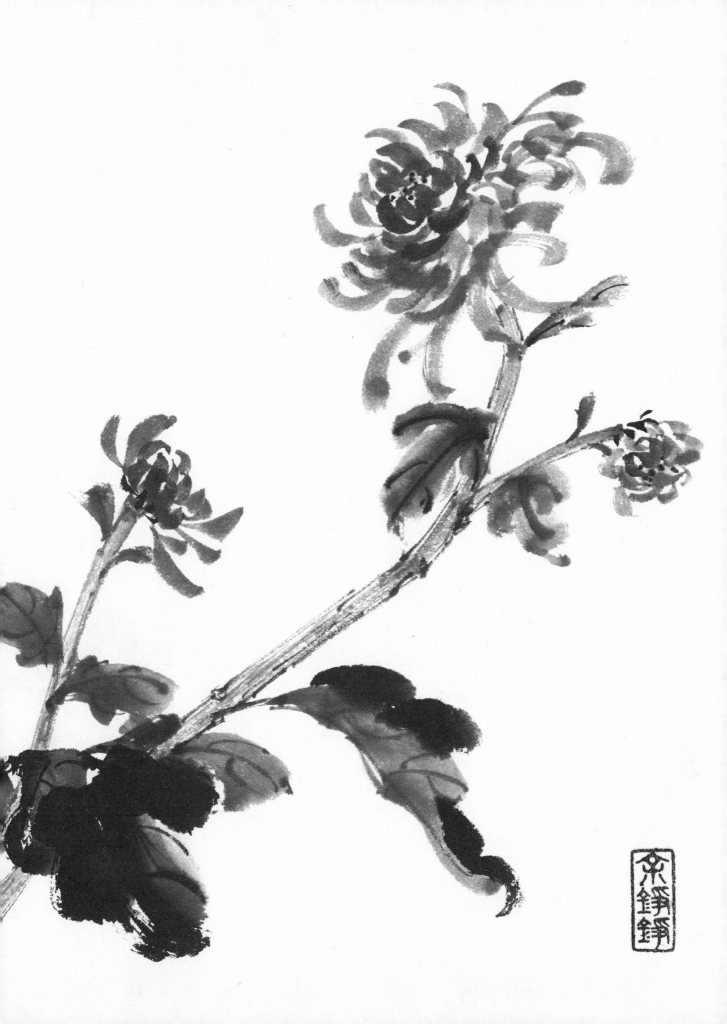

While other flowers have faded
Resolute chrysanthemums linger in splendor
At autumn's twilight casting a spell over
Butterflies dancing in the gentle breeze.
Leslie Tseng-Tseng Yu

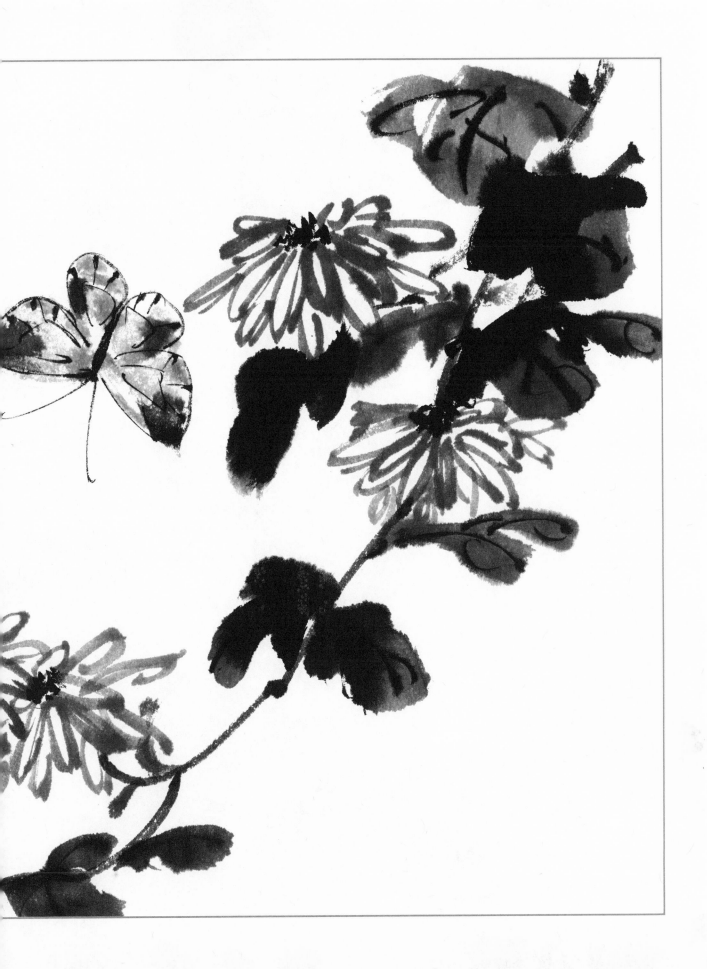

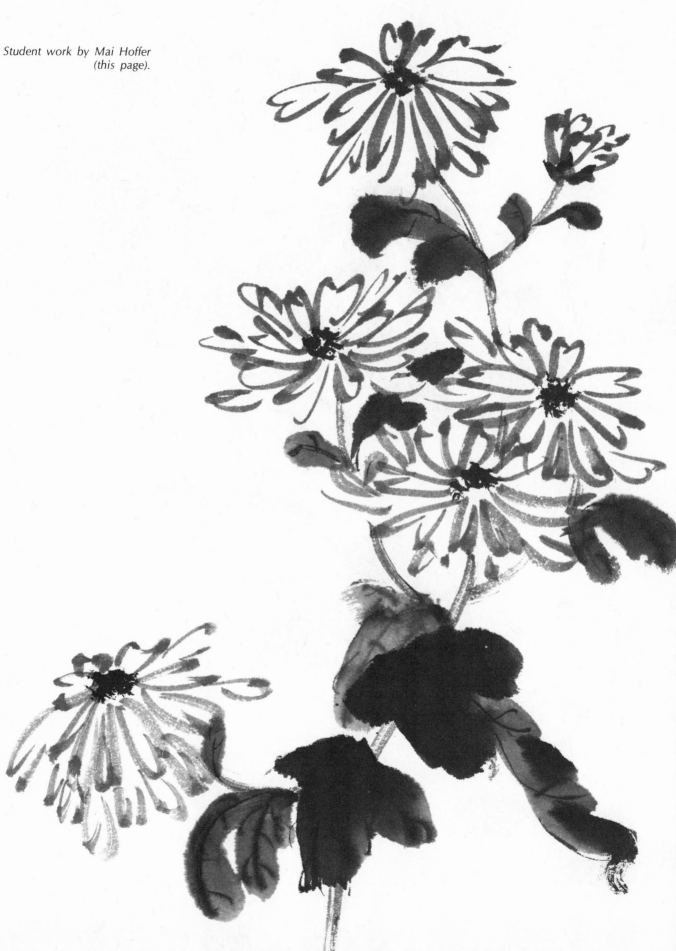

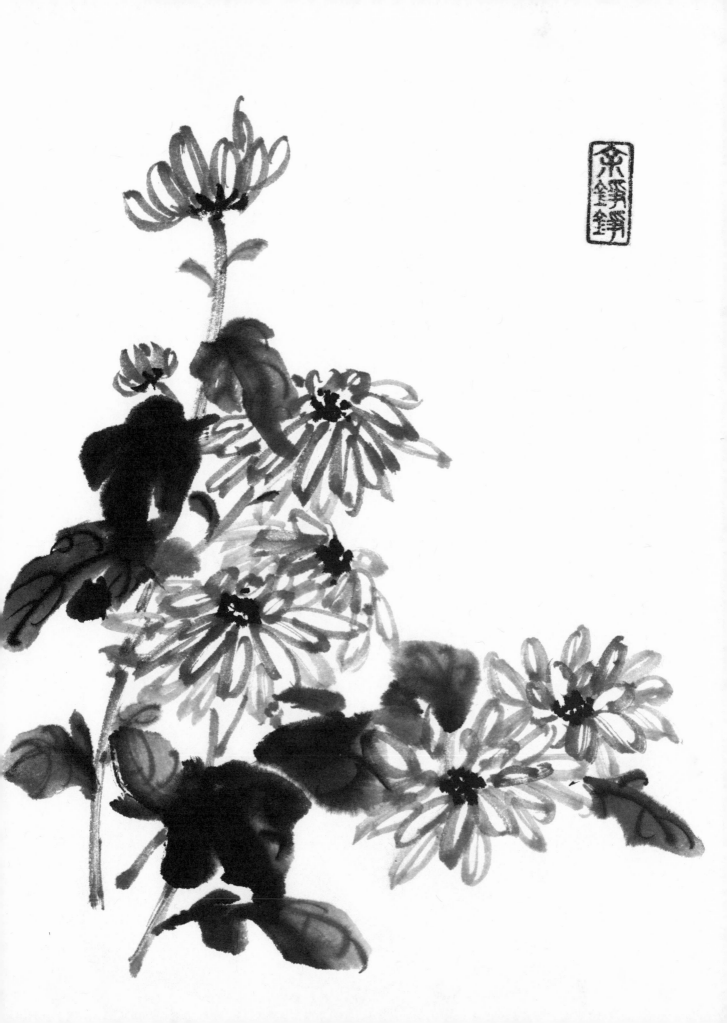

PLUM BLOSSOM WINTER

Flower of flowers for winter, the breathtaking delicacy of the plum blossom is a striking contrast to the starkness of this season. Having the distinction of being the national flower of China, the plum is a symbol of purity, strength, courage, and perseverance. The fragility of the flowers and the firmness of the branches are without equal. The beautiful blossoms emerge and burst into full bloom, unhindered by frost and snow. The plum blossom is admired for its fortitude and represents a person who has the ability to stand firm against adversity. Its resistance to the cold of winter epitomizes the independent and indomitable Chinese spirit. Each of the five petals represents a beneficence: longevity, happiness, health, prosperity, and the natural passing of life. As the emblem of winter, the plum blossom welcomes the beginning of each new year, sending forth its pure, fresh blossoms to renew nature's cycle and to foretell the return of spring.

The incomparable fragile strength of the plum blossom is a perfect vehicle for displaying the corresponding fragile strength of Chinese brushstrokes. In this one subject the full range of the brush's capabilities, its subtlety as well as power, is brought into play. The least amount of ink and the fewest brushstrokes are used to capture the essence of the plum.

BRANCHES

Vital brushwork produces a sense of organic growth.

- Paint the branch by using brush *A* in the vertical position. (Note: Brush *B* may be used, although in the beginning you will probably find brush *A* easier.) Load the brush with dark gray and remove any excess moisture. A dry brush will enable you to achieve a rough, textured effect.
- Your strokes should be strong and firm, with a movement and force similar to that used for painting bamboo branches. Mentally and physically poise your brush for action. With wrist off the paper and strong arm movements, establish and maintain a rhythmic tension throughout. Every line must be done with a single, quick, continuous movement and should have a firm beginning and ending. Generally, branches have a blunt rather than a pointed tip. Making a quick stop before lifting the brush off the paper serves the dual purpose of achieving a strong line (firm branch) and variation in tone (darker at the stops).
- Start thick and get progressively thinner by decreasing the pressure of your brush for each line. This requires mastery of brush control, so initially do not become overly concerned about this point and get bogged down by it.
- Unlike the bamboo branch, there's a slight curve to the lithe plum branch, but the line is more straight than curved. Therefore, think straight— literally and figuratively. Coordinate your mind, eye, and hand.
- Using powerful strokes sometimes causes the brush hairs accidentally to split. When this occurs (middle row, left) so much the better. Utilize it to advantage.
- Make the first branch thicker than the others and connect the offshoots to it in the order of the numbers indicated and in the direction of the arrows (the direction of each branch's natural growth).
- When showing one branch crossing in front of or behind another, leave a slight space, stopping and then starting again on the other side of the branch. Do this without breaking the continuity and flow of the line.
- You should occasionally leave space on the branches for the blossoms (middle right and bottom right).

Study the various aspects of the branches, their structure and their integration, their dependence upon and relationship to one another. Then, through the strength of the brushstrokes, bring them to life.

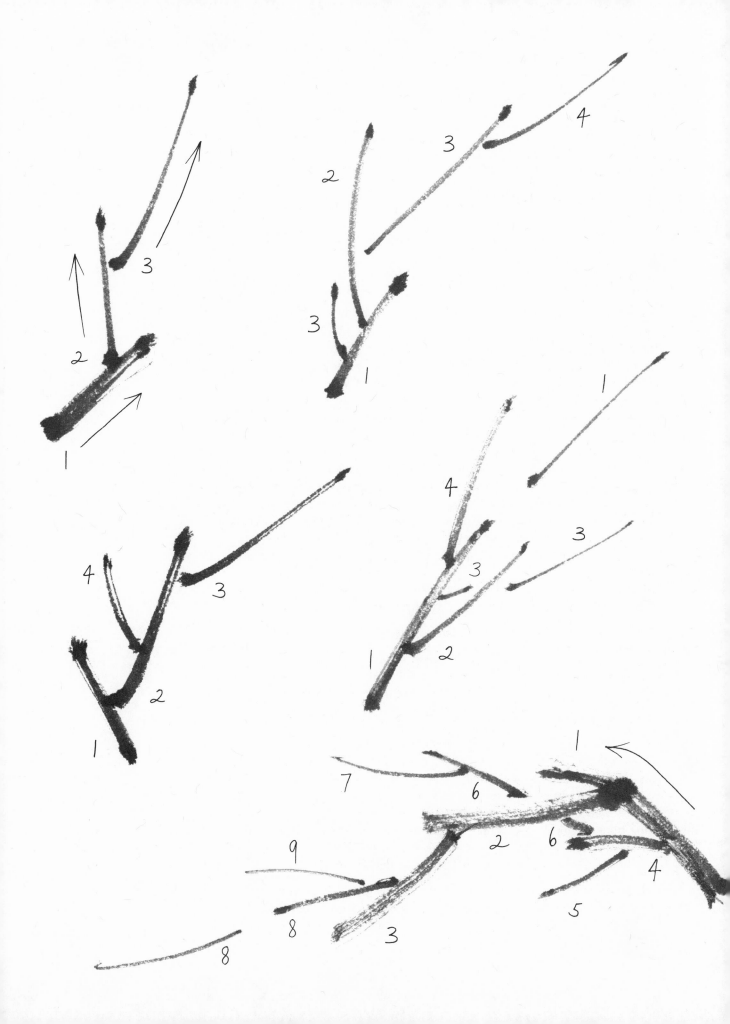

BRANCHES
WITH ACCENTS

Through the branches, nature's infinite variety is evidenced.

Plum branches may be straight or sinuous. In painting branches, vary the thickness, direction, contour, and length of the strokes in relationship to one another.

- When the branches are thicker, you can use the side of your brush (slant position), keeping it somewhat dry for a rough effect. Make sure, however, that your brush is in the vertical position when you are painting thinner branches. Your brush need not be quite as dry for these strokes. Practice the variation from thick to thin until you have a good command of your brush. Also, strive for a contrast of rough and smooth, noting that a dry brush yields a textured surface and a less dry one creates a smoother, softer quality.
- Branches naturally grow in all directions: pointing upward, hanging down, from the right or left. Practice varying the directions of the strokes so that you get the lines right and do justice to the innate strength of the branch.
- Although some of the branches have a slight curve (note the graceful curve of stroke number 4 in the middle right illustration), they can also be stiff and straight, depending on the circumstances. Visualize the kind of line you desire and have a clear mental image before setting your brush down on paper.
- Strive for natural-looking arrangements by crossing some branches in front of or behind others (middle right) and varying the length of the lines.

Since moss grows on plum branches, you may use dots as accents on the surface of the tree.

- Use black ink to contrast with the gray of the branch. With brush *A* in the slant position, "stroke" the dots on the paper in a continuous motion along the branch, inlaying the dots while the branch is still wet so they are integrated. Space the different groups unevenly and limit their number. If you overdo this accent, its impact will be lost. Dot either on one side of the branch or the other, not in the middle. Moss dots also may serve to strengthen a painting by covering an area that is weak.
- You can show leaf buds at the tips of some of the branches. Use brush *A* vertically and paint two different-sized short strokes, pressing and lifting from the top to the bottom toward the branch (top right). As an additional touch, you can add dots randomly on the sides of some of the branches. These may be considered emerging flower buds.

Plum branches range from the very simple to the complex. Once you understand the basic structure of the branches, you can create your own versions. The possibilities for variation, as in nature, are infinite.

126

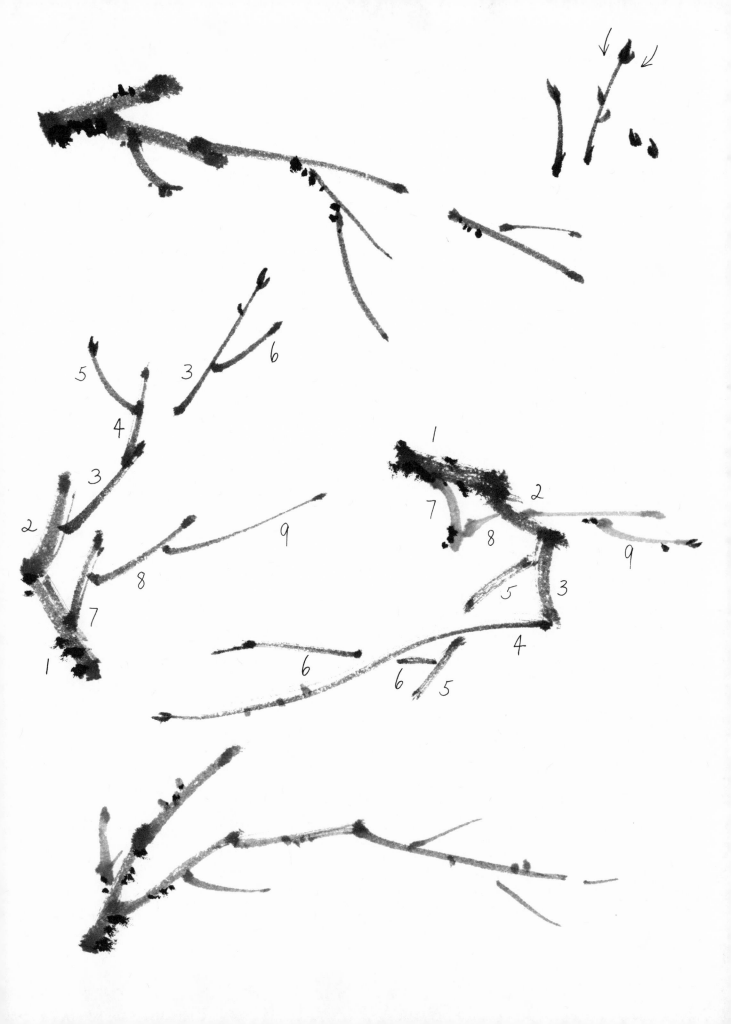

FLOWERS IN THE OUTLINE METHOD

A blossom is a breath of delicacy.

PETALS

- Hold brush A in the vertical position. Use a very small amount of ink on the tip of the brush, of a lighter shade than that used for branches. To achieve a fine line, after taking up the ink, press and roll your brush point against the edge of the plate. This procedure serves the dual purpose of eliminating excess ink and tapering the brush to a fine point. The lines should be delicate yet firm. There should be a smooth flow with your wrist off the paper for the graceful circular petals.
- Although there are varieties of plum that bear four- or six-petaled blossoms, the flowers generally have five petals. Start by painting the main petal or petals and add the others in relation to the main ones. The plum blossoms that are illustrated are more or less life-size and should be so painted.

128

SEPALS

- Use black ink for the sepals. The simple, short, quick, precise stroke is the same type as you used for the chrysanthemum sepals but smaller in proportion to the size of the flower. Remember to vary the thickness, length, and spacing of the strokes. The sepals usually consist of three or four strokes, except when the flower is in full view from the back; then five sepals are seen.

STAMENS

- Use black ink to dot the center of blossoms in full view. For the filaments use very fine, precisely drawn lines, not straight and not too curved. Stroke in either direction, toward the center or from the center outward, whichever feels more natural.
- The filaments should be somewhat unevenly spaced, with some clustered closer together than others. Vary their lengths so they do not appear exactly the same.
- Spread dots (anthers) casually and unevenly at the tips of the filaments or close to them.

129

FLOWERS

- Always hold the brush in the perpendicular position for the entire flower; at no time is it slanted. For the fine detailing of the sepals and stamens, you may rest your wrist on the paper.
- Familiarize yourself with the different flower positions so that you can use them freely in compositions: views from the front, back, and side; facing up or down; inclined; and even falling.

The flowers need not always be complete or perfect (some petals may have fallen or been blown away), but they should retain their subtle elegance and life. The placement of the sepals and stamens should reflect the different positions that the petals assume. Thus, all elements of the flower correspond and harmonize when the blossom is viewed in its various aspects.

Become equally familiar with the different stages of growth from bud to full blossom. Delicately render the mood and nuance of each flower: the tranquility of a bud, the sensual feeling of a partially opened flower, the fresh vitality of a flower in full bloom, and the grace of a fading blossom.

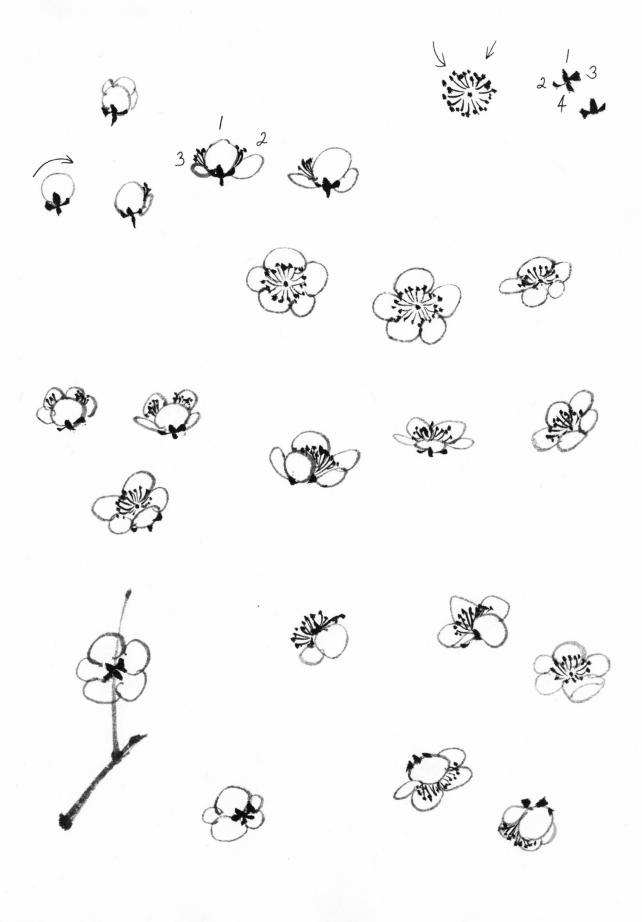

BRANCHES
WITH FLOWERS

Tradition provides the way.

These examples of branches with flowers follow closely the ones in the *Mustard Seed Garden Manual of Painting.* I find them to be excellent; therefore I transmit my rendition of the tradition to you.

- When placing the flowers on the branches, arrange and paint the branches first, leaving openings here and there for the blossoms. Judging the amount of space to leave may be difficult at first, but after a while, familiarity with the flowers will dictate how much space is needed.
- Arrange the flowers in varying positions and in different stages of growth. Buds usually appear at the tip or near the end of the branch. Only a few blossoms should be shown near the tips.
- Depict some longer branches growing and stretching out, bearing a display of blossoms (bottom). Paint some shorter branches with flowers clustered near the fork as if the branches are protecting them (top). Render some flowers grouped both near the intersecting branches and growing along the limb.
- Add the moss dots and/or leaf buds to the branches.

An analysis of the natural design elements inherent in the flower-laden plum branches reveals that contrasting lines and forms are interwoven throughout, achieving unity in variety.

The sepals act as a connection from the flower to the stem, and in turn, the branch. The blossoms are accented by the black ink dots and lines of the sepals and stamens, and the black ink touches are carried over and repeated in the moss dots and/or leaf buds on the branches. Thus, a play of darker ink sets up a connection (the rhythm of the black ink) and contrast (the different ink tones) at the same time.

Another contrast is the delicate tracery of the softly rounded petals set against the strength and thrust of the linear branches. Yet within the rounded flower are the fine lines of the filaments, so that there is the connecting factor of the circular and linear moving through the flowers and branches.

Variety (of form, position, distribution, ink tone, contour, and so forth) and unity (harmony and interrelationships) are of prime consideration in painting a branch with flowers—one that evokes the fragrance of the plum.

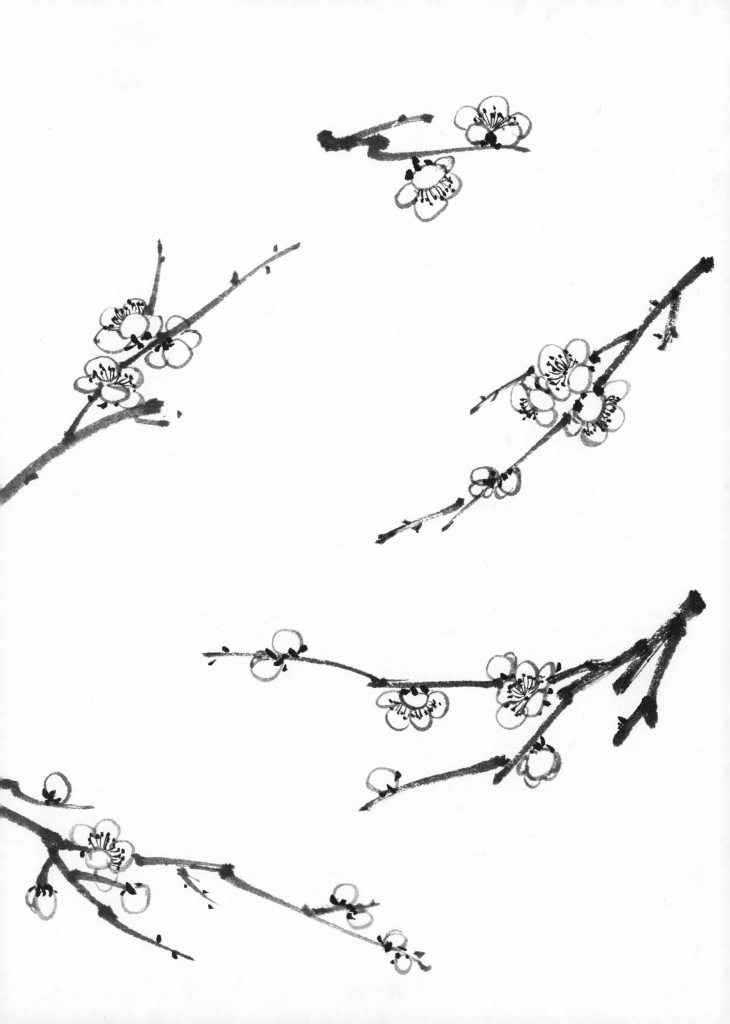

COMPOSITION

The fine flower unblown exhales no sweets.
The fair gem unpolished emits no radiance.
Were it not that once the cold penetrated its stem,
How could the plum blossom emit such fragrance?

This painting employs a compositional scheme often used in Chinese
painting: An element moves off the page and then back on. This extending
beyond the confines of the paper suggests space beyond the pictorial
space. The strategic placement of the branch stimulates the imagination and sets
the tone for movement and rhythmic structure in the composition.

- Begin with the placement of the main branch, the offshoots, then the
 accents.
- Next, add the flowers with finesse. Vary their forms and positions.
 Though the flowers can be scattered among the branches, the distribution
 should not be too even. Leave some branches without any flowers.
- Add the leaf buds last.

Plum blossoms can be sparse, for a subtle and elegant effect, or
abundant, to create an illusion of a profusion of flowers in full bloom. Both are
equally striking, depending upon your preference or expressive mood. The
dual qualities of *yin/yang* are intrinsic in each process and every element. The
two opposing tendencies are in constant operation. Thus we see how a
brushstroke is controlled yet spontaneous; a branch is strong yet supple; a flower
is fragile yet firm; a composition is calculated yet free; a painting is
unique yet familiar. In every instance there is the interplay and resolution of
complementary opposites, striking a finely tuned balance.

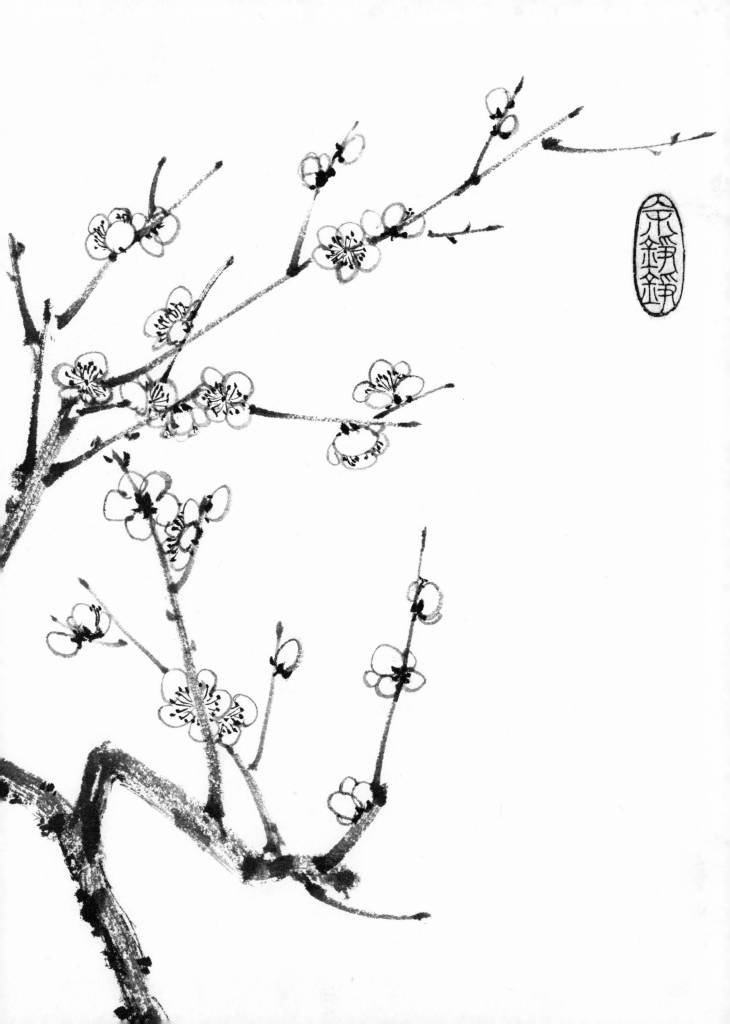

TRUNKS

*Issuing through the trunk is the movement
that governs the growth of the tree.*

Trunks are characterized by gnarled, twisted, and sometimes whimsical
shapes, with knots and rifts on the surface. They have angular forms and a
certain dignity.

- Indicate the basic shape of the trunk with strong, quick, jagged, and
 sinuous strokes. Use brush *B* in the slant position. Load it with gray and dip
 the tip in a little black, keeping the brush on the dry side. The
 natural texture of the tree is related to the dry brush, with the trunk of a
 lighter shade than the branches. Work from the base upward (or
 reverse the direction of the first three strokes if you prefer working from the
 top down). Always keep the darker tone on the bottom of the trunk;
 position the brush accordingly, keeping in mind that the tip of the brush is
 black. As you change the direction of the trunk, each section
 becomes progressively thinner. For the fourth stroke, change your brush to the
 vertical position. The fifth stroke is an outgrowth of the first one.
- For thinner branches, brush *A* may be used, but you can render the
 entire trunk with brush *B*.
- Paint the thick portions of the trunk with the brush on the side (slant
 position). For the thinner ones, the brush is vertical. At no time should the
 brush be in between these two basic positions.
- With brush *A* or *B*, add accentuating lines of black to the still
 semiwet trunk for natural blending. These strokes should be dry, rough, and
 irregular, to emphasize the textural quality of the bark. Try both
 vertical and slant brush positions. In the vertical position, you can split the
 brush for multiple lines in a single stroke: After loading your brush,
 fan the bristles out by pressing on the edge of your ink stone or plate. The
 bottom of the trunk should be more weighted than the top, and one
 side more accentuated than the other.

Do not overwork with too many details and ruin the good primary
strokes. On the other hand, you can utilize the accents to improve the
appearance of your less than perfect strokes. With these additions, you have the
opportunity to better define the trunk, if necessary.

- Disperse moss dots on the trunk for a finishing touch.

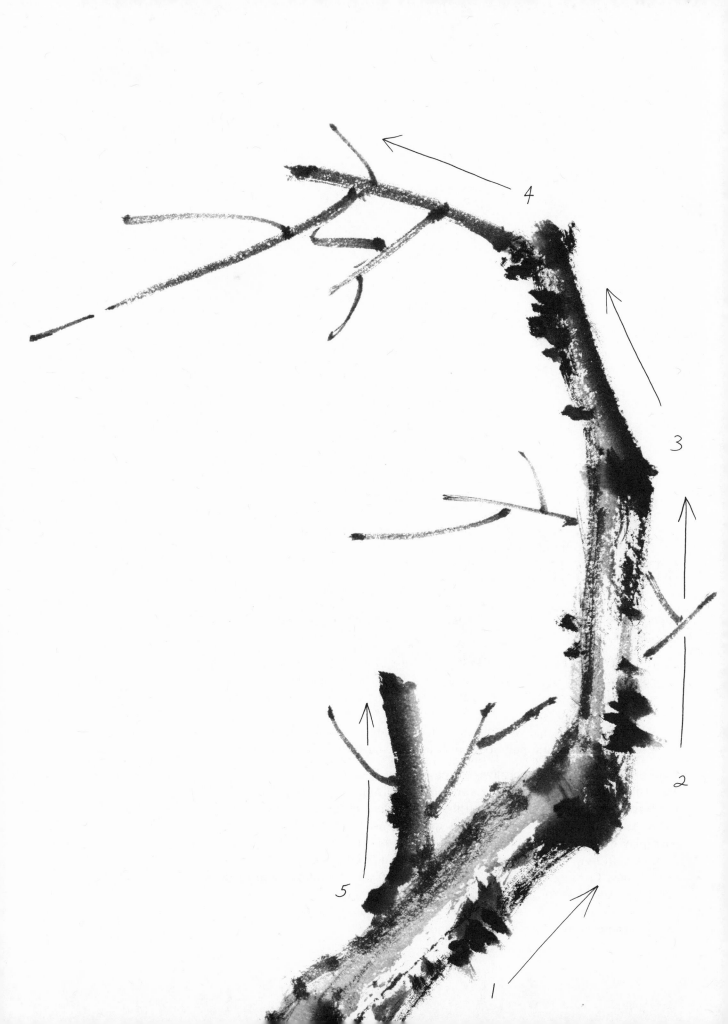

HANGING
BRANCHES

Though perspective changes, the rhythm pulsates and remains upbeat.

- Plum trees can twist and turn in fanciful ways. This part of a hanging
 trunk is painted with brush *B*, loaded with two tones of ink. It is done in a
 single stroke with quick stops at the turns. The only accents are the
 moss dots, added sparingly.
- Start from the top and work downward. Since all the strokes are
 essentially downward, pull your brush toward you with a steady force.

Here the "flying white," evocative and descriptive, is utilized to full
advantage. With the brush quickly sweeping, or "flying," over the paper, the
brush hairs do not consistently touch the surface; thus texture is revealed
by the paper. The resulting spontaneous quality in which brush, ink, and paper
each play their part brings out the inner spirit of the trunk.

Discern how the branches cross in the front as well as in the back
of the trunk. Crossing and overlapping always make a composition more rhythmic
and more natural looking.

You can see that the simpler result is actually more difficult to
attain because every stroke has to be almost perfect.

138

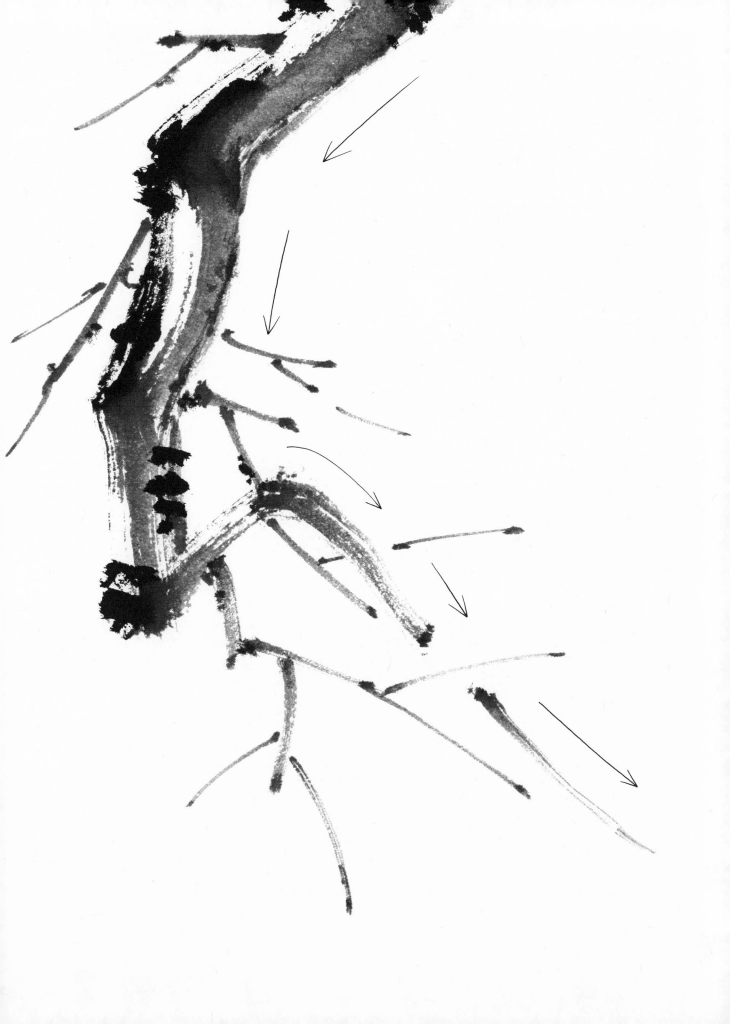

BLOSSOMS IN THE BONELESS METHOD

Fluent strokes impart a lyrical mood.

Use the boneless, rather than the outline, method for shaping and shading these flowers. The blossoms should be rendered with tender care.

As brush C ideally lent itself to shaping the chrysanthemum leaves, the softness of the hairs of brush D are quite suitable for achieving the contour and shape of these flowers. This brush is smaller than brush C and therefore appropriate for the size of the plum blossoms.

- Prepare a small amount of ink in two dishes: one with dark gray and the other with light gray. Load brush D by using the two-tone method, but with only a small quantity of ink. Experience will tell you the right amount.
- To achieve a full view of the petals, use the tip of the brush at a forty-five degree angle from the paper (slant position). Move your brush according to the direction of the arrow (down, up, then around) to paint a soft, round shape. Smooth out the edge with the tip of the brush, if necessary. Do five of these circular strokes, pulling them close together to form the full flower.
- Hold the brush in the vertical position to paint petals viewed from the side. Working toward the base of the flower, press the brush down at the beginning and lift up at the end to render the correct shape.
- For the side views, combine both full strokes and side strokes, bringing them together for the final shape of the flower.
- Vary the "color" of the petals so that they have degrees of shading. Strive for shading in each flower.
- Add the sepals when the flowers are partially dry so that they intermingle smoothly together. Paint the stamens only after the flower is completely dry, so the fine lines of the filaments and dotting of the anthers are not obliterated by spreading of the ink.
- Practice painting the flowers in various positions and stages of growth.
- Add the flowers to the branches in basically the same way as for the flowers in outline form.

The plum blossom embodies the lyrical movements of a poem: its simplicity, tranquility, purity, richness, and fragrance. In composing the flower, as the poem, there is a fluid quality—a fresh spontaneous expression of feeling.

140

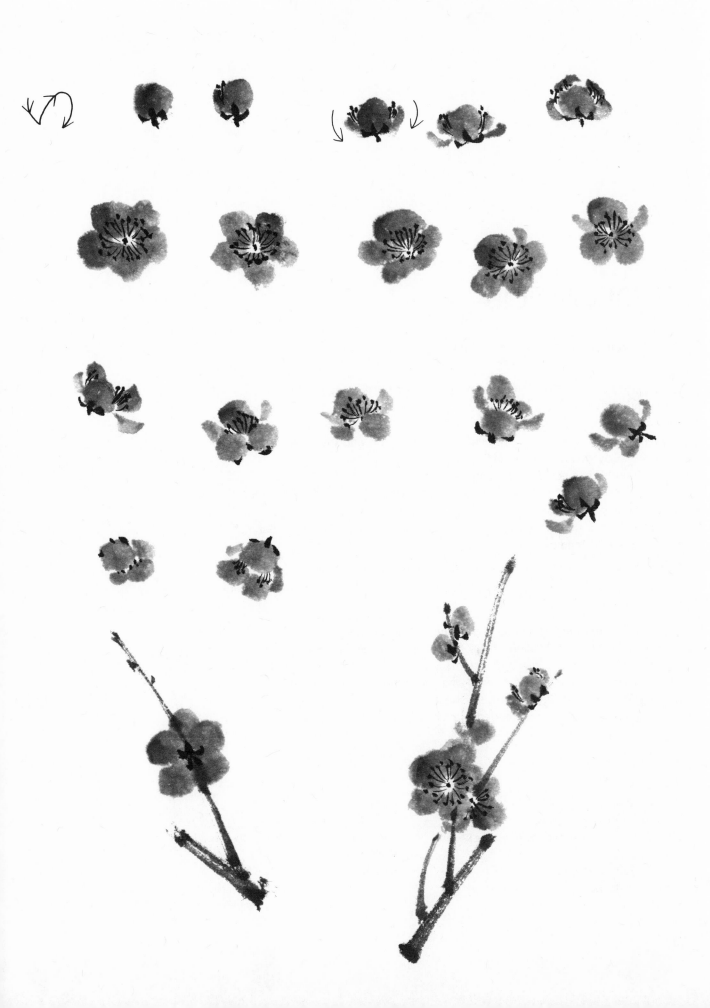

COMPOSITION

The lithe plum belies the passing of time.

This composition can be viewed from any side. Turn the page around:
The painting "works" in every direction. Witness the downward growth and
thrust of the trunk and the movement and upsweep of the branches to
counterbalance it. There is movement in one direction and then another, and a
surge of steady rhythm throughout.

A background bough of a lighter tone is introduced, not only for
contrast, but also to show depth and distance. Without cluttering the composition,
it suggests what is beyond.

Flowers are shown from behind the trunk, partial views peeking out
for a naturalistic rendition.

- First paint the trunks and branches with power and dash; then add
 the flowers and leaf buds. The procedure is the same as for the other plum
 compositions.

When composing plum paintings, be aware of the innumerable
possibilities for the exploration of the theme. They range from the economy of a
composition with only a few elements to trees laden with blossoms that
form a network of lacy patterns. And what powerful tensions may be created: the
old rugged trunk and the young bold shoots of new life, the purity of the
blossoms emerging from the gnarled branches of an aged tree.

THE PLUM TREE

Over a corner of the wall
The old plum tree stretches out its arms.
Though the world is still held in frosty thrall,
It has wakened
From its wintry sleep
And put forth pure white blossoms.

At first glance,
From a distance,
They looked like heaped-up, powdered snow,
Until the spring wind
Brought me
The message of their fragrance.

Wang Anshi (Wang An Shih)
Song Dynasty

142

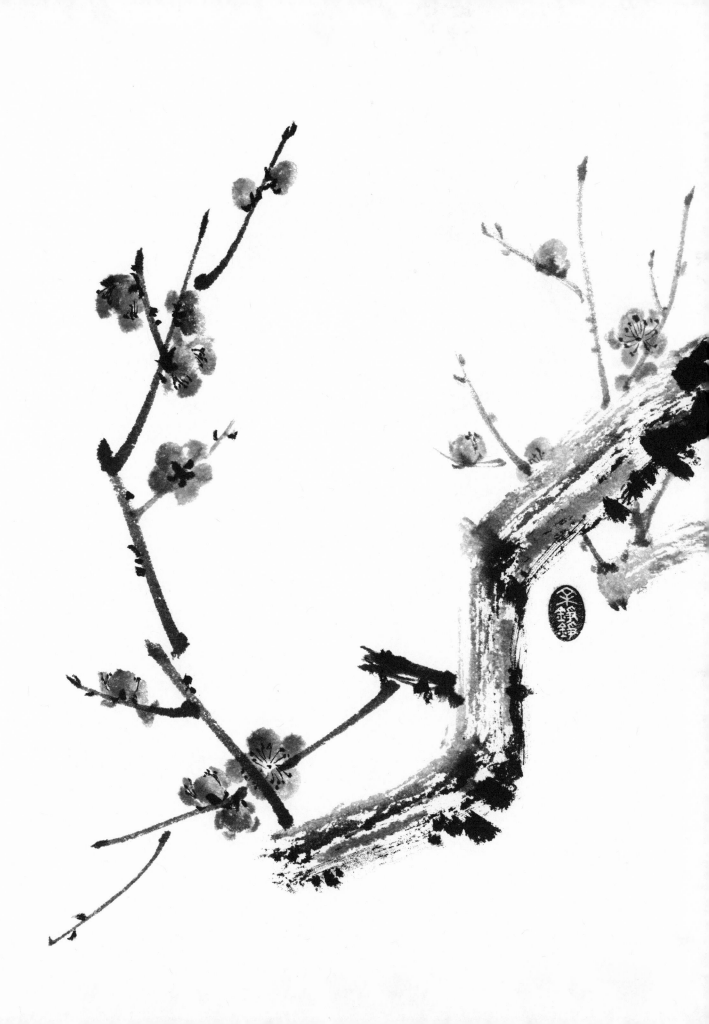

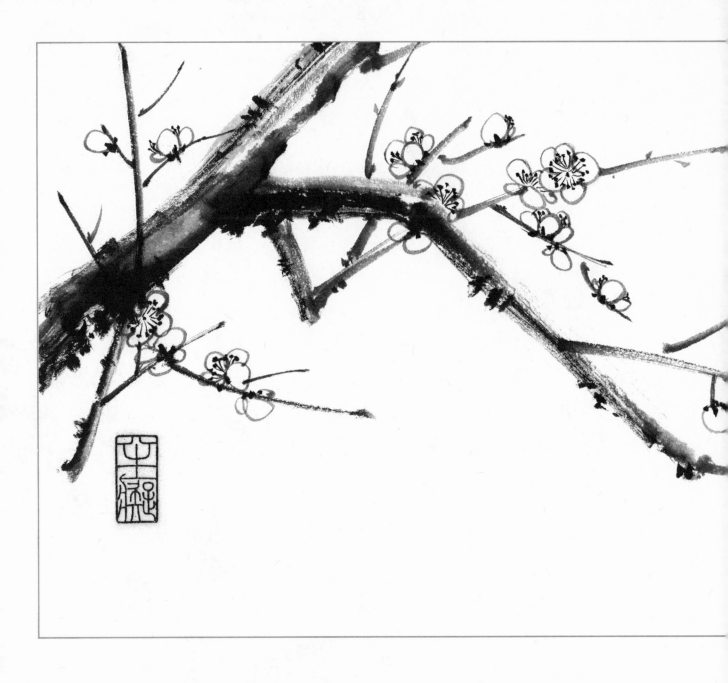

Delicate plum blossoms
Create winter's fine etching
Echoing the soul's silence I marvel
At the strength of nature's fragility.
Leslie Tseng-Tseng Yu

MEMORIES OF CHILDHOOD

The moon
Casts the shadow of the plum
Upon my bed.

I remember well
That day so long ago
When with these hands
I planted that old plum.

Last night was chill and sharp,
And the cover of my bed
Was scant and thin,
But the fragrance of the plum
Stole through my dreams,
And I forgot old age
And frost and cold.

Awaking, I looked out,
And there the bright moon shone
On the newly opened blossoms
Of the plum.

Wu Zongai (Wu Tsung Ai)
Qing Dynasty

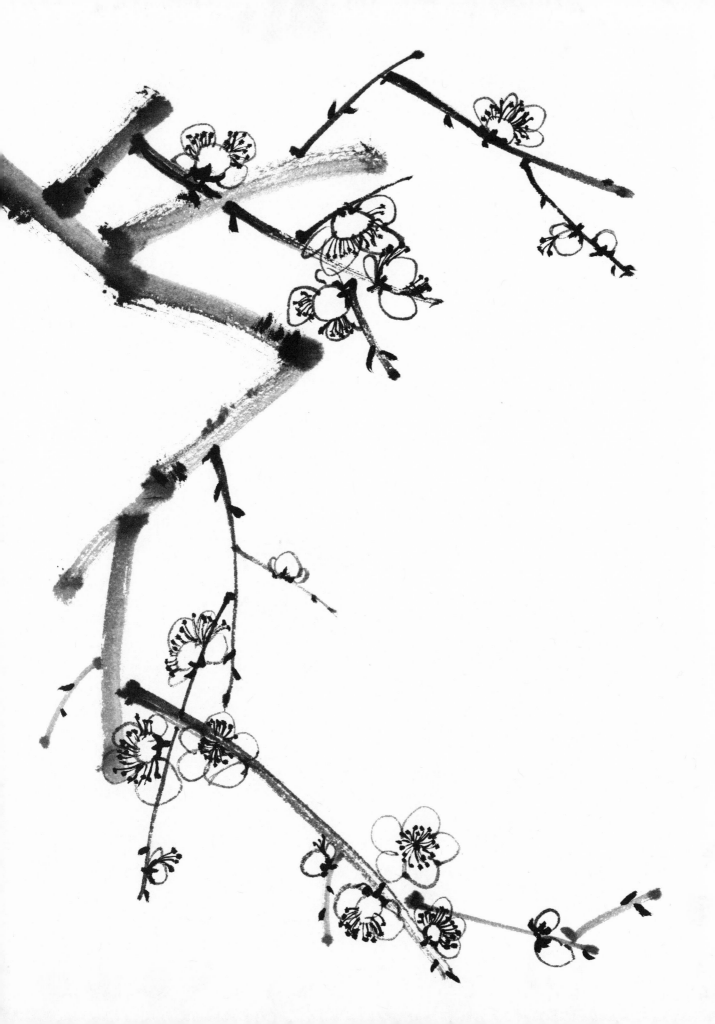

Spirit of spring, the delicately fragrant orchid embodies the freshness of the eternal spring of life. With the unfolding of each new leaf and flower, the orchid, in its unassuming way, announces the arrival of spring. Its exquisite, celestial-like qualities impart a subliminal message. The orchid symbolizes love, quiet beauty, elegance, and refinement. This rare, lively plant is associated with the perfect human being, one who is humble, modest, virtuous, and possesses a purity and nobility of character.

The highly esteemed orchids indigenous to China are small plants of dainty, graceful mien. Their slender leaves gently flutter in the air, evoking poetic charm with their lyrical movements. Fittingly, they dwell in tranquil environments, growing in remote mountain recesses, near wet rocks and streams, or in marshes. From these places, the flower's subtle scent issues forth, luring one to inhale the fresh breath of spring.

The simplicity and elegance of the orchid are best brought out in monochrome painting, in the same spirit as the cursive grass script with its elegant calligraphic strokes. The elusive charm of the ink is optimally displayed by the orchid. "The secret of painting the orchid rests basically in the circulation of the spirit."[14]

LEAVES

The flight of the brush is captured by the indelible ink.

- Fully load brush *B* with jet black ink and use it in the vertical position.
- Execute each leaf with a light, sweeping stroke made entirely through arm movement; the wrist and fingers remain stationary.
- As you paint each leaf, vary the pressure of your stroke. Begin with light pressure of your brush; increase the pressure as you reach the middle of the leaf; then gradually decrease pressure again as you reach the end. Do not stop abruptly, but rather finish the movement in the air with your arm to complete the sweep. Each leaf should be painted without hesitation as it goes from thin to thick to thin once more.
- The long leaves can be done in one or two strokes: a single sweep where the eye can follow the brush's flight, two strokes where the blade turns and twists. After the first stroke, simply lift the brush up and resume at once by adding another stroke without interrupting the momentum of the leaf.
- Practice painting the leaves in each direction—to the right and the counterstrokes to the left—curving and bending them. Try increasing and decreasing the length of the leaves to get the feel of the sweep. A break in the ink is permissible and even desirable, as long as there is continuity in the stroke. Follow the curve and flow of each leaf.

Through brush and ink, the slender orchid leaves rise and twist to reflect nature's smooth flow of spirit.

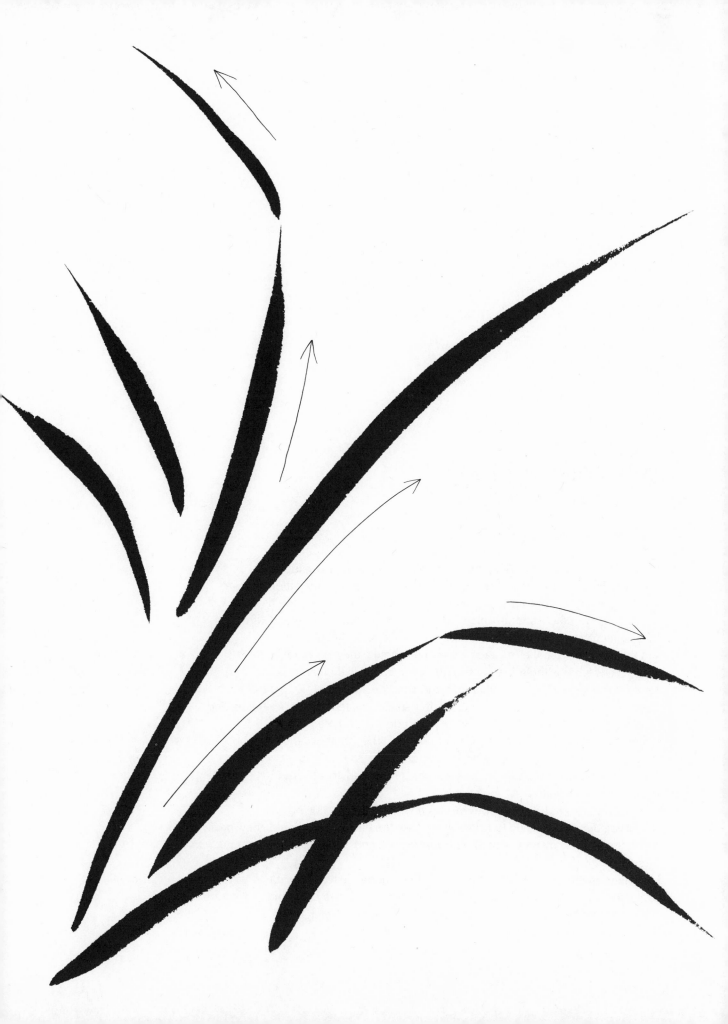

GROUPING LEAVES

Leaf groups are formed by brushstrokes few and swift.

- Begin with three basic strokes for long, pliant leaves that rise upward
 from the base of the plant. The leaves should start at slightly different levels
 at the base but should be clustered close together. One leaf should
 cross over the other, and all·three should move in slightly different directions
 to balance one another. They should not be the same lengths and
 should not grow parallel to each other, nor should they be parallel to the
 paper's edges. The three blades should never cross at the same point.
- These three sweeping lines determine the structure of your
 composition and dominate it. Perceive the space created by these strokes and
 how they relate to one another. Space, in order to be meaningful
 rather than just blank, must be clearly defined. The "shape" and division of
 space must be creatively envisioned.
- Add several shorter strokes to complete the group and to tie the
 orderly design together.
- Although the orchid leaves grow in clusters, they should not be
 confused, bunched up, or too densely massed together. Nor should they be
 too sparsely placed. Each leaf should be distinct and have its own
 direction.
- Vary the length and width of the leaves. The shorter leaves may be
 straighter; the taller ones may arch, flutter, bend, and sway. Orchid leaves are
 conveyed with smooth, undulating strokes, their tapered elegance
 swaying in the calm breeze of spring.

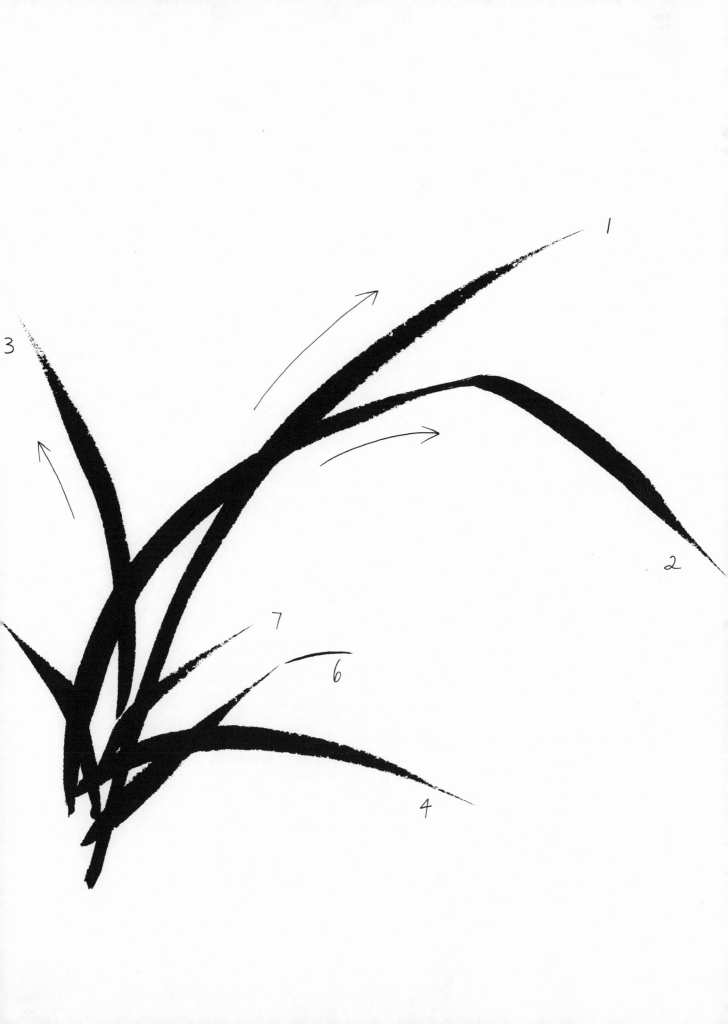

FLOWERS

The orchid is a flower with a joyful air.

- Load either brush *A* or *B* with gray and work a small amount of a darker gray into the tip for shading.
- Hold the brush vertically and move in downward strokes, swift and light. Make one stroke for each petal. You may want to practice the petal strokes at random before attempting the flowers. The petal strokes move from the tip to the base, toward the center, or heart, of the flower.
- The top row shows, step by step, how to paint a flower. The orchid consists of five petals. Consider the narrow crossing strokes (2 and 3) as one petal.
- Before the flower completely dries, with brush *A* indicate the center by dotting it with bold, black ink. The blending of ink will create a fresh, moist effect. The dots are painted with a certain rhythmic flick of the brush (lower right). They are actually calligraphic strokes and closely resemble the three dots in the Chinese character 心 *xin* (heart). One heart joins the petals and gives the spritely flowers their life. The joyful quality of the orchid flows from its heart.
- Practice the flowers in their different positions. Note that the bottom left and middle flowers are hanging down. Follow the directions of the arrows for your strokes.
- You can paint all the flowers before adding the stems with brush *A* since the stems require a much drier brush. They have firm lines with a slight curve.

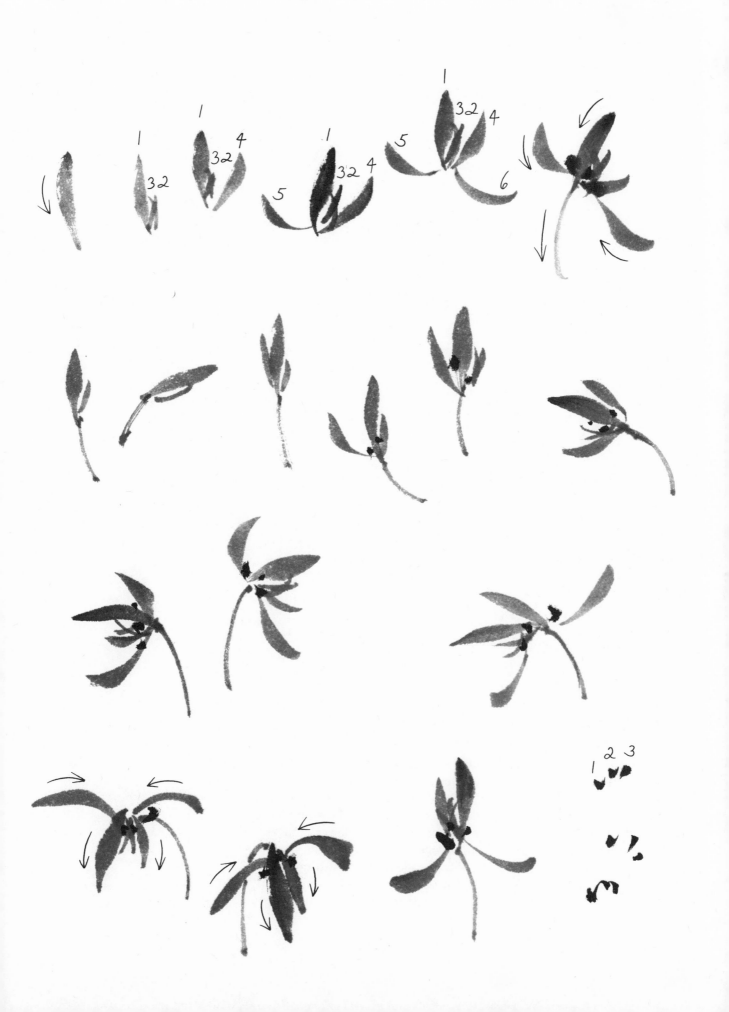

FLOWERS
AND STEMS

Exquisite flowers float atop slender stems.

The spring, or grass, orchid has one flower per stem, whereas the
summer, or marsh, orchid bears two or more blossoms per stem. The flowers of
the grass orchid are supported by a short stem, and the marsh orchid, or
multiflowered variety, has a longer stem.

- Paint the flowers first and then add the stems. Visualize how the stem
 is growing and stroke in that direction. Connect the flowers to the main stem
 with smaller stems that begin below the heart of the flower. Generally
 speaking, flowers should appear on alternate sides of the stem, and buds
 usually appear at the top. When a stem intersects a flower, stop
 before the petal and continue on the other side (bottom left).
- At the base of the plant, paint a sheath of leaves with two downward
 strokes. The sheath wraps around the stem, closely enveloping it.
- Should you do the stem in two strokes instead of one, small sheaths
 can be added to the junction where your brush stops.

156

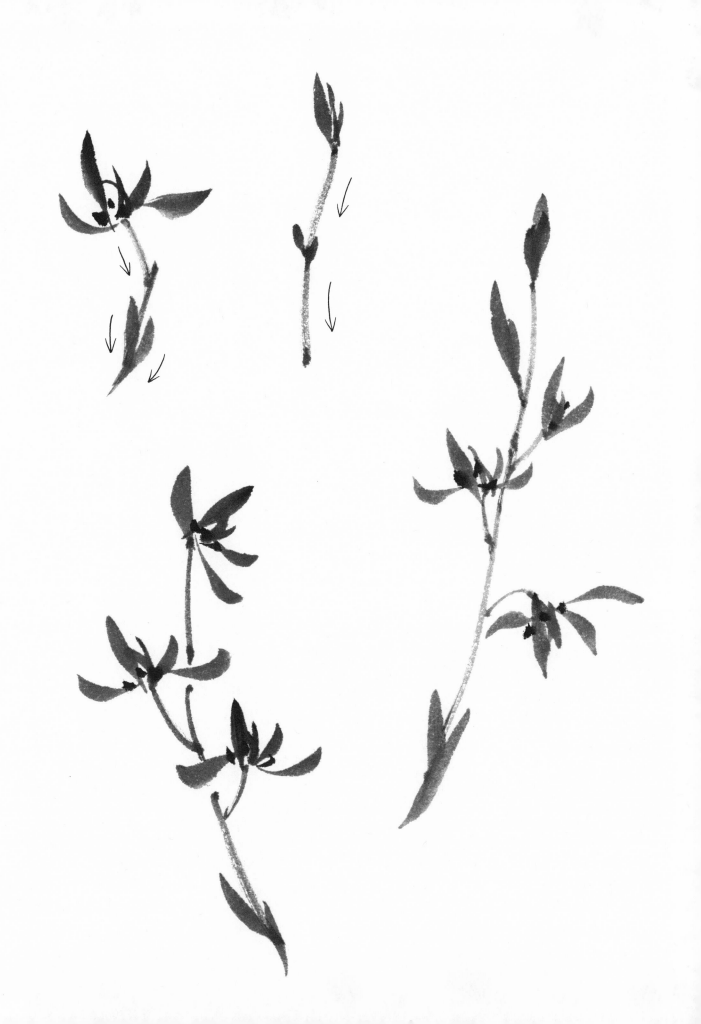

COMPOSITION
WITH SINGLE FLOWERS

Of the Chinese orchid, it is said that "the petals sing and the leaves dance."

This composition follows very closely the example of the leaf grouping
on page 153. But as you can see, no two paintings can be exactly alike.

- Paint the leaves first and then add the flowers in relationship to them.
 Even though they are behind the leaves, you should depict them in their
 entirety by painting over the leaf. The flower will seem to be behind
 the leaf because its inking is lighter.
- Add tonal dabs with your brush to give a suggestion of the ground—a
 moist effect alluding to luxuriant orchids after a spring rain or perhaps to
 orchids wet with dew in the early morning mist.

As a choreographer creates dance compositions, so may you create
compositions that recall the various moods and movements of a dance. Vibrant
leaves exude energy and verve: arching, rising, falling, bending, twisting,
and overlapping in their cadence—creating a rhythmic arabesque of lines across
nature's stage. The choreography of this successive group of rhythmical
steps is executed to the musical modulations of the flower. Melodious sounds
vibrate from the heart of each flower, fresh and alive, enchanting us with
the song of spring.

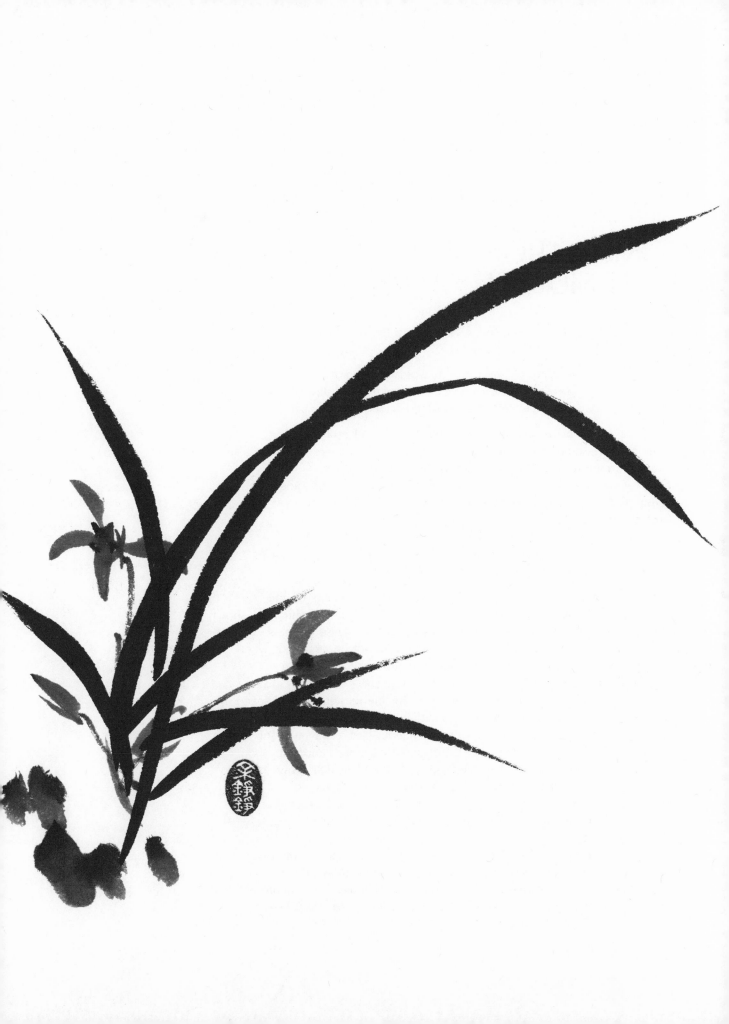

COMPOSITION
WITH MULTIFLOWERS

The orchid embodies lines with living beauty and forms with vital spirit.

This composition emanates off the paper, a typical compositional mode in Chinese painting, where the pictorial space is not limited by the confines of the four borders. Space becomes temporal and fluid rather than fixed.

- The leaves can be either all black or black and shades of gray. In this painting some of the secondary leaves are in gray tones. You can also vary the moisture content of your brush for different effects.
- After you have mastered the regular leaf strokes, you can try others, such as the main stroke illustrated here. Leaves can bend and twist in interesting ways, with varying widths.
- The flowers and leaves should be in perfect harmony, with their linear aspects complementing each other to form an integrated design. The flowers should mingle naturally among the blades.

In orchid compositions, you can start the plant at various points on the paper, thus presenting a number of design possibilities, some of which are shown by the paintings that follow. Compositions can be either dense or sparse. When dense, the subject should retain its clarity and not be confused; when sparse, the orchid can be a terse statement of a few swift strokes strategically placed for dramatic impact.

The orchid offers an excellent opportunity for the masterly use of space. In planning a composition, each element, including space, must be carefully thought out with aesthetic insight and discrimination. It is a matter of subtraction rather than addition in choosing what to include and, more important, what not to include. It is the provocative space, after all, which shows off the supple, sensual lines of the orchid leaves. Asymmetry and dynamic tension are inherent in the Chinese way of spacing. The composition can be dramatically off-center yet be counterbalanced by a single stroke placed right on the mark.

There can be two or more orchid clusters in a painting, in which case their relationship to each other needs to be worked out thoughtfully. The intertwined flowers and leaves should always be intelligible. An example is the complex work on page 165, painted in the manner of Zheng Xie (Cheng Hsieh, 1693–1765), poet, calligrapher, and painter of orchids and bamboo.

160

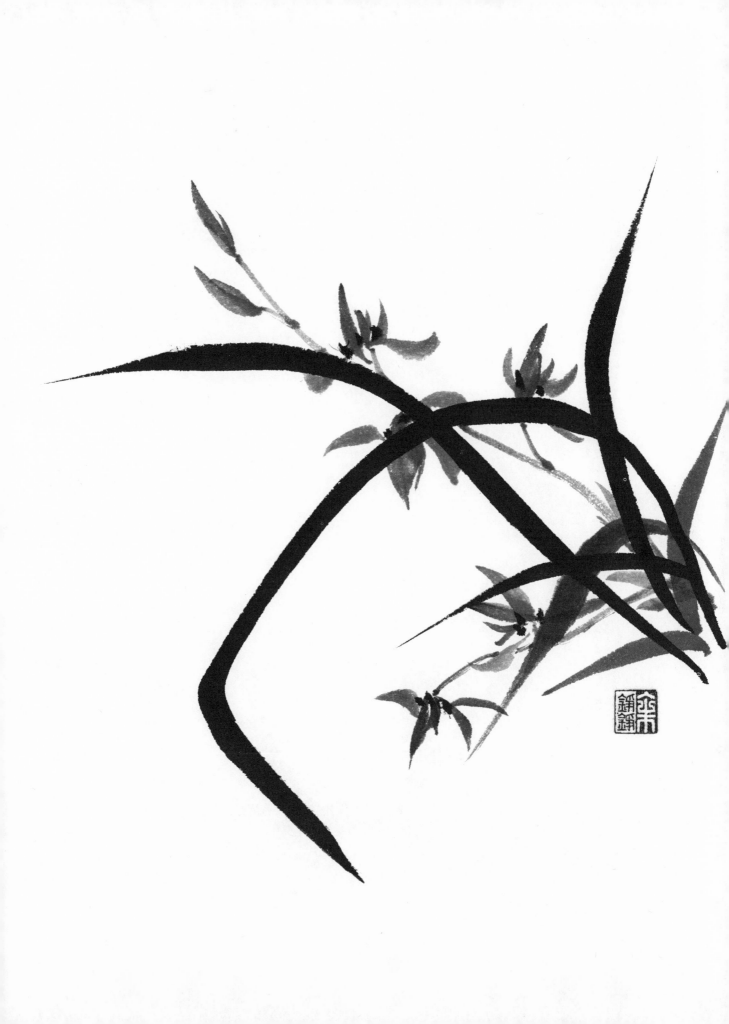

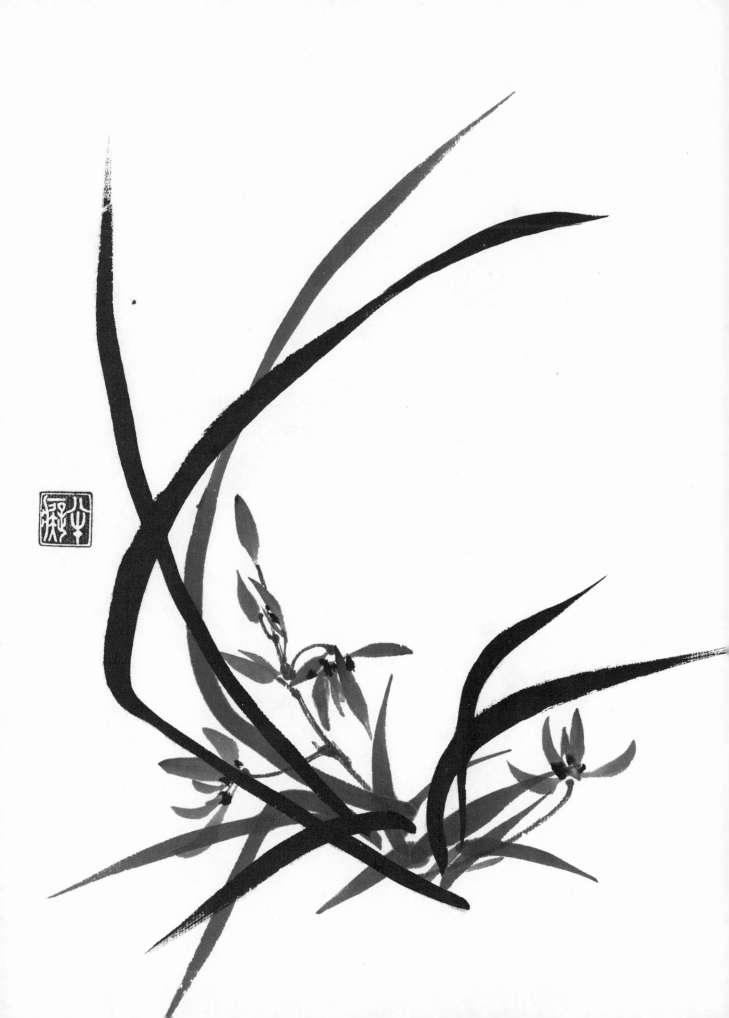

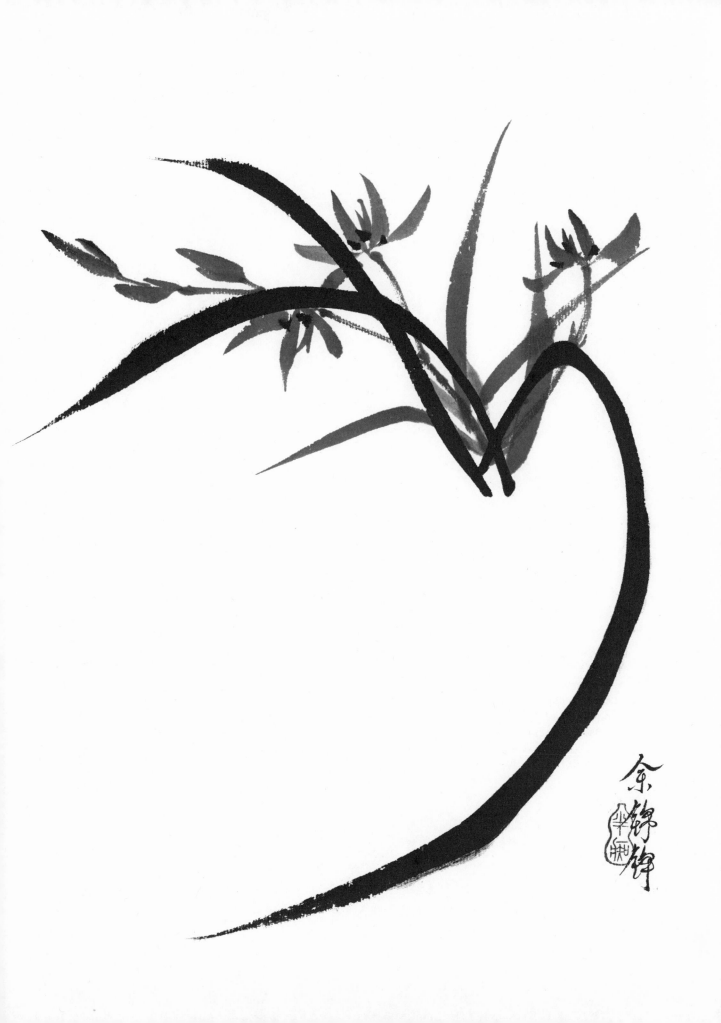

Ethereal spring orchids
Fairylike floating waves
Faint wafts of perfumed air
Intoxicating fragrance.
Leslie Tseng-Tseng Yu

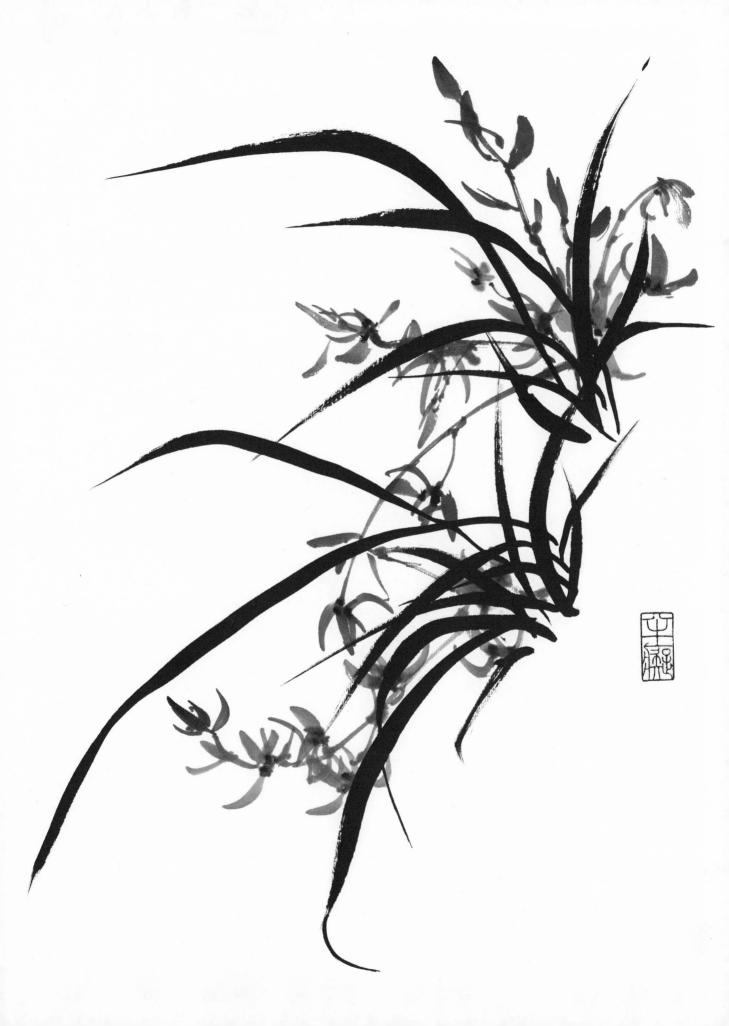

THE CALL OF SPRING

*The blossoms are open
On the cassia tree
And the orchid has unfolded
Its first green leaves.*

*In vain the happy wind of Spring
Will laugh,
If you do not keep your promise
To return.*

Bao Linhui (Pao Lin Hui)
Liu Song Dynasty

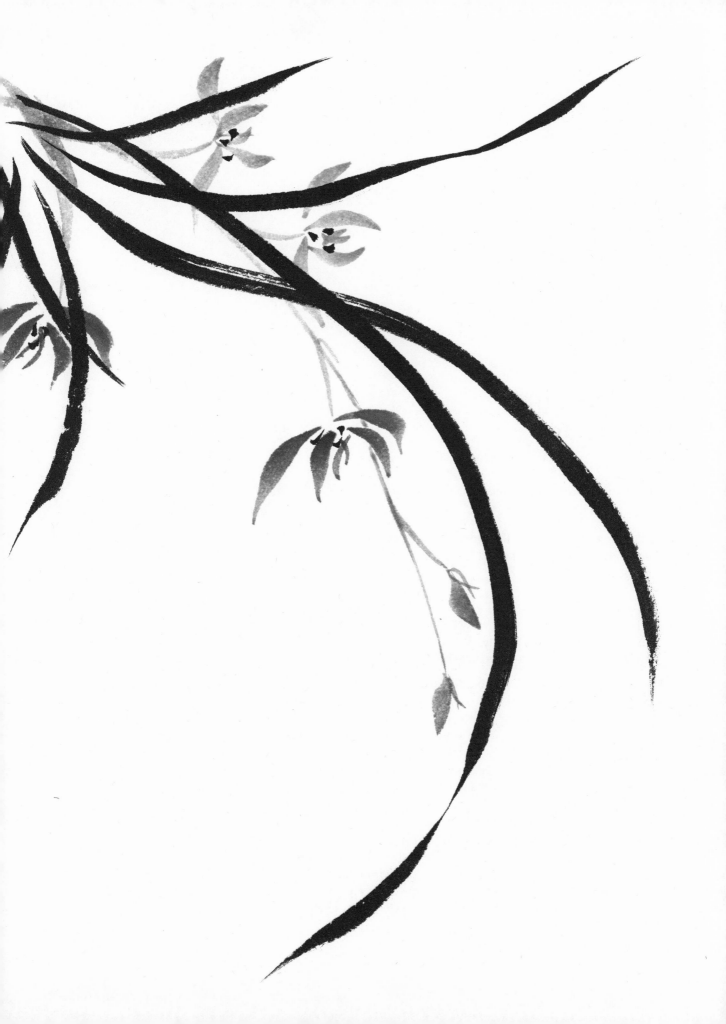

BUTTERFLIES
AND BEES

Small creatures reveal nature's intimacy and grandeur.

At the dawning of spring, the insect world awakens from winter's sleep.
With the emergence of each perfect being, the wonder of nature's ingenuity and
proliferation unfolds.

BUTTERFLIES

The butterfly is a symbol of felicity, joy, and harmonious understanding.
Its irresistible charm is a natural complement to the flower.

- For the basic wing stroke, use brush *D* in two light tones of ink. With
 your brush in the slant position, press down and pivot from the base to
 obtain the roughly triangular shape.
- Do the second stroke in the same way except use only half of the
 brush.
- The third stroke is similar to the boneless stroke for plum petals. With
 your brush in the slant position, move down, up, and then around to form a
 "squarish circle." Paint all three strokes in quick succession, without
 reloading your brush. Be accurate in form and proportion.
- Before the wings are completely dry, draw in the black hair-thin lines
 and patterns with brush *A*. In order to have these flowing lines as fine as
 possible, steady your hand in the air as if poised for flight. Then with
 the lightest touch glide smoothly and confidently across the paper with your
 brush, as if performing a skater's waltz. As skaters gain precision
 through practice, so will you.

168

It is not necessary to follow the contour of the wing strokes exactly. Not only do the resulting white spaces expand the range of tonality, they also convey the natural markings of the butterfly. Avoid symmetrical wings that are stiff and mechanical. Even though butterfly wings in reality are symmetrical, they are seldom viewed from a head-on position. Therefore off-centered wings appear more natural and are more artistic.

- Fill in the body with black ink. This and all the previous details should be added while the wings are still moist, causing the ink to blur slightly for a soft and fuzzy effect befitting the butterfly. You need to work fast.
- Indicate the antennae with very thin, precise, and gracefully curved lines. Try to attain the subtle variation in thickness within each line. This is accomplished by applying slightly more pressure at the beginning and/or at the end—a very delicate balance.
- Add the legs after the butterfly has dried. The lines for the legs should be as fine as thin wire and just as strong. Three pairs of legs can be shown, if appropriate to the particular view. Or they can be omitted altogether.
- Adjust your strokes accordingly for butterflies in different positions. Always paint the forewings toward the center, with the darker shade (brush tip) on top.
- For the butterfly in the second row right, indicate the wings and then immediately add black ink over the outer edges with the tip of brush D (same brush).
- Sensitively render the two butterflies at the bottom of the page with darker tones and without outlining. For broad wings, employ the slant brush position; for thin wings and other details such as the tail of hind wings, use the vertical brush position. When you understand how the brush works and its possibilities, you will naturally know what to do and how to proceed. For instance, it is evident that the butterfly wings (bottom right) are formed by three strokes on each side. Add the details last.

Both wet and dry strokes possess qualities that are expressive of the subject. The wet-on-wet technique results in fuzziness reminiscent of the insect, whereas dry strokes with "flying white" create another kind of surface texture also descriptive of the butterfly. The combination of both types of strokes heightens the visual interest while also connoting a sense of color.

After you have mastered the basics, you can experiment and play with various brushstrokes to create designs of your own, taking your cue directly from nature's intrinsic artistry.

Capture the daintiness, lightness, and alluring beauty of the butterfly. It will add a note of gaiety and whimsical charm to a composition; or the butterfly can be the main subject, as in the painting on page 173. The softly blurred background of the painting is brushed on lightly with brush E to create an atmospheric effect.

BEES

The bee is symbolic of industry and thrift. Though small, it possesses its own monumentality. The bee's symbiotic relationship to the flower represents the essence of life itself.

Use the vertical brush position throughout.

- Use brush A with black ink to paint the head, eyes, and short feelers. Use brush B with dark gray ink for the body (one stroke). Allow the body to dry almost completely before drawing in the markings with brush A.
- For the transparent wings, use brush A with very faint gray—the water you use for rinsing brushes may be ideal for this purpose. Each wing is painted with one stroke, from the wing tip toward the body. The flapping wings of the bee on the left connote that it is in flight, whereas the other two bees are shown in repose.
- Add the legs with fine, definite strokes, using brush A. Three pairs of legs may be shown.

When you add bees to a composition, be sure they bear some relationship to the painting and to each other. Remember that odd numbers are best and that two is an exception.

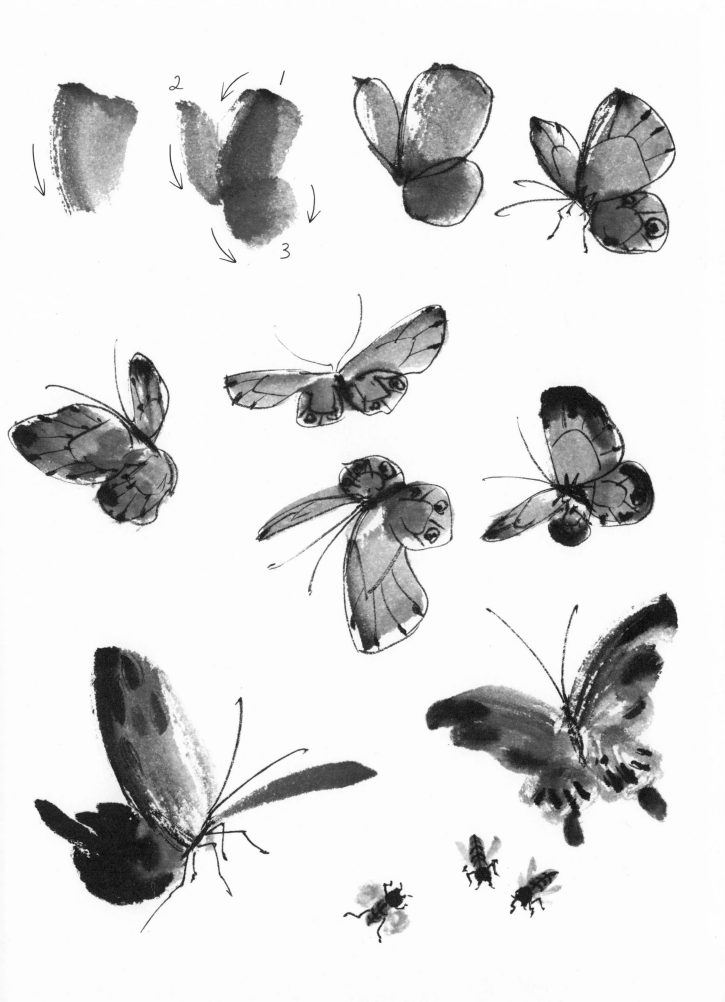

BUTTERFLIES

The blossoms fall like snowflakes
On the cool, deep, dark-green moss,
They lie in white-heaped fragrant drifts
Before the courtyard gates.

The butterflies, not knowing
That the days of spring are done,
Still pursue the flying petals
Across the garden wall.
 Zhu Miaoduan (Chu Miao Tuan)
 Ming Dynasty

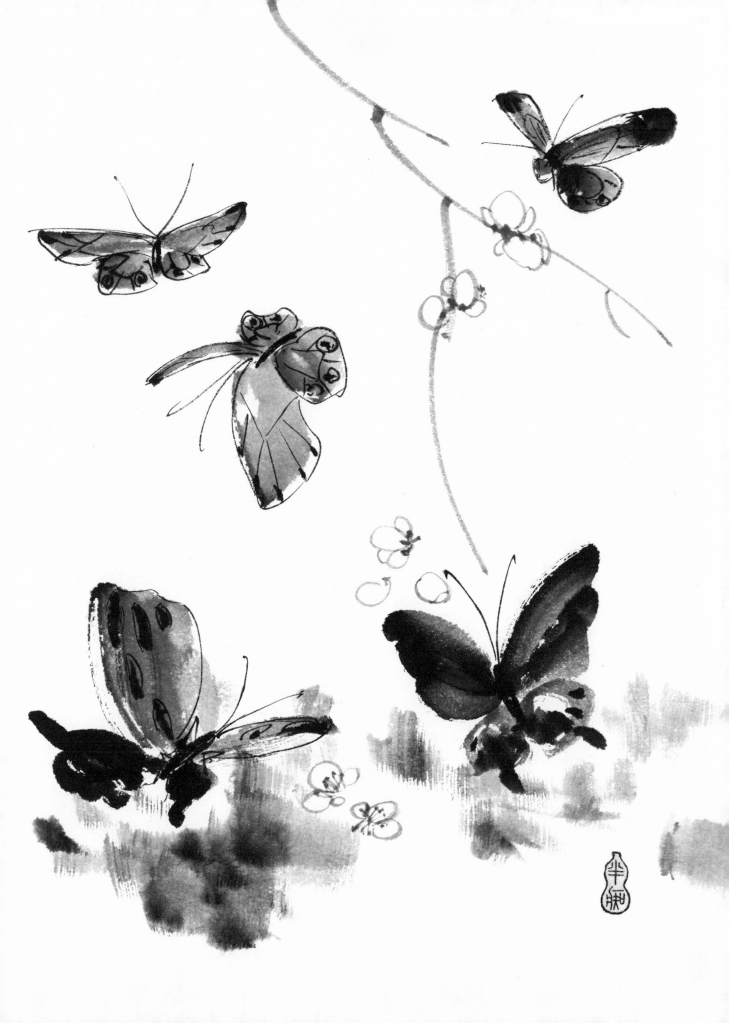

GRASSHOPPER

The grasshopper's song celebrates the renaissance of spring.

It is quite fitting that we end with the grasshopper. Not only is this
delicate creature a symbol of the eternal cycle of life, of birth and rebirth, it can
also be thought of as a symbolic culmination of the painter's skill, a tour
de force of virtuosity. To paint the grasshopper requires a perfectly steady hand
and a highly developed brush discipline. This is true for both the
minutely detailed version and the free rendition. Each demands its own kind of
brush control; both require consummate skill. The detailed grasshopper in
the illustration (page 177) is modeled after one by Qi Baishi (Ch'i Pai-Shih,
1863–1957), renowned master of Chinese painting; the freehand version is
my own interpretation.

The grasshopper's body consists of three parts: the head, thorax, and
abdomen. The wings and legs are attached to the thorax. Use the vertical brush
position for the entire grasshopper.

FREEHAND VERSION

- Load brush *B* with a small amount of gray ink (two tones) and make
 a circular stroke for the head. Then paint a long, swift stroke for the body.
 You can execute this stroke from either direction, depending on
 which direction the grasshopper faces and which way is easier for you.
- Use brush *A* with black ink to indicate the abdomen and to dot the
 eyes. Wait for this to dry.

174

- Articulate the three pairs of legs with spiky precision to achieve lines that are strong and crisp. Do the hind legs first, then the front ones, which are shorter and thinner. Each leg consists of three sections, each section bending in a different way, as shown.
- Make the antennae as fine as possible, in a similar manner as for the butterflies.

Be true to the form of the grasshopper and capture its spirit. But absolute perfection is not necessary as long as the subject has *qi*. Each grasshopper is unique, with its individual personality.

DETAILED VERSION

Be very observant in following each subtle and exacting detail. With a nimble and sure hand, paint every stroke, no matter how minute, carefully and fluently.

- With brush *B* loaded with a small amount of gray (two tones), form the shapes of the head, thorax, and wings. Leave space for the hind leg.
- With brush *A* and just enough black ink to facilitate the flow, meticulously paint in every detail. The lines must be ultrathin; otherwise the grasshopper will appear like a dead weight. Outline the forms made by brush *B*. Outline the top of the body and hind legs. Add the fine markings on the head, thorax, wings, and hind legs.
- Indicate the sections of the abdomen with the tip of brush *B*, and then outline it with brush *A*.

You do not have to follow the order of the above procedure exactly, as long as you can work it out by copying the example.

175

- Add the precise black lines for the legs and antennae.

The result should be as sensitive and delicate as the grasshopper itself.
The vitality of the brushstrokes breathes life into the insect, endowing it with *qi*.
The grasshopper is a vivid example of the Daoist principle, "regard the
great in the small."

GRASSES AND REEDS

To render grasses and reeds, recall the techniques you have learned for
the bamboo and orchid, as a combination of both can be utilized. Here, a dry
brush (*B*) is used to accomplish the desired effect. A few well-placed
strokes will provide the setting and evoke the atmosphere for the grasshopper's
dalliance.

As the end of spring flows into the beginning of summer once
more, we have come full circle in our journey through the four seasons.

176

THE GRASSHOPPER

One small intricate creature
The whole universe
Solitary chirp reverberates in stillness
Recalling timeless seasons.
 Leslie Tseng-Tseng Yu

Verdant orchid leaves mirror
Springtime's subtle green calm
Wine-splashed flowers charm and
Cavort with pure delight.
 Leslie Tseng-Tseng Yu

Orchid

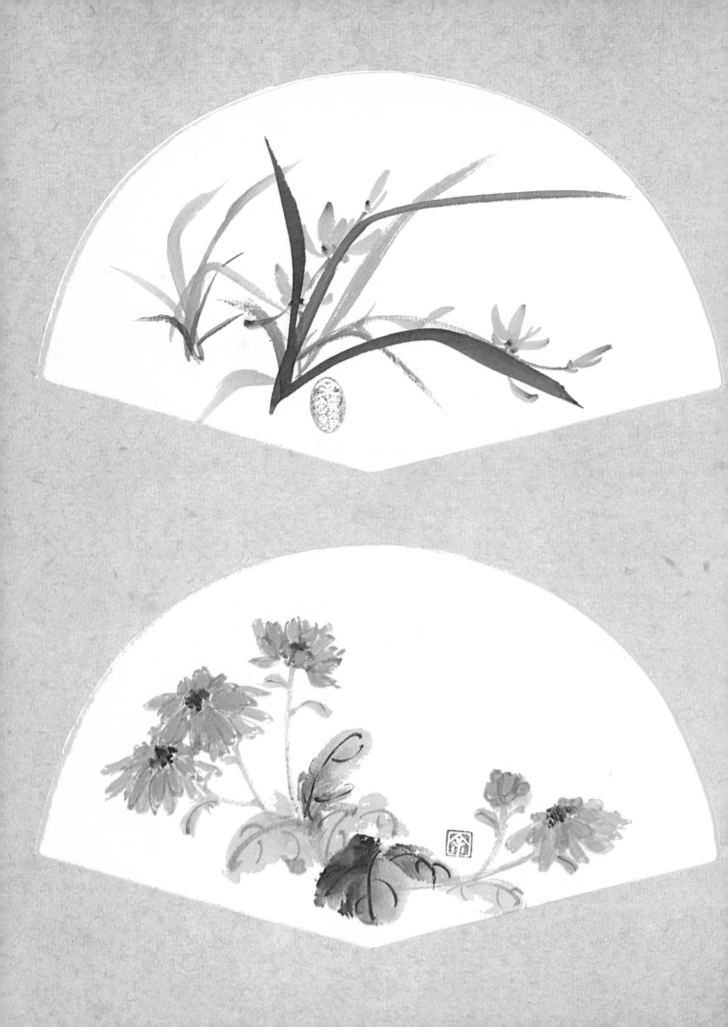

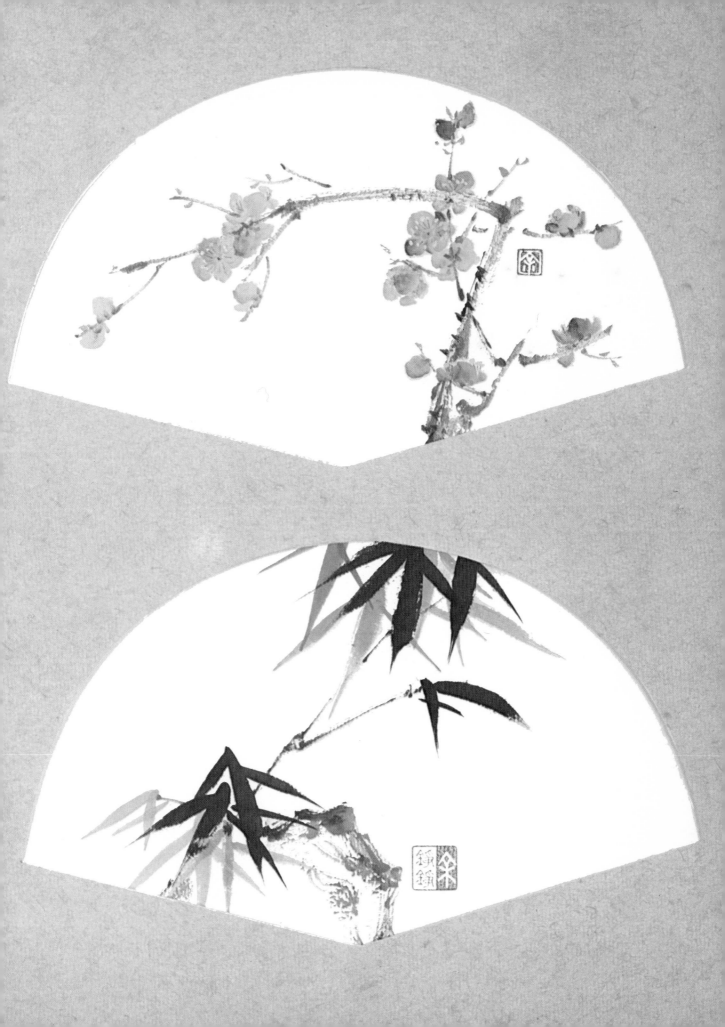

Cabbage and Snowpeas

Radishes and Grasshopper

Daylily

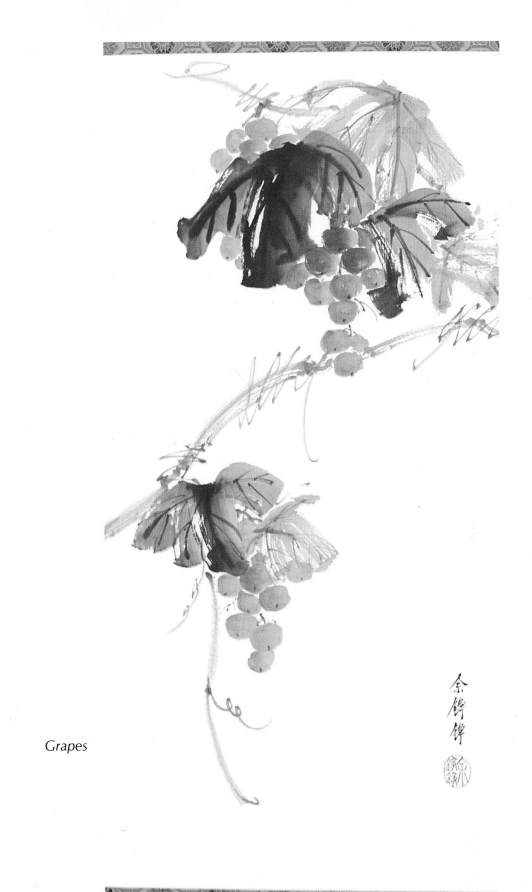

Grapes

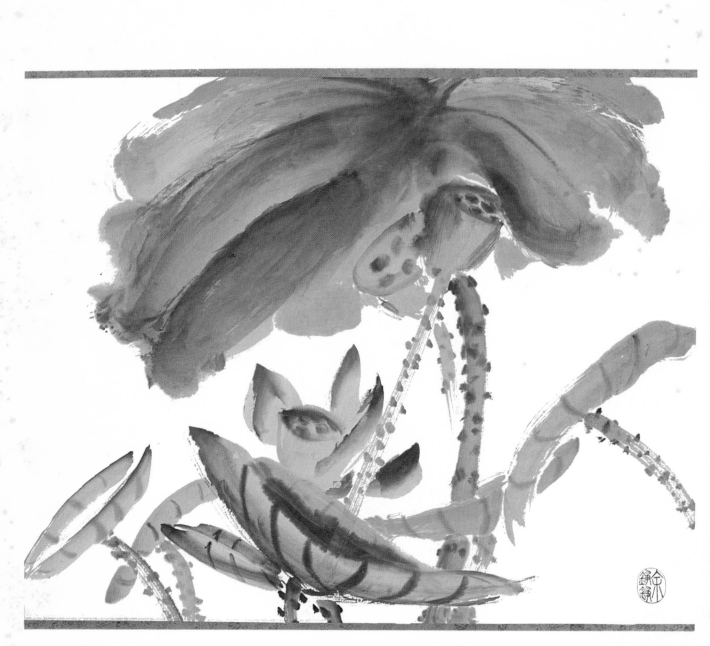

Red Lotus

Crimson lotus languish
In summer's limpid pond
Mellifluous pods burnt amber
Reveal autumn's advent.
Leslie Tseng-Tseng Yu

SUMMARY

A constant renewal of life, the four seasons are cyclical and eternal. Continually changing yet unchanging, at once transitory yet permanent, such is the wonder of the phenomenon we call nature. The opposition of summer and winter, spring and autumn—each season has its own time and place in the intricate and harmonious cosmic order.

Nature provides the essential inspiration for Chinese painting; Chinese painting reflects the essence of nature. In the rhythmic vitality of both, we see the eloquent manifestation of *yin* and *yang*. Nature's infinite variety, in both form and mood, is within the artist's grasp. The artist, by knowing the ways of nature and by cultivating her/his inner resources, can transform the experience into a painting of living beauty. The fleeting moments are miraculously captured by the agility of the brush and made permanent by the indelible mark of the ink. And because of the dynamic quality of the medium, organic vitality permeates every form, revealing its inner spiritual rhythm.

Artistic excellence depends upon depth of experience and totality of comprehension. An essential part of this experience is the understanding that a high degree of technical proficiency is a prerequisite to truly creative work, and a commitment to the same. When you have struggled with the brush and experienced the inherent intricacies of Chinese painting, you begin to realize that the simplicity is not so simple and that spontaneity requires discipline. This insight becomes intuitive rather than intellectual. Concise in expression and precise in execution, the simple elegance of Chinese

painting is the result of a highly evolved process of refinement. This refinement is made possible by a finely honed sensibility, a discerning mind, and a cultivated taste. The distinctive end result of Chinese painting, its immediate impact notwithstanding, can only be *fully* appreciated by the cognoscenti.

After you have been firmly grounded in the rules of Chinese painting and absorbed them as your own, then and only then are you ready to experiment with your own ideas. From the very beginning, you need not be concerned with developing a personal style, because the extraordinarily sensitive brush reveals your individual touch in every brushstroke, whether or not this is your intention. In the Chinese context, the brushstrokes by their very nature are as personal as they are universal. They ensure that your individuality will come through. I am always struck by how accurately my students' works reflect their personalities, which unmistakably reveal themselves in the character of the brushstrokes. Similarly, the practice of Chinese painting can tell you about yourself. In learning about the world and your unique relationship to it, you gain self-awareness. And in cultivating your total self, you are naturally cultivating your style.

The heritage of Chinese painting owes its richness to a broad spectrum of cultural, social, and historical influences. The sum total is a civilization made manifest by the brush and ink. The traditional, time-honored discipline of Chinese painting offers an aesthetic-philosophic unity and a foundation of technical excellence. It is the creative understanding of, and

adherence to, tradition that ultimately permits freedom and innovation. Tradition, after all, is not an entity separate and remote from life. Not only are we part and perpetuator of tradition, at the same time we also create it. In the dynamic, living tradition of Chinese painting, the past has great value and significance here and now. The finest in Chinese painting almost always embrace both originality of expression and fidelity to classic principles. In the final analysis, all art is contemporaneous, speaking to us directly in a universal language, and the oldest may well be the newest.

In the spiritual act of painting, first you must empty your mind and quiet your heart. The contemplative process may be long and deliberate, but once you are ready, you should "seize the brush" and proceed without hesitation. The painting must be swiftly executed "in one breath," transforming that moment in time to the timeless. Chinese painting is an affirmation of the beauty of life, an enrichment of the spirit, and an expression of the immortality of the Dao. To me, there is no exhilaration higher than to take up the brush to paint a good line and to create a beautiful form.

As each season has its own time and place in nature's grand design, so it is with the four classical subjects of Chinese painting: the evergreen bamboo, the hardy chrysanthemum, the delicate plum blossom, and the exquisite orchid. It is said that to master the bamboo requires a lifetime; perhaps the other subjects need half a lifetime. With the introduction to such a marvelous infinite path, let us begin.

NOTES

1. Dard Hunter, *Papermaking: The History and Technique of an Ancient Craft* (New York: Dover Publications, Inc., 1978), p. 465.
2. *Ibid.*, p. 467.
3. Mai-mai Sze, *The Way of Chinese Painting: Its Ideas and Technique* (New York: Vintage Books, 1959), p. 69.
4. *Ibid.*
5. Dard Hunter, *Papermaking in Pioneer America* (Philadelphia: University of Pennsylvania Press, 1952), pp. 2, 6-7.
6. *Ibid.*, pp. 2-4.
7. Wan-go Weng, "The World in the Teapot," *I-Hsing Ware* (New York: China Institute, 1977), p. 88.
8. Chiang Yee, *Chinese Calligraphy: An Introduction to Its Aesthetic and Technique*, 3rd rev. ed. (Cambridge, Mass.: Harvard University Press, 1973), p. 236.
9. Hunter, *Papermaking: The History and Technique*, pp. 465, 467.
10. Sze, *The Way of Chinese Painting*, p. 71.
11. *Ibid.*
12. *Ibid.*, p. 97.
13. Florence Ayscough, "The Chinese Idea of a Garden," *The China Journal of Science and Arts* (March 1923), p. 137. From C. A. S. Williams, *Outlines of Chinese Symbolism and Art Motives*, 3rd rev. ed. (New York: Dover Publications, Inc., 1976), p. 70.
14. Sze, *The Way of Chinese Painting*, p. 275.

CHRONOLOGY

Shang	ca. 1523–1028 B.C.
Zhou	ca. 1027–256 B.C.
Qin	221–207 B.C.
Han	206 B.C.–220 A.D.
Three Kingdoms	220–265
Six Dynasties	265–589
Sui	589–618
Tang	618–907
Five Dynasties	907–960
Song	960–1279
Yuan	1279–1368
Ming	1368–1644
Qing	1644–1911
Chinese Republic	1912–1949
Chinese People's Republic	1949–

SELECTIVE BIBLIOGRAPHY

Chang Chung-yuan. *Creativity and Taoism: A Study of Chinese Philosophy, Art, and Poetry*. New York: Harper & Row, Publishers, Inc., 1970.

Chang Shu-Chi. *Painting in the Chinese Manner*. New York: The Viking Press, 1960.

Chiang Yee. *Chinese Calligraphy: An Introduction of its Aesthetic and Technique*, 3rd rev. ed. Cambridge, Mass.: Harvard University Press, 1973.

Chow, Johnson Su-Sing. *The Fundamentals of Chinese Floral Painting*. Taipei: Art Book Co., Ltd., 1979.

Hejzlar, Josef. *Chinese Watercolors*. London: Octopus Books, Limited, 1978.

Rowley, George. *Principles of Chinese Painting*, rev. ed. Princeton, N.J.: Princeton University Press, 1974.

Sze, Mai-mai. *The Way of Chinese Painting: Its Ideas and Technique*. New York: Vintage Books, 1959.

Van Briessen, Fritz. *The Way of the Brush*. Rutland, Vt., and Tokyo: Charles E. Tuttle Company, 1962.

Watts, Alan. *Tao: The Watercourse Way*. New York: Pantheon Books, 1975.

 Published in the Autumn of 1981